How to Identify Prints

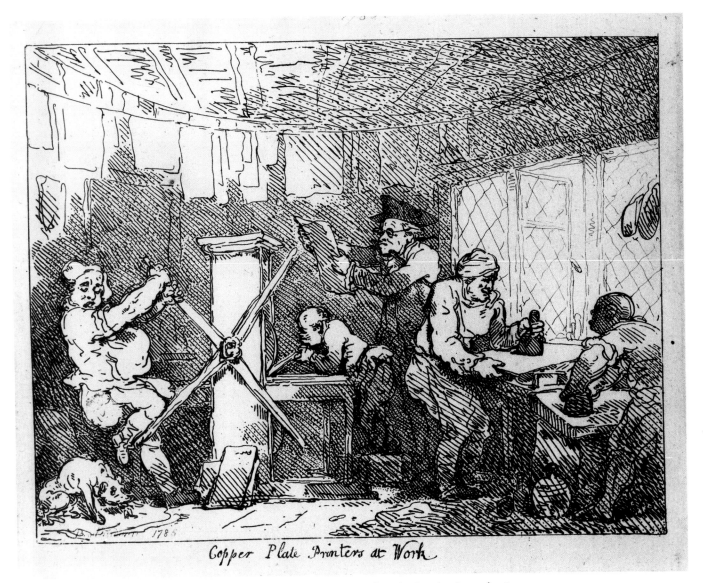

Copper Plate Printers at Work

'Copper Plate Printers at Work', an etching by Rowlandson of 1785
showing printers inking (right) and printing on the rolling press just such an
intaglio print as Rowlandson's own etching (actual size).

BAMBER GASCOIGNE

How to Identify Prints

A complete guide to manual and mechanical processes
from woodcut to inkjet

SECOND EDITION

with 272 illustrations, 40 in color

First published in the United States of America in hardcover
in 1986 by Thames & Hudson Inc., 500 Fifth Avenue,
New York, New York 10110

thamesandhudsonusa.com

Revised paperback edition 2004

Library of Congress Catalog Card Number 2003112372
ISBN 0-500-28480-6

Printed and bound in Spain by Artes Gráficas Toledo, S.A.U.
D.L. TO: 77-2004

CONTENTS

I The prints

PRINT FAMILIES

1 The three types of print
2 Other images known as prints
3 Manual prints and process prints
4 Monochrome prints and colour prints

MANUAL PRINTS

Monochrome

Relief

5 Woodcuts
6 Wood engravings
7 Metal relief prints
8 Modern relief methods

Intaglio

9 Engravings
10 Etchings
11 Drypoints
12 Line engravings
13 Steel engravings
14 Crayon manner and stipple engravings
15 Soft ground etchings
16 Mezzotints
17 Aquatints

18 Other total methods in intaglio

Planographic

19 Lithographs
20 Transfer lithographs

Colour

Relief

21 Chiaroscuro woodcuts
22 Colour woodcuts
23 Tinted wood engravings and colour wood engravings
24 Relief colour from metal blocks
25 Modern relief methods in colour

Intaglio

26 Colour mezzotints, aquatints, stipple engravings

Planographic

27 Tinted lithographs
28 Colour lithographs

Mixed method

29 Baxter prints
30 Nelson prints
31 New methods in colour

PROCESS PRINTS

32 Categories of process print

Monochrome

Relief

33 Line blocks
34 Relief halftones

Intaglio

35 Nature prints
36 Photogalvanographs
37 Line photogravures
38 Tone photogravures
39 Gravures (machine-printed)

Planographic

40 Collotypes
41 Photolithographs

Colour

42 Relief
43 Intaglio
44 Planographic

SCREENPRINTS AND NON-PRINTS

45 Screenprints
46 Monotypes and *clichés-verre*

II Keys to identification

III Reference

The idea for this book arose when I had begun to collect prints of the area in which I live, and naturally I wished to know what I was buying – a matter on which the dealers themselves were often vague. I read many books on the subject and picked up the basic facts, but no book really showed me in detail what I should be looking for to identify a print. Instead they spent much valuable space on the aesthetic history of prints and on technical aspects of how to create an engraving, etching or lithograph. This was fascinating material but it belonged in books other than the one I had in mind. My own immediate problem was not that I had any unidentified engravings by Dürer (very few people own these without knowing what they are), nor that I was about to make a print myself. I merely wanted to be able to describe correctly the attractive image of Richmond Bridge that I had bought for a few pounds round the corner.

So this book was a belated answer to my own needs and was written with that single purpose, as an aid to the identification of prints. It therefore drifts into art history only in so far as broad historical guidelines are useful in knowing what to expect at what period. It discusses the making and the printing of the original plate to the extent that this helps in the work of detection, for it is the telltale signs of how the image was made and was transferred to the paper which provide the most important clues.

Above all the book is not concerned with artistic merit. We all live surrounded by prints. From billboards to brochures, from books and magazines, printed images compete for our attention. There can hardly be a house in the developed world which does not have a print on the kitchen table, decorating a packet of cereal or biscuits or tea. The picture of milk cascading onto cornflakes is just as much a print as any other. As with so many prints of the past, it is the modern printer's best available answer to a commercial need. It is susceptible to exactly the same processes of detection as a great work of art, such as an etching by Rembrandt.

In the eighteen years since its first publication this book has been reprinted several times, but this is the first time it has been updated – to coincide with the first paperback edition. No new printing technique has been developed during that period; but two that were then in their infancy, laser printing (or xerography) and inkjet printing, have become infinitely more sophisticated and are now a familiar feature of the everyday images that surround us. This edition therefore goes more fully into techniques for identifying them.

ACKNOWLEDGMENTS

Behind the creation of any book such as this are the many friends and acquaintances with a similar enthusiasm for prints who over the years have shared their knowledge and expertise. They are too numerous to thank individually, but one man does stand out above all others in the amount of help and encouragement he has given me over the years as well as specifically on this book. Michael Twyman, recently retired as Professor in the Department of Typography at Reading University, is unstintingly generous in sharing his vast knowledge of printing history, and I was relieved and immensely grateful when he agreed to read the book in typescript. His many excellent suggestions have been incorporated, and the book is very much improved as a result (though where we agreed to differ, any quirks of interpretation remain mine alone).

The illustrations nearly all come from prints in my own possession. The exceptions are those from the late Peter Jackson (Figure 89), who generously allowed me to browse through his superb collection; from the British Library (Figures 4 and 15); from the John Rylands University Library of Manchester (Figure 29); and from Colnaghi Prints (Figure 8). David Dimbleby kindly permitted the reproduction of two items from the *Richmond and Twickenham Times*. I would also like to thank the artists who have given me permission to reproduce their prints or details from them: Tessa Beaver (Figures 70, 71), Kathleen Caddick (Figure 159), Carmen Gracia (Figure 104), Terence Millington (Figure 92), Bevis Sale (Figure 93) and Bob Sanders (Figures 110, 111).

Finally my thanks to the editor of this book, Emily Lane, who helped immeasurably in solving the structural and organizational problems arising with material of this kind, and to the designer, Ian Mackenzie-Kerr, who has been exceptionally attentive to the author's wishes in the difficult matter of relating the numerous illustrations to the text.

B.G.

HOW TO USE THIS BOOK

Purpose

This book is not for reading. It is for dipping into, as part of a specific detective process – that of analysing how the printer's ink has been transferred to a particular piece of paper which carries an image. In other words, identifying a print.

The emphasis throughout is on the image, that being the essential characteristic of what most of us consider to be a print. But there are often subsidiary clues in any accompanying printed text, so this is also dealt with.

In the interests of dipping, the book is arranged in self-contained numbered sections with cross-references. This makes it simple to extract information of varying degrees of complexity. Some readers will wish to know the difference between engraving and etching, or what a litho-graph looks like. Many will have no need of such information. Few, perhaps, will be able to bring to mind without a moment's thought the charac-teristic features of a glyphograph or heliogravure.

Structure

Part I, sections 1–46, is concerned with the various types of printed image, including those which are not strictly speaking produced by printing but are conventionally classed as prints.

Part II, sections 47–79, deals with topics relevant to the business of identification – visual evidence of different kinds, visible to the naked eye or with magnification; specific areas of possible confusion; the historical development of particular genres, such as illustrated books, postcards and stamps; and technical processes an understanding of which may help in distinguishing between prints.

Part III, sections 80–107, provides a Print Vocabulary, which sets out terminology for the families of prints (80); a Select Bibliography (81); the Sherlock Holmes Approach, a step-by-step guide to identification (82–106); and a Glossary-Index, which gives references to numbered sections in the book and also brief definitions of additional technical terms.

Method of use

i. If you have no idea what your print may be

Start with the Sherlock Holmes approach (82–106), consisting of a series of questions. By a process of yes/no answers these will lead to the appropriate section of the book.

This method should work equally well for someone with no knowledge of prints trying to identify a quite common example and for someone with considerable knowledge confronted by a rarity.

ii. If you have an idea what the print may be and wish to confirm it

Look up the technique which you have in mind (woodcut, etching, lithograph, etc.) in the Glossary-Index (107). There you will find the section number of the main entry followed by a description of other relevant entries, any of which may throw light on your specific area of uncertainty.

iii. If you have a clear idea of what technique or techniques have gone into the making of your print but are uncertain how to describe it

Look for it in the Print Vocabulary (80), where a broad definition of each term is given, making it possible to choose the description best suited to the print in question.

The equipment you will need is some form of magnifying glass. For most purposes any glass giving magnification between 4× and 10× is sufficient, and the advantage of the lower magnification is that you are able to view a larger area of the print. The easiest type of glass to use is one which sits on the surface of the paper, thus ensuring that the image is permanently in focus. The complete stillness of the image, never possible if one is holding the glass by hand, enables the eye to relax – an essential factor when looking for evidence to settle a ticklish point. If the owner of the print is worried about the glass touching its surface, a thin sheet of acetate laid on the print will avoid any danger of damage and will not

impair the clarity. Any contact with the print surface is unlikely to be allowed in public collections. The more usual magnifier for examining prints and drawings, at which no one will take offence, is the small folding glass available from any oculist and usually magnifying up to about 10 x ; this is, incidentally, the only magnifier which can be used when attempting to identify a framed print, but the sheet of glass makes identification unnecessarily difficult and to resolve any doubts a print will often need to be removed from its frame. The plastic type of magnifying glass which sits on the surface of the print is available from photographic shops, being in common use for looking at 35mm transparencies. The very useful model on the right in Figure 1 is known as a linen-prover, being designed for assessing the fineness of the weave in linen, and is often available from stamp dealers. The conventional form of magnifying glass, as used for reading small print, enlarges only about 1.5 x or 2 x which is insufficient for purposes of detection.

There are on the market some very effective miniature microscopes which are astonishingly cheap (between £10 and £15 at the time of writing). They give a 30 x magnification and can be very useful for specific purposes. Sometimes a printed line or letter which looks planographic at 10 x will suddenly at 30 x reveal the squashed-ink rim of relief printing. However for most purposes the extra enlargement actually confuses matters. The process of detection is essentially that of looking for the patterns of ink which are characteristic of the different methods.

At 5 x or 10 x these often become startlingly clear. At 30 x the emphasis shifts from the pattern of ink to the broken texture within the ink surface itself, thus often obscuring the issue.

The illustrations have been chosen, mainly from inexpensive prints in my own possession, to reveal some particular characteristic for which the detective is on the lookout. They are therefore more typical than a random specimen is likely to be, and the same qualities may well fail to show up in another print of the same kind – perhaps because it is a bad impression, or is on bad paper, or is itself untypical. So the absence of signs in a print when compared with an illustration need not be conclusive. It is only the presence of a specific feature which may provide a useful clue in the process of detection.

It is important to emphasize that there is no point in looking through a glass at the close-up details given in this book. All the glass will reveal is the very recognizable characteristic of halftone offset lithography, the process by which the book is printed (described in 41c). The details are devised so that when seen at reading distance on the page they will appear to the eye much as the same detail on the original print would appear through a glass.

In the captions, for guidance, the size of the reproduction relative to the size of the original is given – whether a reduction (for instance 0.5 x , or half size) or an enlargement (2 x , or twice actual size).

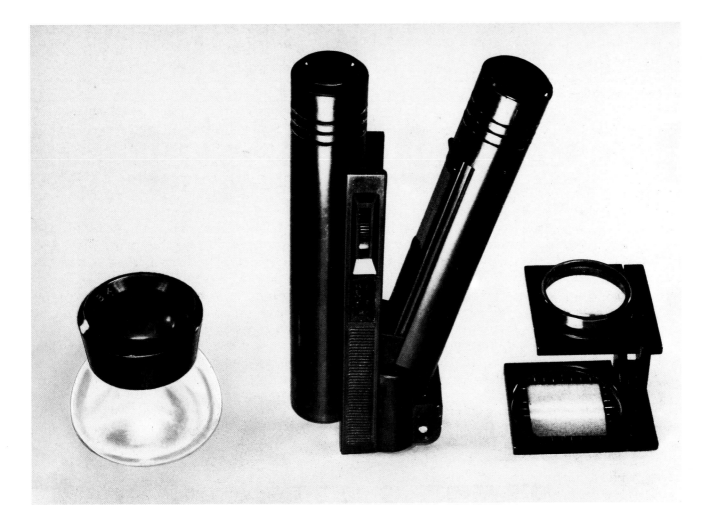

1 Three types of glass: left, enlarging 8x; centre, a microscope with built-in light, enlarging 30x; right, a linen-prover, enlarging about 4x

2 A sheet of manufactured tint, or letratone, as seen though the microscope at 30x, showing the ink squashed by relief printing into the fleece-like surface of the paper.

3 The linen-prover on the same sheet of letratone, showing 4x enlargement.

PRINT FAMILIES

1 THE THREE TYPES OF PRINT

In the long history of printing, and in all the variety of printed images, there are only three basic types of print. This may seem too absolute to be believable, but when looked at more closely it verges on the obvious. Printing is strictly defined as the transferring of ink from a prepared printing surface (the block, plate or stone carrying the image) to a piece of paper or other material. The ink can be carried on raised parts of the printing surface (relief), in lowered grooves (intaglio) or on the surface itself (planographic or surface). Above the surface, below the surface, on the surface – there can be no other way. But within the trio there are major differences, and it is these which provide all the important clues in the identification of a print. They are differences deriving from how the image is created on the printing surface, from how it is inked, and from how the ink behaves when transferred to the paper. Banknotes, which are usually excellent examples of printing, will provide the most readily available examples of the basic characteristics. Anyone eager to jump straight to a practical example, and with a crisp U.S., British or E.U. banknote to hand, will find the relevant details in 77a.

a Relief By far the oldest of the three methods is relief. It already has at least eleven centuries behind it, as opposed to five for intaglio and less than two for planographic, and only in the past few years has it begun to lose its predominance as the most common form of printing. Figure 4 is a detail from the earliest known printed book, which the Chinese Buddhist monk Wang Chieh produced on 11 May 868 'in order in deep reverence to perpetuate the memory of his parents'. Figure 5 comes from an issue of my local newspaper dated 5 August 1983. In each case the printing is by the relief method. Wang Chieh had to cut around each separate Chinese character and around every line of his picture to achieve the flat raised printing surface on his plank of wood, whereas the Richmond printers were using modified nineteenth-century technology to create a raised metal printing surface on a rotating cylinder. But the point is that in each case the ink was transferred under pressure from a raised surface to paper, and each will therefore exhibit the basic characteristics of relief printing.

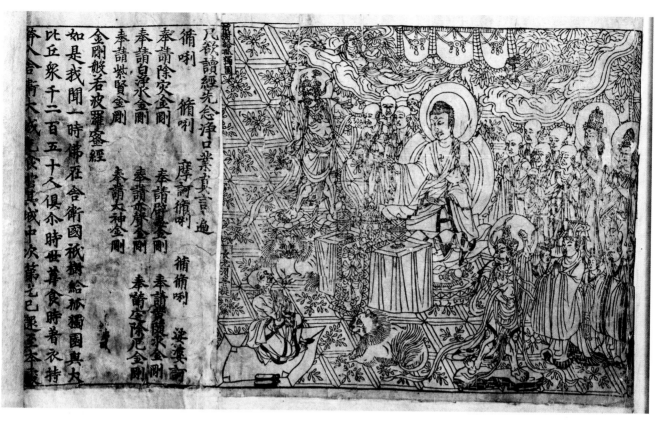

4 The woodcut illustration in the *Diamond Sutra*, 868 (0.4×).

5 A line block from the *Richmond and Twickenham Times*, 1983 (0.45×).

The relief block is ready for use as soon as all the non-printing areas have been cut away, leaving the image as the only remaining part of the original surface. Ink can be applied to the printing areas by simple dabbing, but the flat raised nature of the image is also perfectly suited to the more rapid and efficient use of a roller. The roller is charged with thick printer's ink and is then passed across the surface of the block. It is too rigid to sink into the recessed parts of the block, so the ink is only transferred to the printing areas.

The block is now ready to be printed. Again, at the simplest level, the ink can be transferred by laying the paper down on the block and rubbing it with a hard rounded surface, such as the back of a spoon. But the impression is more rapidly and efficiently achieved in the ordinary printer's press, as used from the fifteenth century for pages of text. The paper is laid on the inked block and is covered with a protective layer (the tympan) before being subjected to pressure from the flat plate (the platen) of the printing press. Not only is the ink squashed to the edges of the printing areas, but these areas are themselves pressed into the paper sufficiently hard to appear in most cases as a raised or embossed pattern on the reverse side. This sure sign of relief printing can be seen in varying degrees on the text pages of almost any book published before our own century. It is most visible on the back of the title page or wherever a large part of any page remains blank, as at a chapter

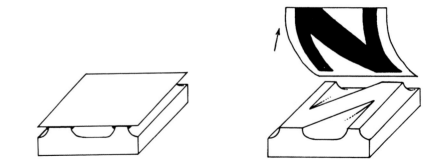

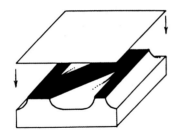

6 The stages of relief printing.

end, with text on the other side. Sometimes it can be felt with the tip of a finger more easily than it can be seen.

Figure 6 shows the cross section of a relief printing block which will print a thick and a thin line. The paper has a more porous surface than the block, so when the two are pressed together the paper picks the ink off the areas standing in relief. At the moment of printing the ink is squashed towards wherever the pressure is less, which is in effect round the sides of each raised area of the block. The single most reliable characteristic of relief printing is the build-up of ink at the edges of printed areas, causing a darker rim round at least some part. We are all familiar with one version of relief printing in the form of the everyday rubber stamp, which on its raised surface picks up ink from the pad and transfers it under the pressure of our hand onto the paper. The older metal stamps often showed the squashed effect of the ink, pushed to the edge of the letters.

b Intaglio

Intaglio is Italian for incising or engraving. There is no familiar household version of intaglio printing, partly because the printing process requires much greater pressure. As Figure 7 shows, the ink is held in grooves below the surface of the plate, and this immediately makes possible one distinction which is a basic characteristic of intaglio printing. The grooves can be of different depths and will therefore hold varying amounts of ink, meaning that a line can be darker or lighter as well as thicker or thinner. A similar effect can be achieved in relief printing, through devices which will be described later (51d), but this variation in the intensity of ink on the paper is a feature primarily of intaglio.

The intaglio plate is ready for use when the image has been achieved in the form of these recessed areas below the flat surface of the metal, whether the recesses have been manually cut with the engraving tool or chemically etched away by acid. The ink must go fully into every recess. To facilitate this the plate is usually warmed, and the ink is often forced into the lines more securely with a dabber after being rolled over the plate. The ink is then carefully wiped off the surface, leaving it only in the recessed grooves which constitute the image.

If paper were now placed on this prepared plate, and the two were subjected to the even pressure of the relief press (1a), most of the ink would

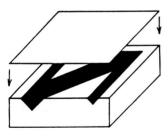

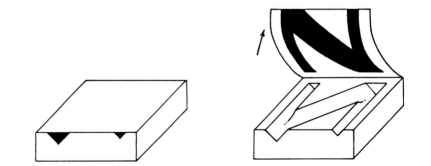

7 The stages of intaglio printing.

remain within the grooves. For the paper to pick out the ink various crucial modifications are required in the design of the press and the method of printing. Plate and paper must together be subjected to much greater pressure than in relief printing; the pressure must be transmitted down into the deepest grooves of the plate; and the paper must itself be capable of reaching down into those grooves.

These requirements are met by making the paper damp before placing it on the plate and by laying on thick lamb's-wool blankets before passing the complete sandwich (plate, paper, blankets) through a glorified version of the old-fashioned mangle. The two large cylinders of the intaglio press, commonly known also as the rolling press, exert sufficient pressure on the lamb's wool to force the paper into the grooves. This, combined with the considerable amount of ink held in a deep groove, means that a dark line on a good intaglio print, when seen through a glass, will seem to rise up at one –

8 Intaglio printing: in *The Three Trees*, of 1669, Rembrandt has used various methods to achieve the ink-bearing recesses in the plate – etching, engraving and drypoint (0.4×).

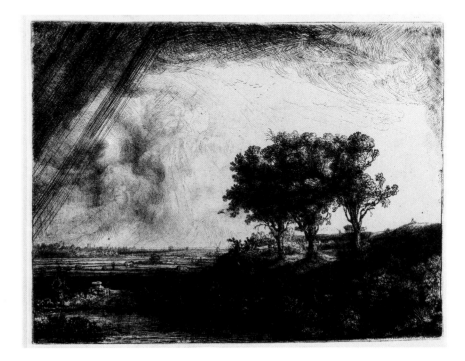

much like a line of rust from an otherwise clean metal surface. The top cylinder will also press the paper down around the bevelled edges of the plate, providing that other exclusive characteristic of an intaglio print, the plate mark.

The variable depth of the groove is also the reason why intaglio prints will be darker and stronger if printed early in the edition. The process of wiping and printing a copper plate wears down its surface, causing the deep grooves to become shallower and the shallow ones sometimes to disappear entirely. So a late impression, from a worn plate, will not only look relatively faint but may also lack much of the fine detail of the image.

c Planographic

The youngest method of printing, known as planographic or surface printing, has in recent years overtaken its rivals to become the most common of the three among the printed images around us. Lithography, the original and the most usual form of planographic printing, is based on the eternal antipathy between grease and water, as a result of which certain parts of a semi-absorbent surface can be made receptive to the printer's ink while other parts – those which will remain blank in the printed image – reject it. The printing surface can therefore be flat, and in principle the different areas of its surface (however small each such area may be) must either print solid or not print at all.

9 Planographic printing: a chalk lithograph by Honoré Daumier, c.1840 (0.6×). The hatter is assuring his customer that the article fits him 'like a glove'.

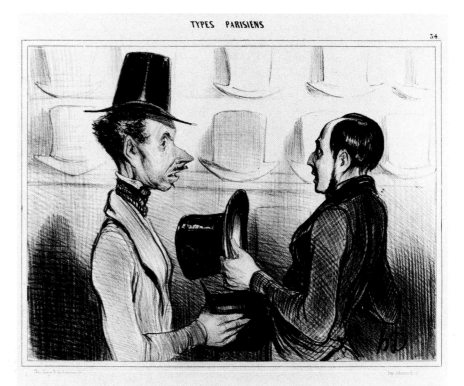

TYPES PARISIENS

34

Ça vous coiffe comme un tant!

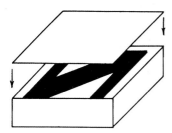
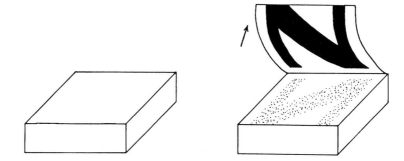

10 The stages of planographic printing.

The appearance of the ink in a typical lithograph derives from these factors. It has an evenness of tone between all the inked areas, for the ink either adheres fully to the printing surface or is fully rejected by it (apparent variations in tone being achieved by the amount of paper covered in ink rather than by the depth of ink), and it has an evenness of tone within each inked area for there are no patches of lighter pressure towards which the ink will be squashed. But though this flatness is the main characteristic of the printed image, it will often become apparent only through a glass. The medium is so versatile that a good lithographer can achieve almost any effect to the eye.

The lithographic stone, or a related substance such as roughened zinc or aluminium, is ready for use when the image has been created on it in the form of greasy marks. A succession of chemical processes serves to make these marks fully receptive to grease and fully resistant to water, and at the same time to make the unmarked parts of the stone receptive to water and therefore resistant to grease. The stone is now dampened, affecting only the non-printing areas, and a roller charged with greasy printer's ink is passed over its surface. The ink remains on the roller wherever it meets a damp part of the stone (anyone who has tried to grease a wet baking tin will know this form of rejection from bitter experience), but it is transferred from the roller to the stone wherever it encounters grease.

The image now exists in ink on the surface of the flat stone. In the traditional lithographic press the paper is laid on the stone, with sufficient backing material and a thin sheet of metal above it, and the whole package is passed on runners under a bar of wood covered in leather known as the scraper. The downward pressure of the scraper transfers the ink from stone to paper. The scraper is normally less wide than the stone (though wider, of course, than the image), so no pressure is exerted on the paper at the edges of the stone and there will in such a case be no impression mark or plate mark.

In recent years this traditional method of lithographic printing has been extended to include the offset principle. Instead of the paper being placed upon the stone (or, almost invariably now, metal plate) and the ink being transferred by the pressure of a scraper, both paper and plate lie, carefully aligned, along the bed of the press. A rubber-covered offset cylinder rolls over the inked plate, picking up the ink, and then moves on to roll over the

paper, depositing the ink. There are two advantages. One is that the image need no longer be in reverse on the plate (the offset cylinder itself effects a reversal), and the other is that register (68) is made more reliable in colour work, which forms the greater part of modern lithography by artists. It is easier to place and to grip a sheet of paper accurately on the bed of a finely-engineered modern press than to lower it face down over an inked plate.

2 OTHER IMAGES KNOWN AS PRINTS

The definition of a print adopted in this book is that of an image formed in ink which has been transferred (by pressure, the 'impression') from a printing surface (the block, plate or stone). The fact of the separate printing surface means that the image exists independently of each impression and can therefore be exactly repeated, while the transferring of ink by contact from one surface to another inevitably involves the reversal of the image. These two factors – repeatability and reversal – can be seen as the essential characteristics of all traditional printing methods, establishing them as a recognizable family from which other methods of duplicating an image are excluded (brass-rubbing, for example, where the image is repeatable but not reversed).

In common usage the word 'print' extends beyond the more limited category thought of as 'printing'. A photograph is often spoken of as a print (in such a phrase as 'a 10 × 8 black-and-white print'), even though we do not describe the resulting image as 'printed'. For the most part the dividing lines, however blurred in terms of vocabulary, are sufficiently clear in our minds. Nobody will be surprised that photographs are excluded from a book entitled *How to Identify Prints* – though the probability of confusion between certain types of photograph and prints is dealt with in 57a.

a Screenprint There are a few categories outside my narrow family of printing which would be surprising omissions. The most significant of these is screen-printing (repeatable but without reversal), which has become in recent decades an important technique both for artist printmakers and for commercial printers. For this reason alone the screenprint (45) would demand inclusion. And although the technique is more closely related to colouring by stencil than to true printing, there is in fact a natural affinity between a screenprint and a traditional colour print in the sense that the image is built up by the application of a succession of inks of different colours.

b Monotype and *cliché-verre* Other less common methods – the monotype (46a) and the *cliché-verre* (46b) – earn a place because they have traditionally been included in books on prints. A monotype (involving reversal but not repeatable) is more closely akin to a painting. And a *cliché-verre* is a photograph.

c Xerox and laser One recent method that falls outside my traditional categories is the reproduction of images by electrostatic printing or xerography, commonly referred to as xerox. The nature and appearance of xerography, easily confused with some traditional forms of print, is dealt with in 57g.

Xerox being a trademark, desktop printers operating by xerography are usually referred to as laser printers. The phrase is a misnomer. The laser does not print in any recognizable sense. It merely conveys instructions from a computer to create an electrostatic field for printing by xerography.

d Inkjet In recent years inkjet has become an extremely efficient and cheap way of printing both black-and-white and colour from computer-generated text and images. As a result an inkjet printer is now a familiar item in the majority of computer-owning households. A printer of this kind turns the electronic impulses from the computer into marks on paper by directing tiny jets of ink in the manner of an airbrush. As with halftone process prints (34), a tonal image in either monochrome or full colour is achieved by the relative density and size of dots (or any other screen patterns) in lighter or darker areas.

3 MANUAL PRINTS AND PROCESS PRINTS

Up to the mid-nineteenth century all prints were manual in the sense that the image to be printed was created directly on the final printing surface, whether of wood, metal or stone, by the hand of an artist or craftsman. During the nineteenth century there was much research to enable the artist to originate the image on a more congenial material (paper being the most congenial of all), after which the image could be transferred to a printing surface by any of various methods involving technical rather than manual skill on the part of the printer. Such prints became known as process prints (32).

A borderline case is the transfer lithograph, where the image is achieved on paper and then transferred to stone. Since an early and important use of this technique was by artists, and since the lithographic ink used on the paper becomes the actual image-forming ink on the stone, the transfer lithograph has been treated here as a manual print (20).

In spite of this one exception, the distinction between manual and process prints is a clear and basic one, affecting both the final appearance of the print and in most cases any judgment of its intrinsic value. Because of this value judgment most books on prints discuss only the manual varieties. But the vast majority of the printed images in the world today are process prints, which must therefore feature largely in the task of identification.

4 MONOCHROME PRINTS AND COLOUR PRINTS

Monochrome prints are those which use only a single ink. Traditionally the ink for prints has been black, though there were periods when sepia was popular. But a print in red ink – or green or heliotrope or gamboge – is still monochrome if no second printed colour is used. The clues for identifying its nature will remain exactly the same as with black ink.

From the days of the earliest European woodcuts, prints have been sold with hand-colouring to those who were willing to pay ('penny plain, twopence coloured' was the relative cost of the two versions in the early nineteenth century when buying printed sheets of characters for toy theatres). But when identifying such a print, the colour is an irrelevant extra ingredient, added after the print itself was complete. The print has to be analysed as with any other monochrome print, though in describing such an example one would add that it is 'coloured'. It is a useful distinction, and one that is followed in this book, to refer to prints with hand-painted colour as 'coloured', reserving the term 'colour print' for those where two or more inks are printed. Black counts in this context as a colour. So a black image tinted with just one other printed colour is classed as a colour print alongside a chromolithograph using perhaps twenty inks of different hues.

Relief

a Origin and character

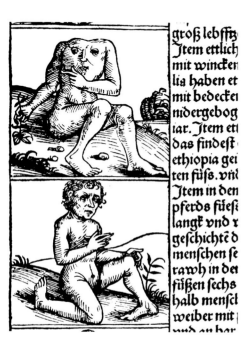

11 Woodcut illustrations beside the text in the *Nuremberg Chronicle*, 1493 (actual size).

5 WOODCUTS

Some six centuries after the invention of the wood block in the East (1*a*) the craft was developed in Europe, in about 1400. In both areas the early woodcuts were for the most part simple holy images for sale to pilgrims. The lines were drawn on the plank side of the wood (that being the largest side of any normal piece of wood, cut with the grain, as opposed to the end of the plank which is cut across the grain). Every part of the wood surface was then removed except the lines of the image, using a sharp knife for the delicate areas and a flat gouge for the wide open spaces, a task similar to woodcarving. When the block was completed, the image stood up as a level surface in relief. Ink could be applied to it with a dabber and it could then either be stamped by hand onto a piece of paper to transfer the image, or the paper could be laid face down on the block and its back could be rubbed to lift the ink evenly. The latter has always been traditional in the East and was probably the method first used in Europe.

The lasting contribution of the relief print in the West derived from two inventions perfected in the 1450s, the printing press and movable type. The press, using pressure applied by a lever, would provide a quicker and more reliable way of printing the image. Even more important was the fact that the lines of the image stood up in relief in exactly the same way as the printer's type. It was easy to lock the two firmly into position and to print text and picture together, achieving an illustrated page at a single operation. Figure 11 is a marginal detail from perhaps the most ambitious of Europe's early books with printed illustrations, the *Nuremberg Chronicle*, a history of the entire world which was published in Nuremberg in 1493. Thanks to this compatibility in the printing of text and image the various human monsters, a popular element in travellers' tales of the time, were able to be shown in convincing detail exactly beside the passage telling where in the world they were to be found.

The men with faces in their chest or back-to-front feet are carved from the wood without much sophistication and therefore show clearly some of the basic characteristics of the woodcut – in particular the stark contrast between the pure white of the areas which have been cut away and the pure black of those which remain, together with the very solid outline to the figures which is natural in a craft involving paring away rather than linear drawing in the creation of the final image. The heavy but uneven black frame to the image is also typical of the early woodcut.

b Sixteenth-century development

When the *Nuremberg Chronicle* was published Albrecht Dürer, himself a native of the city, was twenty-two. It is thought that he may even have been involved in a small way as an apprentice in the preparation of the illustrations. But he was soon to show that it was possible to achieve much more delicate effects in this medium, even allowing for the relative coarseness of both the block and the tools. Under his influence the woodcut

11

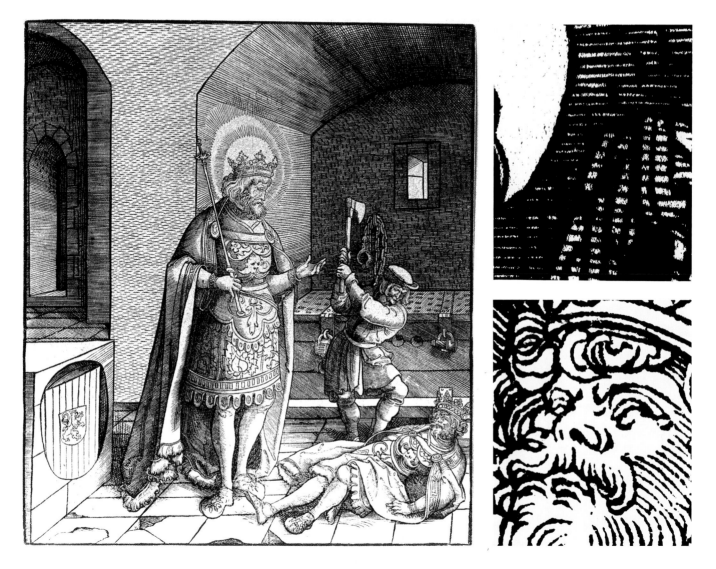

12–14 Woodcut by Hans Leonard Beck, *c.*1515 (0.6×) and two details (5×).

rapidly lost its primitive appearance. Figure 12 is a print of about 1515. At first sight it appears to be a conventional linear composition, the type of image which has been drawn rather than carved away. The very firm black lines surrounding the scene and defining the edges of walls and windows give the first clue that it may be a woodcut, but it is not until parts are inspected in close-up that the identification becomes certain. 12

The first detail shows the axe head and the chains against the wall. A basic test of a relief print is to try to imagine anyone drawing such an image in black lines. It is possible that a draughtsman would decide to have the axe blade and each link of the chain pure white, but he would achieve this by drawing a black line around the spaces. It is not conceivable that he would then allow the separate black details of the wall to join up at all points with his outline. These shapes have to be the result not of draughtsmanship but of 13

carving, and it is not then difficult to refocus the mind and to see all the patches of pure white as areas cut away in the black printing surface. Immediately, the character and the skill of a good woodcut become clear. In the detail the chain is almost impossible to interpret as such. In the full print, seen at a normal distance, it is an entirely convincing representation. The wood-block cutter has achieved the desired illusion in a convention unfamiliar to us but in keeping with the demands of his craft.

The head of the fallen king is more nearly as it might be drawn, but again there are telltale signs of the woodcut. Look at his mouth and moustache. In these black lines there is no regularity of width or direction. It is hard to imagine anyone actually drawing them but they can be quite easily seen, once again, as those areas left by the blockmaker's knife as he scoops away the white. 14

c Decline

As woodcuts became more sophisticated, the work of cutting away the white areas seemed more tiresome. A process in which the artist or craftsman could directly create the black lines would be much preferable, and by the mid-fifteenth century such a process had already made its first tentative appearance in the form of copper engraving, used mainly at that time for playing cards. By the seventeenth century engraving and the related process of etching had displaced the woodcut from its position as the most common form of printed image and even of book illustration. But there was one intrinsic disadvantage to the new methods. They were intaglio, and so were incompatible with the relief printing of a book's text. They could only be issued as separate prints which the customer's own binder would combine with the text – hence the conventional 'Instructions to the Binder' at the end of so many books, explaining where the 'plates' should go. It was for this reason, in the late eighteenth century, that the relief method of printing book illustrations came back into its own in the form of wood engraving (6) and achieved another century or so of prominence.

d Revival

Since the late nineteenth century there has been a revival of interest among artists in using the plank side of wood, in the old tradition of woodcuts, the major attraction now being the natural beauty of its grain – sometimes accentuated by a brisk dressing down with a wire brush. In such prints the texture will often directly suggest the method, when combined with the starkness of design appropriate to a hand-carved block in a relatively rough material. 15

Exit.

15 Woodcut by Edward Gordon Craig for *Hamlet*, 1930, showing the grain of the wood in the black area (0.7×).

6 WOOD ENGRAVINGS

The revival of relief printing for book illustration was made possible by a drastic change in the craft towards the end of the eighteenth century. Woodcuts had been carved on the plank side of the wood, with the grain, and the tendency of the grain to crumble meant that the carving had to be done by drawing a sharp blade towards one (held in the hand like a pen) and that exceptionally fine detail was difficult to achieve. In place of this the English engraver Thomas Bewick, the undisputed genius of the revival in the late eighteenth century, perfected a method of working across the end grain of very hard wood such as box. On this much more dense and stable surface he was able to use a version of the conventional copper engraver's tool, driving a graver through the wood away from him. From this difference comes the distinction between the names – woodcut for a block which has been cut with a knife on the plank side, wood engraving for a block which is engraved across the grain. There can be verbal confusion between an engraving (9) and a wood engraving, since they share a name and use a similar tool; but the wood engraver creates a relief block, cutting away the non-printing areas, whereas the intaglio engraver scoops out the lines which will print.

The graver was capable of thinner and more precise incisions than a knife, and the end grain could take finer detail than the plank edge of the wood. The result was that Bewick was able to achieve his effects within the miniature medium of the vignette. Figure 16, literally a thumbnail sketch in scale, is an example of the unforced humour which caused Bewick's immediate and lasting popularity, but Figure 17 is more typical of the famous vignettes with which he illustrated his books on British quadrupeds and birds. It is printed here to its original size, and to the eye it appears to be a conventional image drawn in black. Only when a detail is blown up does it become clear that Bewick has not in fact tried to imitate the black lines of a pen drawing. He has accepted that the nature of a relief block involves the removal of the white areas, and he has taken out the white shapes with his graver in the most economical way to achieve a convincing black image. His is the true and instinctive art of the wood engraver. From the detective's point of view the honesty of his technique makes it unusually easy to identify this as a relief print, with the white areas scooped from the black.

16 A Bewick vignette, 1804 (actual size).

17, 18 A Bewick vignette, 1804 (*right*, actual size) and an enlarged detail from it (5×).

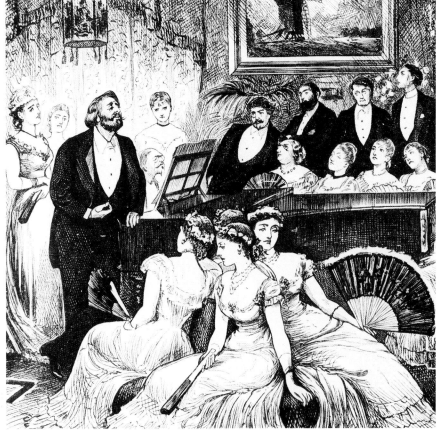

19–21 Facsimile wood engraving after a drawing by George Du Maurier, *c*.1880 (0.7×), and two details (*above*, 3.8×; *below*, 2.5×).

b Facsimile wood engravings

By restoring the relief block to a state of excellence, Bewick paved the way for the mid-nineteenth-century explosion of books and magazines with illustrations on the text pages. But the craftsmen churning out thousands of wood blocks to meet the deadlines on the presses were not themselves the originating artists, as Bewick had been. Wood engraving became a purely reproductive medium, though one of extraordinary skill. The artists normally drew their pictures in black ink and the engravers struggled to carve in and out between every tiny stroke sketched in by the pen of a Tenniel or a Du Maurier. Figure 19 is a measure of the level of reproduction which the blockmakers achieved. The lines of the ladies' dresses in the foreground have nothing to do with the nature of a wood engraving but everything to do with the carefree lines of a pen and ink drawing, and it is alarming to imagine the care needed to engrave away all the white spaces and to preserve only those delicate traceries. To find the characteristics of a wood block in such a print one needs to look in areas where white and black are more evenly balanced. The singer's hair and beard can more convincingly be seen as white scoops out of black than as a subject drawn in black, and with that change of perception it becomes easy to see even the thin lines on his neck as areas left by the graver rather than separately drawn lines.

19
21

20

c Interpretive wood engravings

Sometimes it was the artist who drew his image in reverse onto the specially whitened surface of the wood block; on other occasions there was an intermediate craftsman who copied the drawing onto the block. In either case the engraver was cutting round specific black lines and shapes on the surface of the wood. But from the 1860s it became an increasingly common practice to project a photograph of the image onto the wood block, sensitized on its surface in the same way as a sheet of photographic paper. The photograph might be of a wash drawing, much less precise in detail than the previous pen and ink. The engraver suddenly had no clear black lines to preserve in the surface of the block. He had instead a variety of tones which it was up to him to interpret in the medium of wood engraving.

In this change, from so-called 'facsimile' to 'interpretive' wood engraving, the characteristic signs of the engraved white line become once again easier to identify as the engraver finds his own best short cuts to achieve the necessary effects. Figure 22 must be based on a fairly free and impressionistic sketch. The shading in the sky reveals an unashamed use of the quickest way

22

23

22–24 Interpretive wood engraving from a sketch of the London riverside near St Paul's, c.1885 (0.6×), and two details (3×).

25, 26 Photoxylograph, or wood engraving from a photograph, *c.*1890 (actual size), and a detail (4.5×).

to achieve an even tone in a wood engraving, by cutting away a grid of parallel white lines to leave a pattern of larger or smaller dots. The play of light and shade on the waterfront to the left is achieved with much greater subtlety, but again it is easy to see that the eccentrically shaped black areas have been left behind by the white scoops of the engraving tool.

d Photoxylographs

From the middle of the century, when photographs became easily available, it was the natural desire of the public to enjoy images of reality in this uniquely authentic form without the artist as intermediary, and it was the natural desire of the printer to meet this demand. But although experiments began in earnest in the 1850s, there was for several decades no way in which the range of tones in a photograph could be achieved mechanically on a printer's block, plate or stone. The only solution was to recreate laboriously by hand the *appearance* of a photograph. After transferring the image to the surface of his block as a photographic print (by coating the block with a photographic emulsion and then exposing it beneath the negative), a simple process dignified at the time with the name of photoxylography, the craftsman of the time settled down to imitating its tones in the very different medium of wood engraving. This was a skill at which American wood engravers were widely agreed to excel, and a measure of their achievement can be seen in Figure 25, a photograph of an old man published in the *Century Magazine* of New York. It does indeed look very like a photograph, with the man's skin, hair, beard and coat showing a variety of convincing textures. But seen in close-up, the white lines of a wood engraving become immediately apparent, as does the vast amount of labour involved.

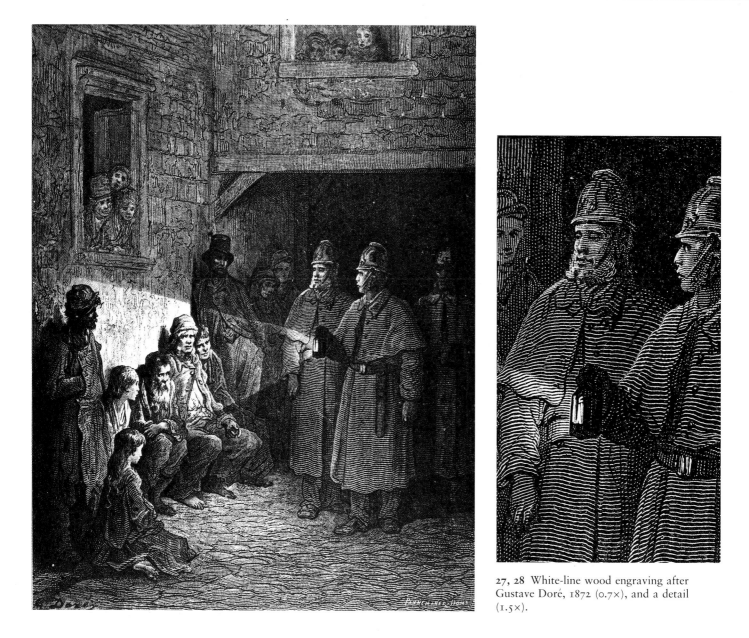

27, 28 White-line wood engraving after Gustave Doré, 1872 (0.7×), and a detail (1.5×).

e White-line wood engravings Clearly the relief printer was in desperate need of a simpler solution and finally it arrived, first in the form of the line block (33) and then of the halftone block (34). Wood engraving lost its commercial status but gradually acquired a new role as a medium for artists, enjoying considerable popularity in the first half of the twentieth century. The artist-engravers, horrified at the lengths to which their commercial predecessors had gone to conceal what they held to be the true white-line nature of wood engraving, themselves flew to the other extreme. No wood engraving was considered artistic unless it was exclusively composed of white lines. In this they went

far beyond the convention of wood engraving pioneered by Bewick – that of an apparently normal black image which on closer inspection is defined by the white spaces. As a result their prints nearly all have the appearance of moonlit scenes, with solid black backgrounds and the foreground details in white. At least, from this book's point of view, they have the merit of being instantly recognizable. But the artists were wrong in thinking that the despised Victorian craftsmen did not understand the potential of white-line engraving. They were capable of using it to magnificent effect for an appropriate scene, such as Doré's view of a night-time police‚round in the Whitechapel district of London.

27, 28

7 METAL RELIEF PRINTS

a Metalcuts in the dotted manner

During the first hundred years of European printing, particularly in Germany in the late fifteenth century, craftsmen occasionally used metal instead of wood for relief prints. The material was probably type metal (an alloy of lead, tin and antimony, akin to pewter). The method included the punching of dots and stars into the surface of the metal, thus enlivening the solid black areas of the final print with patterns of white, and making these prints extremely easy to recognize. They are most often referred to now as metalcuts in the dotted manner, or simply as dotted prints, though in older books they go by the French name of *manière criblée* (riddled-with-shot manner).

29

b Metalcuts and metal engravings

Metal soon dropped out of use for large-scale relief prints, being replaced by the more sophisticated intaglio use of metal in the form of engravings, but from the sixteenth to the eighteenth centuries relief vignettes would sometimes be cut in metal rather than wood. The engraver's burin was a natural tool for this purpose, and the first steps towards wood engraving were probably taken in this medium. The borderline between metalcut and metal engraving is a narrow one, the white areas in the metalcut being gouged away with broader strokes (as in a woodcut) and the metal engraving showing the fine white lines of the burin. Such prints will usually be impossible to distinguish on the printed page from woodcuts and wood engravings.

c Relief etchings

It was the etched metal block, rather than the engraved version, which was to play a major role in printing history. Its eventual use, when it acquired the name 'line block' (33), would be exclusively commercial. But it had been developed originally by that least commercial of artists, William Blake, who wanted a method of printing his own visionary books. According to an early biographer the solution came to him when the spirit of his dead brother appeared and recommended that he draw his designs in an acid-resisting liquid on a copper plate, and then use acid to etch down the unwanted areas. Blake would be left with his design as a raised surface, which he could print

29 Metalcut in the dotted manner of *Christ on the Mount of Olives*, c.1470 (0.85×).

as a relief block. This was in broad terms the method which he used for *Songs of Innocence* (1789) and his other 'illuminated' books. He never revealed his secret, but the pages contain long passages of hand-written script so fluent in execution that Blake could hardly have been using the reversed mirror-writing which is necessary when working directly on the plate. It is now generally accepted that he must have discovered some form of transfer process so that he could write on paper, press that against the copper, and achieve an acid-resist where the letters had been transferred.

During the first half of the nineteenth century several printers experimented with relief etching, but without much success. It was not until the second half of the century that Blake's method became common, with the spread of the line block which, together with the related halftone block (34), would provide for nearly a hundred years the standard method of printing illustrations.

In the unlikely event of coming across an unidentified relief etching by Blake, it is certainly his own intensely personal style of illustration which will provide the first clue rather than the method of printing. Even so, Blake's early version of the line block shares with its commercial successor the same identifying characteristics. The behaviour of the ink will reveal it as relief-printed (51a), but the lines of the image will be more free than could be achieved by a knife or graver cutting away the white on either side.

8 MODERN RELIEF METHODS

During the twentieth century the range of materials used for making relief blocks has been greatly extended beyond the traditional wood or metal. The chief rival, linoleum, has long been popular in schools and colleges because it is both cheap and easy to work, but it became dignified by the attention of several artists, in particular Picasso, who in his seventies did a famous series of linocuts. Relief prints have also been made from sheets of rubber, vinyl, hardboard, chipboard and many other materials. They have even been built up from separate objects of roughly the same height glued to a base, cardboard and stiff fabrics being natural materials for this purpose, while a recent book on the subject includes among suitable substances 'dried cereals or uncooked pasta'. A print made from objects glued to the block is known as a collagraph or collograph. If a traditional press is being used, then the ingredients need to be strong enough to withstand that amount of pressure. But almost anything becomes possible if the artist is using the ancient method of rubbing the back of the paper after laying it down on the block.

The main consideration will be to identify such a work as a relief print, and the only reliable clue will be the behaviour of ink and paper in relief printing (51a, 59a). The sheer size of many a modern relief print, in the style of a conventional woodcut, will suggest a composition material rather than natural wood. Equally the absence of grain may imply linoleum, rubber or hardboard rather than plywood or chipboard.

Intaglio

9 ENGRAVINGS

Intaglio printing began probably in the 1430s, though the earliest dated engraving is not till 1446. As has often been pointed out, the concept of forming a picture by cutting lines in some hard material goes all the way back to cave paintings; and the idea of emphasizing the image by rubbing pigment into the lines is almost as old. Engraved seals, leaving the incised design visible in relief on wax, were a halfway stage towards printing. But it was not until the fifteenth century that it occurred to anyone that ink could be held very precisely in engraved lines in metal plates (almost invariably copper) and could be transferred under pressure from plate to paper.

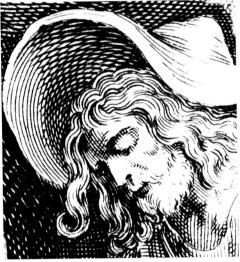

30, 31 A typical workmanlike engraving of the early seventeenth century (0.6×), and a detail showing the characteristic style imposed by the discipline of the burin (3×).

a Method and style

The physical act of engraving in metal is so demanding that it forces a particular style upon the craftsman and so incidentally provides the most recognizable characteristic of such a print. The engraving tool, known as a burin, has a sharply pointed V-shaped section. The engraver holds it almost parallel with the plate before forcing the point into the surface of the copper and driving it in a direction away from himself to scoop out a sliver of metal. The plate usually rests on a leather pad or cushion, and to achieve a curved line the engraver turns both pad and plate towards the point of his burin, rather than altering direction with his cutting hand. The result is a very steady and considered line, with crisp edges where the burin has cut through

30,
31

the copper. Such a line also tends to be pointed at each end, for the burin must dip down into the copper to begin the stroke and rise up again to end it, though this effect can be minimized – for example by lifting the burin very sharply at the end of the line and then going back over the cut in the opposite direction, thus achieving two almost blunt ends. But this takes time, and the average engraved line will taper towards at least one end.

The nature of the work dictated a style of modelling based on parallel lines, often splendidly curved. Short scoops and flicks and dots were also natural to the burin, and formed an important element in the style long before branching off on their own to become stipple engraving (14). Crosshatching, the inevitable solution to the problem of tonal areas in a linear medium, was often enlivened by a little flick within each diamond in the so-called dot-and-lozenge technique. But there was one excellent device more natural to engraving than to any other print medium, and control of it constituted the engraver's greatest skill. If the burin is pushed deeper into the copper the line naturally becomes wider, and when its point is raised again towards the surface of the metal the line thins. This sculptural quality, inherent in the tool and the material, enabled a good engraver to suggest a three-dimensional object by this means alone. The knee in an engraving of the Apollo Belvedere provides a good example.

32

33,
34

32 Detail of an engraving, showing the dot-and-lozenge style of crosshatching (20×).

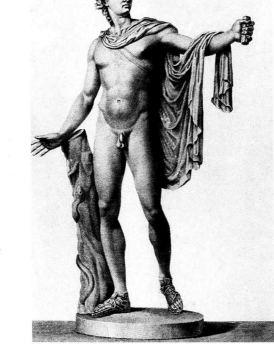

33, 34 Engraving of the Apollo Belvedere, late eighteenth century (0.25×), and a detail, with the modelling achieved entirely by variation in the width of the engraved line (3.25×).

b Reproductive and mixed method engravings

In the early years of engraving, roughly 1450 to 1520, when enthusiasm for the new method was at its height, many painters in Germany and Italy engraved their own images on copper and produced great works of art. But during the sixteenth century this exacting medium gradually became the preserve of craftsmen, reproducing the images of others rather than creating their own. Technically excellent work was still done, but genius had moved elsewhere – in particular to the newer and less constricting discipline of etching.

From the eighteenth century onwards a few pure engravings were still produced, often looking like the most mechanical of exercises, but the burin took its place for the most part as just one tool in the printmaker's cabinet – useful above all for providing strong foreground details of faces or limbs or 49 costume after the greater part of the image, and all the background, had been achieved on the plate with much less labour by etching. These mixed method prints were the staple of commercial publishers during the eighteenth and much of the nineteenth centuries, and they form the bulk of those prints sold as 'engravings' today. They are dealt with in 12. Meanwhile, in the present revival of interest in intaglio printing, the burin has come back slightly into favour. Its characteristic line can be seen from time to time in prints by modern artists, but few would have the patience or the skill to complete a whole print, as five hundred years ago, by engraved line alone.

10 ETCHINGS

During the early period of engraving artists must often have hankered for a less laborious way of achieving their image on the copper plate, but the solution was not arrived at – in the form of etching – until the beginning of the sixteenth century. The first dated etching is of 1513.

a Method

The etching process uses acid in place of the burin to achieve the recessed ink-bearing lines in the metal plate, and it enables the artist to draw those 239– lines almost as freely as if sketching with a pencil on paper. The copper plate 243 is heated and wax is rubbed over its surface to provide a thin but even coating, known as the ground. Once cooled and hardened, this coating is impervious to acid; and so the plate in this condition, with its back protected by varnish, would remain unaffected if immersed in a bath of acid. The etcher's task is to open up lines in the wax, exposing the copper surface and allowing the acid to eat into the metal in those areas alone. The longer the 35 acid is allowed to bite, the deeper and broader will the line become (broader because the acid will eat sideways as well), and the darker it will print. By varying the length of bite from one area of the print to another, or even from line to line, the etcher has control over the intensity of a line just as the engraver can control it by driving his burin more or less deeply through the copper.

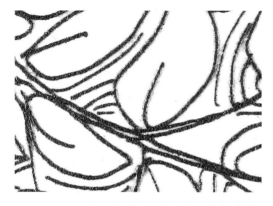

35 Detail of an etching in which all the lines have been bitten equally (5×).

36 Detail of an etching with very primitive use of stopping out (7×).

37 Skilful use of stopping out in a steel engraving of *c*.1830 (7×).

b Stopping out The simplest way for the etcher to keep some lines lighter than others is through the stopping-out process. This involves removing the plate from the acid, washing and drying it, and then painting varnish over those lines which have been sufficiently bitten. They will remain unaltered when the plate is returned to the acid, whereas others – or other parts of the same line – will continue to become deeper and broader. This process can be repeated many times, and if done with subtlety it will be very hard to tell where each stopped-out area begins and ends. Figure 36 is an example where it has not 36 been achieved with subtlety. It is the rough and ready attempt of a seventeenth-century Dutch etcher to suggest a cloud. After the first bite of the acid he has stopped out a cloud-shaped area among the lines in his sky before returning the plate to the acid bath. He has been left with a brutal transition from thin faint lines on the left to broad dark lines on the right. But they were the same lines originally, when drawn with the etching needle through the wax ground. The difference is only in the length of time during which the acid has acted upon the metal. By contrast Figure 37 shows an 37 example where the stopping out, to suggest the lighter water under a bridge, has been achieved very successfully.

c Variable depth and freedom of line

An alternative method is to add new lines to the image during the etching process. An example can be seen in Figure 39, where the dark lines of the tree are entirely separate from the fainter details. Clearly the careful process of stopping out has not been used here. Instead the plate has probably been removed from the acid when the dark lines were already well bitten. The artist etcher, George Cruikshank, then drew some more lines through his ground – among and even across his existing lines. When the plate was returned to the acid for a short while, the first lines became even darker while the new additions achieved the lightly etched tone which Cruikshank required for his contrast.

The full Cruikshank print is shown in Figure 38 (the detail comes from the top), and it provides a good example of why etching has been the intaglio process most attractive to artists. One reason is the freedom of the line – Cruikshank seems to have achieved this glimpse of Grimaldi on stage with the ease of someone dashing off a quick sketch – and another is the ability to provide dramatic contrasts between lines that are light or dark, delicate or heavy, through the mere action of the acid.

38, 39 An etching by George Cruikshank, 1838 (0.8×), and a detail showing lightly and heavily etched lines overlapping (4.8×).

d Surface tone and *retroussage*

Cruikshank was using the medium as the quickest and least restricting way of achieving a commercial purpose – that of illustrating a book – with the specific advantage that no hand other than his would be involved in the process. But the shining example of Rembrandt, the greatest of all etchers, 8

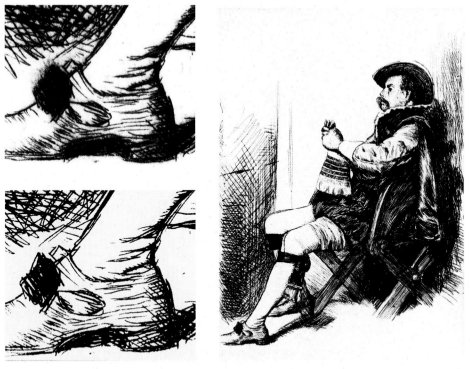

40–43 Two impressions of the same etching by Charles Keene, *c*.1880 – *left* and *above centre* with *retroussage*, *right* and *below centre* wiped clean (0.7× and 2.7×).

has meant that etching has also been foremost in artists' minds as a means of original expression. As such the medium was at its most popular from the mid-nineteenth century onwards, when the so-called Etching Revival led to a flood of 'artist's etchings'. The most visible characteristic of this movement, making the prints appear very different from Cruikshank's, was an obsession with surface tone. This refers to the pale and attractive bloom which can be imparted to the paper by a thin film of ink left on the surface of the plate. The overall degree of tone is regulated by how thoroughly the plate is wiped before printing, but extra tone could be added in specific areas of the plate by the method known as *retroussage*. This was the use of a feather or cloth to tease a little ink from some of the lines after the plate had been wiped, thus giving a richer and more romantic quality to that part of the print. Figures 40 and 43 are two impressions from the same etched plate, one with *retroussage* and the other with the plate wiped clean. The full print shows the difference in effect, and the close-up details of the foot reveal how it is achieved. Only a very slight surface tone has been left from the wiping itself (one stocking is fractionally less white than the other), but the real difference has come from ink being dragged out of some of the etched lines, particularly in the heavy shading and on the buckle, to make a darker and richer localized tone.

40, 43 41, 42

e Use in line engravings

Though ideally suited to the needs of the artist, etching has also been a stock-in-trade for the ordinary intaglio printmaker. The majority of reproductive prints from the eighteenth century onwards – commonly known as line engravings (12) – include many etched lines and details. Etching was also a useful linear ingredient in the tonal process of aquatint (17).

47-
49
68

11 DRYPOINTS

The quickest way of making a printable mark on a copper plate is to score the surface of the metal with a sharp point. Unlike the engraving tool, which lifts a sliver of metal clean out of the plate, a needle-like point will merely push the metal up to either side of the line – much as if scoring the surface of a pat of butter with the point of a knife. When this burr has been removed with a scraper the result is a shallow scratched groove, which will print with an appearance similar to that of a quick stroke with a hard pencil. From the early years of intaglio printmaking the convenience of the drypoint needle (sharply pointed in hard steel or with a diamond) meant that it was often used for adding final and light touches in both engravings and etchings.

If this had been the sole use made of drypoint, it would merit mention in books on printmaking only as a minor adjunct to the engraver's burin. But it acquired a unique characteristic of its own through the attention of the artist-etchers, Rembrandt as ever prominent amongst them. They turned it 8 to a new and very fruitful purpose by the simple device of not scraping away the burr. The printed result of this is startling, for the tiny rims of raised and jagged metal retain the ink in a manner quite unlike the grooves recessed below the surface of the copper. When forced in the press against the absorbent paper, the ink is transferred in a warm blur very different from the precise lines and dots of true intaglio.

With this discovery it was realized that the quickest way to achieve an area of rich localized tone in a print was to score that part of the plate heavily in drypoint, and Rembrandt often used this technique when adding the final touches to an etching. But in the late nineteenth century, as an extension of the Etching Revival, drypoint became a medium much used for its own sake 44-
46 without the partnership of etched lines. It had the immediate attraction of allowing the artist to create the plate himself, ready for printing, without even the use of acid. And in the somewhat precious fashion of the time for very limited editions, it seemed almost a virtue that drypoint will produce only a small number of good impressions, since the raised metal burr is extremely vulnerable both to the wiping process and to the pressure during printing.

The drypoint needle has to force its way through the surface of the plate against the resistance of the metal, and this fact has a pronounced effect on the appearance of the resulting print. The lines look scratched or even slashed, both in terms of draughtsmanship and in physical character. They will tend to be short, and either straight or in very simple curves, as opposed

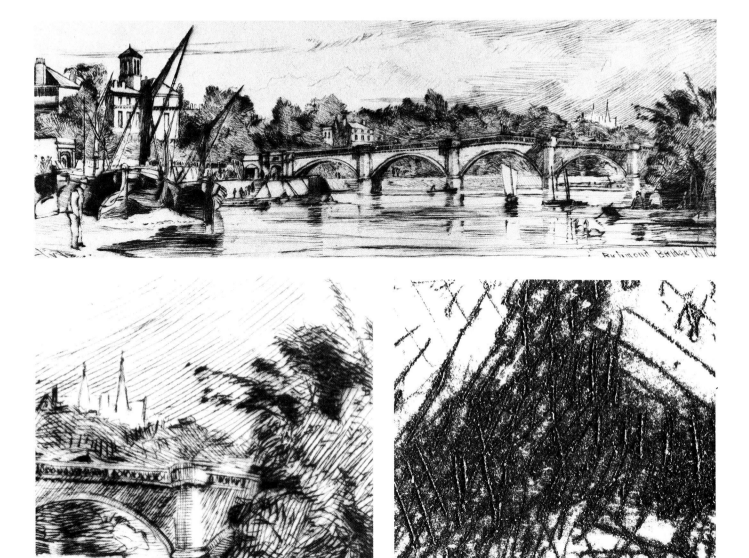

44–46 A typical drypoint of the late nineteenth century, starkly linear in its drawing style and with sudden patches of dark tone where the burr has held the ink (0.7×), and two details. *Above*, detail showing the scratched linear quality and patches of burr (2×); *above right*, detail showing the white lines, as if slashed in the dark areas, which are a characteristic of drypoint (10×).

to the more languid lines of an etching. And they will often appear to be scored in the paper itself, giving almost the appearance of a gash and suggesting strongly the violence of the line's origin. If the ink has penetrated deeply into the groove in the copper, that central line will print very black while the burr on either side gives a softer and more uneven tone. This slashed appearance is often heightened by a further accident. A very pronounced burr on either side of the groove may sometimes hold sufficient ink to print as a separate line, parallel to the intaglio line scored in the plate. The resulting effect will be that of a single line with a white or pale centre.

12 LINE ENGRAVINGS

a The term This is a term often used for those intaglio prints of the eighteenth and nineteenth centuries which create the image by linear means alone, as distinct from the other forms of 'engraved' plates – whether mezzotint, aquatint or stipple – which are capable of suggesting tone. As such it could be taken to include a pure engraving or a pure etching, but these were relatively uncommon in the eighteenth century and the term has much more usefully become attached to the typical commercial print of that period which combined etching with engraving.

b Etching and engraving Etching, almost a century younger than engraving, provided several obvious short cuts for the printmaker. It was a far simpler way of getting onto the plate many of the basic details of the image, particularly in the background. The parallel lines of skies could be ruled much more quickly with an etching 264 needle than engraved with a burin. The straight edges and right angles of architecture were almost impossible in engraving but easy in etching. And foliage could be suggested with a series of carefree squiggles instead of laboriously scooped curves. On the other hand there were areas where the burin had an advantage over the etching needle. With its deep swelling lines it was far better at suggesting the curve of a cheek or the folds of a dress. And if an early proof revealed that more emphasis was needed in any part of the image, whether by darkening a shadow or softening a transition with some delicate crosshatching, it was far quicker to engrave the extra lines than to lay a whole new wax ground on the plate and return it to the acid bath for the corrections.

So the two disciplines found themselves to be natural allies. The standard procedure which developed was for all the background and generalized details to be etched (a proof pulled at this stage being known as the 'etched state'), and then for the engraver to work up the foreground figures and areas of emphasis. (For an example, see Figure 49.) This was the skilful and 49 more important part of the work, and the craftsman was usually credited on the print with the word 'sculpsit', meaning 'engraved'. This is no doubt part of the reason why these mixed method prints, the vast majority of all intaglio prints ever published, have conventionally been known as engravings.

c Copper and steel The period of commercial line engraving, roughly 1700–1880, included a change in the metal used – from copper to steel. Copper was much easier to work, but its relative softness meant that a plate began to show signs of wear after a few hundred impressions, giving an anaemic appearance with total 262 loss of the more delicate lines in the printed result. The rapidly expanding nineteenth-century market made economic sense of the change to the more intractable material, steel, and line engravings are therefore subdivided into copper engravings and steel engravings (13). Steel began to replace copper for smaller plates from the 1820s, though very large subjects – such as expensive reproductions of paintings – continued to be engraved on copper.

13 STEEL ENGRAVINGS

In the early years of the nineteenth century there were various experiments in the use of steel as a material for engraved plates, the main intention at the time being to print long runs of banknotes which would remain identical throughout the run and which would be so finely engraved as to make forgery difficult. It was only around 1820 that these same virtues began to be applied to the production of prints, and steel started to oust the traditional copper plate.

a Method and market

Even before the introduction of steel plates there had been a tendency towards prints which were smaller and more finely engraved than the average in the previous century, and the new medium perfectly suited this fashion. Lines engraved in the harder metal could be closer together and also shallower, printing in a paler tone on the paper. Figure 47 is an excellent example of what the new medium could achieve, from within the first year or two of its use. It is also typical of the sentimental subjects illustrated in the flood of ladies' annuals which were the publishing phenomenon of the 1820s and 1830s and which turned steel engraving for a while into a boom industry. Figure 47 is reproduced to the original scale. Figure 48 is an enlargement showing the extraordinary fineness of the triple crosshatching which provides the tone in the sky. Figure 49, an enlargement of Ferdinand's

47

48

49

47–49 A steel engraving of the 1820s of a scene from *The Tempest* (actual size), and two details: *centre*, the exceptionally delicate triple crosshatching made possible by the steel plate; *right*, the contrast between the etched background and the engraved leg (both 5.2×).

leg, shows the standard relationship between etching and engraving in a line engraving. The background has been achieved entirely by etching, with the space for the foot and calf stopped out to remain smooth metal. Within this empty area the engraver has then plied his burin to excellent effect, suggesting the rounded calf by traditional engraving methods.

The other great outlet for steel engravings was in topographical views, from the thousands of detailed scenes illustrating works of travel or history down to the delightful vignettes which were sold in paper-bound batches of half a dozen, much like postcards today, to tourists.

244

50

b Steel-facing

If steel was hard-wearing in the printing it was also hard work to engrave, and in the 1830s and 1840s the proportion of engraving to etching tended to fall until the average steel engraving, in spite of its name, was almost entirely etched. In the 1850s there was a discovery which meant that the engraver would no longer have to grapple with steel. This was the so-called 'steel-facing', in which a thin layer of iron (not steel) was deposited by electro-plating on the surface of a copper plate, after engraving and before printing. The resulting surface was not so hard-wearing as a steel plate, but as soon as it showed signs of deterioration it could be chemically removed and a new layer deposited on the copper. The copper plate itself remained therefore in pristine condition, and engravers returned to working on the more friendly metal, confident that an indefinite run of impressions could be produced without danger of the more delicate lines beginning to vanish. These prints also are usually referred to as steel engravings.

50 A steel-engraved vignette of the Abbot's Kitchen at Glastonbury, 1855 (actual size).

51, 52 Cupid from a crayon manner engraving of the late eighteenth century (actual size), and a detail showing the dotted linear tracks of the roulette in imitation of crayon or chalk (5×).

14 CRAYON MANNER AND STIPPLE ENGRAVINGS

Stipple is a familiar technique in many branches of pictorial art, being a method of suggesting tone by means of dots grouped more or less closely together. It was used occasionally in engravings from the fifteenth century onwards, but it became a routine aspect of printmaking only from the mid-eighteenth century. At that time it was developed in France for the specific purpose of reproducing a type of drawing then popular, done in chalk or crayon on rough paper.

a Crayon manner engravings

Any chalk line is composed of dots of chalk which have stuck to the raised parts of the paper surface, and it was these tiny dots which could be quite convincingly reproduced in intaglio printmaking. To avoid putting each of them in by hand a machine called a roulette was devised. This was a metal wheel with a random pattern of sharp points (variously sized, shaped and spaced) projecting from its circumference. When the copper plate had been covered with the protective wax ground, the roulette could be run over it following the lines of the drawing to be reproduced. The resulting pattern of dots, when etched, would provide a passable imitation of the original chalk. Roulettes could be broader or narrower, with larger or smaller points, so as to adapt to the chalk and the paper of the original. The type of print so

51, 52

53, 54 A stipple-engraved romantic subject of *c.*1800 (actual size), and a detail showing the repeated pattern achieved with the mace-head or *mattoir* (8×).

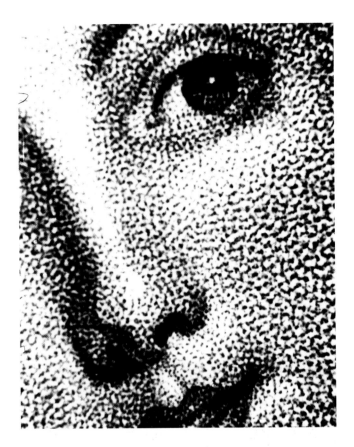

produced is known, from its intentions, as being in the chalk or crayon manner. Such prints, although etched, have traditionally been known as crayon manner engravings.

b Stipple engravings From the 1760s stipple developed, largely in England, from the linear techniques of the crayon manner to something more broadly tonal. The roulette was by its nature linear in application, for it had to be rolled in a given direction over the plate. It was largely replaced in the new method by the *mattoir* or 'mace-head'. This was a punch-like metal tool with a flat head, from which projected a random pattern of dots or, more often, worm-like curves. The *mattoir* came with a comfortable wooden handle for pressing it through the wax ground if the plate was to be etched, or with a metal one for bashing it directly into the copper surface of the plate in a technique which was known as *opus mallei* or 'mallet work'. The smaller dots needed for detail could also be produced either with the etching needle through the wax ground or with a modified form of the burin, known as the stipple tool, which was adapted for nicking small flicks of metal from the copper. Even the drypoint needle could be used in a dotting manner.

The normal procedure, as with the equivalent reproductive line engravings (12), was for most of the work to be done by etching and for the

189-
191

finishing touches to be added with the stipple tool. There is not likely to be any real need to distinguish one type of dot from another, but the etched version will tend to be round while an engraved dot will be angular, more like a flick, since the tool has had to plunge down into the metal and come up again. Even though the majority of the work was etched, stipple engraving has become the conventional term for such a print.

The heyday of stipple engraving was 1770 to 1810, the period of those 53, 54 decorative romantic prints of which Bartolozzi was the master, but it survived much longer into the nineteenth century as just one of the weapons in the engraver's armoury, being used particularly for the modelling of the 218, 219 face in engraved portraits.

15 SOFT GROUND ETCHINGS

a Method Imitation of the soft broken line of a crayon, achieved mechanically in crayon manner engraving (14), was possible with less labour and more art by another method. In soft ground etching the normal wax etching ground has tallow added before being spread on the plate. This has the effect of preventing the ground from fully hardening, keeping it instead in a slightly

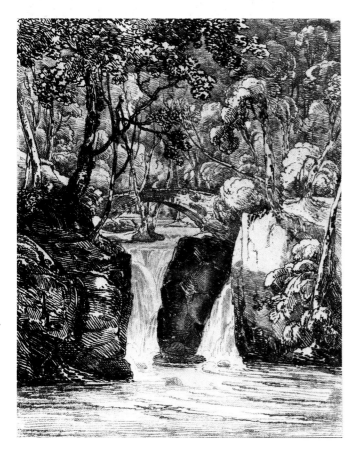

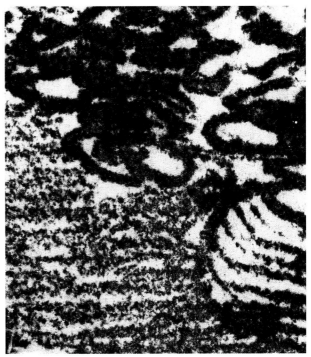

55, 56 A soft ground etching of c.1800, with a typically free and broken quality of line (0.4×), and a detail showing the variation possible both in density and in intensity of line (5×).

tacky condition. A sheet of paper is laid over the ground and the artist draws on the paper with a pencil or other similar point. When the paper is lifted, the ground under the drawn line sticks to the paper and so exposes the copper plate. However the nature of the ground prevents it from coming up as one piece, so the copper is exposed in a fragmented line very different from the clean line of normal etching. The width of this line is affected by the width of the point pressed on the paper, and the proportion of wax which sticks to the paper varies with the amount of pressure – heavy pressure raising more of the ground and so providing a more fully etched line on the plate, which in turn will print more densely. As in the normal etching process, the intensity of the line can be controlled by the amount of time that the acid bites. So the width of the drawing instrument, the amount of pressure and the length of bite are all variables by which the artist is able to achieve a line which is broad or narrow, fragmented or dense, light or dark. Add to these advantages the fact that the drawing itself is done with considerable freedom on paper, and it is clear that soft ground etching is a process of great flexibility and subtlety. It had been known but little used in the seventeenth century, and first became of importance during the eighteenth – originally as an easier way than stipple for reproducing chalk drawings, but soon also as a medium for artists creating original works. It remained popular into the 1820s, when it began to be replaced by lithography – capable of achieving very similar effects even more directly.

177

55,
56

b Modern uses

Soft ground etching has had a major revival in the mid-twentieth century, with the realization that a wide variety of textures – paper, fabrics, leaves and numerous other 'found' objects – can be pressed into the soft ground. Any such material, when lifted off the ground, brings up more of the wax on those parts which are thicker and have therefore been pressed in more firmly. In the etching process these become the deeper and darker areas of the plate, being more exposed to the acid, and so the printed result is a very accurate facsimile of the original substance. The texture on the plate is susceptible to further modification by varying the bite, or by burnishing part of the bitten plate, and this aspect of soft ground etching has provided artists with an unprecedented range of background effects. The process itself is not entirely new – Gillray appears to have tried it on rare occasions in the late eighteenth century – but it is only recently that it has become a widely used feature of intaglio printing.

57

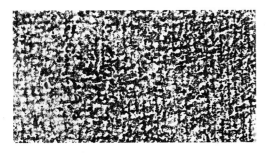

57 Detail of a Gillray etching of 1790, in which he seems to have used fabric and soft ground to achieve his texture (3×).

16 MEZZOTINTS

The early forms of intaglio printmaking, engraving and etching, were purely linear in approach. The medium was much in need of a tonal process, and it was discovered in the mid-seventeenth century in the form of mezzotint, the very name of which, from the Italian *mezzotinto* ('half tint'), claims the achievement of the middle range of tones.

The manner of creating a mezzotint is fascinating and is unique among the printing processes. It shares with woodcuts and wood engravings the characteristic of beginning with a surface which will print a solid black and then working towards the image by introducing patches of light. But woodcuts and wood engravings are not easily capable of rendering tone, for the wood must in principle either be left in position to print black or scooped away to leave the paper white. The special characteristic of mezzotint is that the black can be smoothed away, to give any shade of grey on the path towards pure white.

180–182

a Method The first stage of preparing a mezzotint plate is a laborious one, a fact which has caused the process to be comparatively neglected during our own century. The entire printing surface of the copper plate has to be roughened to a texture similar to fine sandpaper, consisting of tiny troughs and peaks in the metal which between them will hold a rich supply of ink – even after the plate has been wiped – and will print an even and velvety black. In the very early days of mezzotinting this microscopically chewed-up texture was achieved by running a spiked roulette again and again over those areas of the plate where dark shadow was required, but very soon it was found to be far more effective to work up an even ground over the entire plate. For this purpose a tool called a rocker was used, in shape like a broad chisel with a curved and serrated end to the blade. The rocker was gradually worked in one direction over the surface of the plate (anyone who has ever chopped herbs with the French tool called a *lunette* will know the rocking action involved). As the rocker moves across the plate it leaves a series of dotted lines scored in the copper, in the same closely packed zigzag pattern which a pencil makes if one is shading an area with continuous strokes back and forth. Each recessed dot forces up a tiny amount of displaced copper, and it is this bloom of fragile peaks, known as the burr, which will hold the ink in such a way as to give early impressions a superb velvety quality in the darkest tones. When the entire plate has been rocked in one direction the process is repeated from a slightly different angle, and then repeated again and again in ever more directions. The manuals suggest that forty complete coverings of the copper surface will be adequate, but it is said that as many as eighty would continue to give improved results.

When the plate is ready, the artist or craftsman prepares to work on every patch of it except those which are required to print a solid black. His method is that of smoothing away to varying degrees the fragile burr. For drastic results he uses a scraper and for gentler effects the burnisher, a narrow tongue of metal which by steady rubbing can impart its own smoothness to the copper below. The dark greys will receive only the gentlest attention from the burnisher, while the pure whites will be scraped and then burnished until the copper gleams smooth again with no trace remaining of the rocker's teeth. It is the pale grey areas, just short of the white highlights, which show the most characteristic signs of the mezzotint. Here all the raised burr has been burnished away, leaving none of the velvety mezzotint quality. All that

58 The separate lines of the mezzotint rocker revealing themselves at the edge of the image (6×).

59 *above right* Detail of the sky from a mezzotint of 1830, showing the threadbare look of the pale areas; the bird has been etched in after the burnishing (4.2×).

remains is the clear-cut toothmarks of the rocker in those few directions in which it happens to have been pressed most deeply into the metal, appearing therefore as faint lines made up of thin dashes.

If the whole plate is thought of as a dark tweed, still in perfect condition in the black areas, the pale grey patches have an authentically threadbare look 59 – for it is here that the nap has been worn away until the underlying structure shows through. And as with fabric, it is round the edges that the separate 58 threads will often appear – in the ends of the criss-cross lines, left by the rocker and not fully burnished away.

b Popularity and problems

Mezzotint achieved its peak of brilliance in the late eighteenth century, when it was the most widely used medium for large printed portraits, especially 60, those reproduced from paintings. Early impressions from such plates are 61 among the wonders of printmaking, particularly when the special bloom of the printed surface has not been rubbed – as it can be even by a sheet of paper brushing across it. Such a happy survival is quite unusual, so fragile is the texture, and the rarity of good mezzotints is increased by the fact that after relatively few impressions the raised burr on the plate begins to flatten and some of the richness of the black tones becomes lost. At the same time the modelling in the paler areas begins to fade away, eventually reducing human features to a faint ghostliness. This did not deter any commercial printseller with a popular subject on his hands. He merely set to with a small rocker or with a roulette to restore the patches of shade on which the modelling 62 depended. Such attention might successfully extend the life of a plate, but could also result in a very coarse print.

The adoption of steel plates in the 1820s went a long way towards solving this problem, and the mezzotint had something of a revival in the mid-nineteenth century. By then it was more often used as part of a mixed method print, combined usually with etching. The heavy lines would be etched before the plate was rocked. Lighter ones could be added through a transparent wax ground when the plate was almost finished. The introduction of steel-facing in the 1850s (13b) also made possible unlimited use of existing copper mezzotint plates.

60, 61 *above and top left* A mezzotint of 1778 (0.3×), and a detail showing the image achieved entirely in the correct mezzotint manner by burnishing away from dark to light (2×).

62 *left* The same detail from a later impression of the same print. After much wear on the plate (the amount can be judged in the area of the cheek) the dark tones have been clumsily renewed with the roulette; the result is brutal in close-up but will seem adequate when the whole print is viewed at a normal distance (2×).

c Modern versions During the twentieth century various ways have been found to avoid the laborious process of rocking the plate. These include passing the plate through the press several times with a sheet of rough sandpaper face down upon it (sand-grain mezzotint) and roughening the surface all over with carborundum stones or some other abrasive (carborundum mezzotint). Such solutions are validly grouped with mezzotint because of certain shared characteristics. They use direct force on the surface of the plate rather than the action of acid; the intention is to cover it so densely with ink-retaining pits and ridges that it will print a solid black; and the method of achieving the image is by burnishing down to produce the full range of tones and highlights. Such a print will therefore seem to have the general quality of a mezzotint, though it is unlikely to have the richness of a genuine mezzotint nor will it show in the lighter areas the characteristic straight lines of the rocker's serrated edge.

17 AQUATINTS

The mezzotint technique with its dark and rich tones (16) was well suited to such subjects as portraits, interiors or night scenes, particularly when reproduced from oil paintings. It was less appropriate for landscape, but for this the printmakers found a perfect solution in the form of aquatint. The method seems to have been briefly discovered in the mid-seventeenth century, then forgotten until the mid-eighteenth. From the 1770s it became an increasingly common technique, in keeping with the popularity of watercolour painting. The name aquatint merely reflects the fact that this method was able to imitate the effect of a watercolour wash.

a Method An aquatint achieves gradations of tone through a very fine network, etched to various depths by the action of acid. The network, entirely random in its patterning, encloses tiny islands of white. It is these islands which are the essential characteristic of the medium, for they are caused by the separate globules of the aquatint ground which have adhered to the plate. These globules prevent the acid from attacking the copper immediately below them, only allowing it to operate in the gaps between them.

The aquatint ground can consist of any of various substances which have certain qualities in common. They must be capable of being reduced to fine particles, of being fixed to the polished copper, and of resisting acid. The most frequently used have been resin (the vegetable gum exuded by certain trees) and such mineral substances as asphalt, bitumen or pitch, which are constituents of tar.

There are two ways in which these materials can be spread over the plate. One is by letting them fall onto the metal as a dry dust, and then heating the plate so that each separate grain of resin or asphalt melts and sticks to the copper. This will give an irregular pattern, for the grains will be of slightly different sizes, they will settle unevenly, and when melted some will merge

63

63 Dust-ground aquatint grain, with white flecks randomly scattered on a dark ground (5×).

64 Spirit-ground aquatint grain, consisting of a firm network of black lines isolating larger patches of white (5×).

with their neighbours, allowing the acid through to the copper only in very unpredictable squiggles which will nevertheless tend to encircle islands of white, however large or small. The other method, much used in the eighteenth century but less common in recent years, is to dissolve the resin or asphalt in a distilled spirit such as alcohol. This is then poured over the plate. As the alcohol evaporates, it leaves a thin film of resin in suspension. Insufficient to cover the whole surface, the film will split apart and reticulate in the final stages of drying and will do so in a very regular pattern. The analogy is with the cracks in a thin dried film of mud – as opposed to a scattering of various sized pebbles, which is more akin to the dust method. In each case the aquatinter has very considerable control. Different substances, suspended in varying quantities in the alcohol, will reticulate in recognizably different ways – some circular in pattern, some almost linear. And the texture of the dust aquatint will vary according to how finely the dust is ground, and how thickly the plate is covered.

186–188

64, 183–185

There can even be variations in the aquatint ground from one part of a plate to another. With the dust method, certain parts of the plate can be protected from a fine dust and reserved for later application of a coarse dust. With the spirit method it was found that if the plate were left on an incline to dry, the lower parts would show a coarser grain – a distinction very useful in landscape, where the foreground invariably needed a stronger texture than the sky. Beyond all these special variables the aquatinter had also the normal controls of the etching process. Some areas could be bitten longer than others, to give a darker tone, and most aquatints use four or five such gradations within the image.

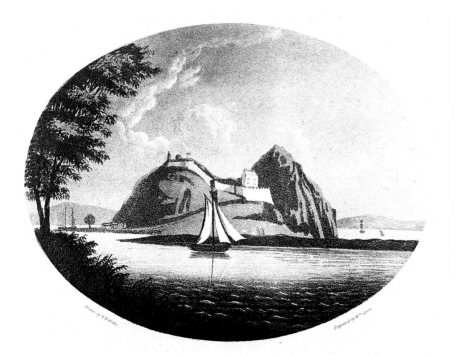

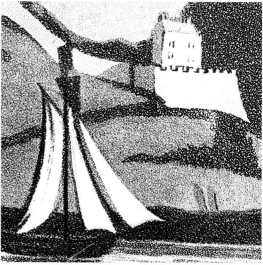

65, 66 A spirit-ground aquatint of
c.1800 (0.5×), without any etched lines,
and a detail showing sharply delineated
areas of stopping out (1.5×).

b Stopping out and lift ground

Above is a typical example of a simple landscape aquatint of around 1800. In the detail there are at least four depths of biting: the lightest is the sunny patch of wall as it climbs the hill, then there is the sky, and the two tones of the hillside. This is in addition to the pure white of the paper, which is allowed to show through uninterrupted on the sails of the boat, on the sun-drenched wall of the house and on parts of the clouds. The method of achieving this was a mixture of ordinary stopping out (10*b*) and of the lift-ground technique (60).

(margin: 65, 66)

c Etching and burnishing

In the landscape aquatint there is not a single etched line, for the medium was capable of standing entirely on its own. However the addition of line was undoubtedly useful, particularly in the delineation of human figures and of architecture, and it was usual for aquatint to be combined with linear etching. Sometimes soft ground etching (15) was preferred, giving a broken line more in keeping with the aquatint tones. Outlines were often etched before the application of the aquatint ground, providing a useful guideline to the stopping out of given areas, but etched lines could also be added after the aquatint was bitten.

Figure 67 is an example of the use of aquatint by the greatest master of the medium, Goya. He has used stopping out with extreme boldness – in the glaring white of the monk's bald head or the sunlit table cloth. He has in places combined these stark patches of white with the more gentle gradations which can only be achieved with the scraper and burnisher, tools

(margin: 67)

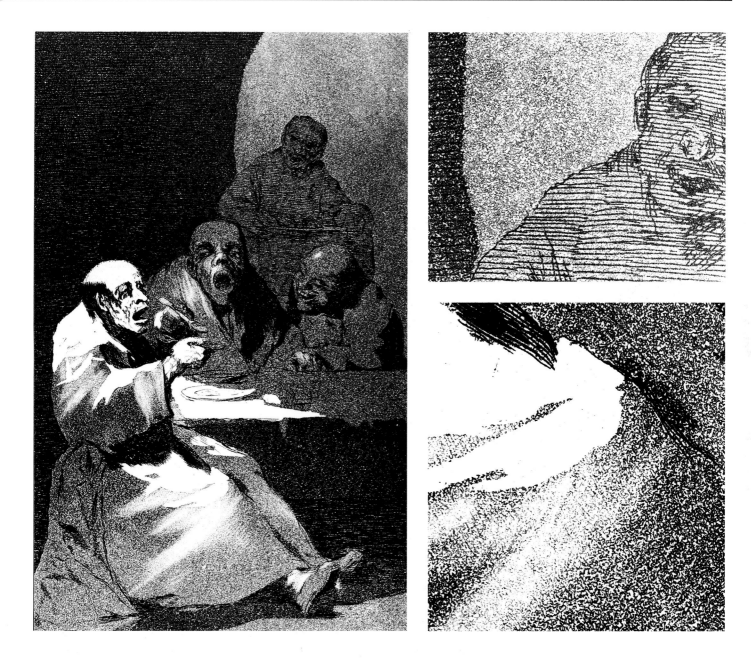

67–69 A dust-ground aquatint by Goya, 1799 (0.75×), and two details (3×). The upper detail shows etched lines over two areas of aquatint bitten to different depths. The lower detail shows bold use of stopping out (the pure white) and of the burnisher (the broken white) to vary the highlights.

normally associated with mezzotint rather than aquatint. An example is the area below the foreground monk's right knee. And he has used etched lines in a very free manner in conjunction with the aquatint tone. In Figure 68 the etched lines on the left exactly coincide with the edge of the more deeply bitten area of aquatint, thus doubling the effect of shadow. But the head of the monk is etched in freely against the aquatint ground, which can be seen to continue as a level tone behind the etched lines – hard though this is to believe when looking at the same detail in the whole print.

69
68

d Modern uses

Aquatint had its heyday from 1770 to 1830, after which it began to be supplanted by the lithograph, for lithography offered a simpler method of achieving the element of picturesque in the best of the commercial prints, was capable of much longer runs without deterioration of the image, and provided artists with a more fully autographic medium, demanding nothing so laborious as the laying and stopping out of the aquatint ground. But aquatint remains, at its best, an astonishingly beautiful tonal process, and as such it has played a major role in the modern revival of intaglio printmaking.

As with other methods, short cuts have been found for achieving effects similar to aquatint, the chief of which is spattering the plate with drops of stopping-out varnish from a spray gun or aerosol. This spray-ground technique exactly follows the basic principle of aquatint – covering the plate with globules of acid-resisting ground – and will therefore approximate to the appearance of a conventional aquatint, though the islands of white are likely to be more perfectly round. Of the two older methods, the spirit ground seems now to be entirely out of favour. With spray ground remaining a relative rarity, nearly all modern aquatints are achieved by the time-honoured method of allowing resin dust to settle and then fixing it to the copper plate by heat.

18 OTHER TONAL METHODS IN INTAGLIO

Although the vast majority of tonal intaglio prints are mezzotints or aquatints, there are a few other processes which have been used from time to time. Sulphur prints (18*a*) are in a class of their own. The remainder can be classified as those in which a semi-porous ground is achieved mechanically (18*b*); those in which a semi-porous ground is achieved chemically (18*c*); and those in which acid is applied directly to the plate (18*d*). Prints in which a texture has been achieved by mechanical means directly on the plate are more akin to the mezzotint process and are dealt with in 16*c*.

a Sulphur prints

Sulphur corrodes copper, forming copper sulphide and leaving the surface of a copper plate very finely pitted and therefore capable of holding ink and of printing an extremely delicate tone. The corrosion is achieved in one of two ways: either by mixing sulphur into a paste with vegetable oil and leaving it smeared on specific areas of the plate; or by sprinkling sulphur on the plate and then heating it. As with the etching process for an aquatint, the bite can be varied by the length of the chemical action. But the sulphur corrodes too evenly to achieve much variety of tone, even with a long bite. A sulphur print therefore cannot print very dark (roulette work was usually added to give strength to the shadows) and the plate tends to wear rapidly. The main use of the process was in the eighteenth century for the reproduction of wash effects in old master drawings, a task for which it was largely replaced by the much more versatile aquatint. Like the other tonal methods in this section, sulphur is occasionally used by printmakers today.

b Mechanical penetration of a ground

It is possible to create a textural pattern by mechanical means in the ordinary hard wax ground of the etching process. The best known example is the twentieth-century technique of sand-grain etching, in which sandpaper is laid face down on the grounded plate and the two are passed together through the intaglio press. When the process has been repeated two or three times, with a slight shift in the position of the sandpaper, the etching ground is perforated all over with the fine granular texture of the sand. The image can then be etched to differing depths by stopping out, exactly as with an aquatint, though the texture will be very different from an aquatint when seen through a glass – being composed of small black dots (each a grain of sand) in place of the white patches surrounded by meandering black lines which are characteristic of aquatint. The result will also differ from the mezzotint version of sand grain (16c), for there the grains of sand physically displace dots of copper which form an ink-retaining burr.

In a similar etching process the hard ground is wire-brushed. Again the tones can be graded by stopping out, but they will be composed of fine lines rather than dots.

c Chemical penetration of a ground

It is possible to perforate the hard wax ground before etching by chemical rather than mechanical means. The commonest method has been to sprinkle granulated sugar or salt on the ground while it is still hot and liquid. The grains displace a little wax by their own weight and settle on the surface of the plate. When the ground is cold and hard, the plate is rinsed in water. This dissolves the sugar or salt, leaving a mass of tiny holes in the ground. After etching, and grading by stopping out, these will leave on the plate a random pattern of pits of varied depth. Through a glass the tone will be seen to consist of clusters of black dots, very different from the wormlike lines and hollow circles of aquatint.

A rarely used method of creating tone, related to sugar and salt grains only in deriving from a non-manual perforation of the ground, involves heating the hard wax ground to the point where it begins to crack all over. The acid can then find its way through these flaws in the surface, which will give a reticulated pattern of lines similar in kind to aquatint.

d Acid used on an ungrounded plate

The action of acid directly on the plate will itself produce a tone, for the acid does not bite evenly and therefore roughens the surface, and etchers have often used this technique to give warmth to large open areas of the image. With the normal movement of acid over the metal, achieved by brushing away the bubbles of gas with a feather, this so-called 'open bite' will result in a light grey tone. However in modern printmaking it has been fashionable to go for a mottled pattern in open bite areas, created by allowing the bubbles of gas to remain. Each bubble protects the metal immediately beneath it from the action of the acid, and a tiny circular ring of copper is left standing slightly raised. This rim will cause ink to collect against it but will itself be wiped clean, resulting, in the finished print, in a white ring set in a blodge of darkness. The effect is very like photographs of craters of the moon.

70

70 An area of open bite, with the crater-like effect from allowing bubbles of gas to form during the biting (3×).

71 Detail from the same print by Tessa Beaver as Figure 70, showing two different layers of deep etch (2×). The cross shape with an aquatint grain is the surface of the plate. The rectangular areas are etched down from that (notice the slight build-up of ink at the edges); and the curved shape is more deeply etched again (heavy build-up of ink along the edges).

Open bite is the term used for acid attacking any area which has not been stopped out, but it is also possible to achieve a similar effect locally by painting acid onto the plate where required. This is usually called brush bite. Areas of a print which have been open bitten or brush bitten will have a characteristic ink rim round the edges, where the ink has gathered at the sudden change of level in the plate surface.

Just as acid can be brushed onto the plate, so it can be dropped or spattered on in what is often called 'spit bite'. Each area of spit bite will have in miniature the characteristic of open bite.

Occasionally etchers have dipped an entire plate, already fully etched, into the acid bath to give a very faint overall tone. This generalized form of open bite will be hard to distinguish from a thin film of ink deliberately left in the wiping of the plate to achieve a similar effect, known as surface tone (10*d*).

An entirely random ground involving open bite is sometimes laid in modern printmaking, in a process which is identical to that of hand-marbling paper and which gives a similar marbled result. Varnish is floated on water and the copper plate is gently lowered to touch the surface. It picks up both varnish and water. When the plate is lifted the water runs off, but the more viscous varnish remains in place and dries to form a hard ground. The acid eats into the copper in those areas left exposed by the water.

A purely modern use of open bite is the deep-etch technique. This is a matter of allowing open bite to continue for so long within specific areas that there is a quite appreciable difference in level between the bitten parts and the surrounding plate. Two effects are achieved by this. There is a very marked build-up of ink at the cliff edge around the bitten areas, giving a strong linear effect, and there is pronounced embossing of the paper (most easily visible on the back) where it has been forced by the press into the deeply bitten cavity.

The deepest etch of all is one used purely for its embossing effect in the type of print known as blind intaglio, which is really a low relief in paper – though justifiably classed as a print since it is achieved in the intaglio press. In an extreme case the copper plate may be up to 4 cm thick, in place of the usual 1.5 mm, and it is sometimes etched right through. It is passed through the press uninked, with a sheet of very thick damp paper and many layers of soft blankets. For very deep embossing the paper is left to dry on the plate – *in* the plate would be a more appropriate phrase – and it emerges as a rigid and often very striking sculptural object.

Planographic

19 LITHOGRAPHS

The principle of lithography was discovered in Germany by Aloys Senefelder in 1798. It was soon widely used for music printing and there were early experiments in the new medium by artists, but the great surge in lithography came after about 1820 when the commercial printers saw that they now had at their disposal a device of unprecedented ease and versatility. Not only could local views, or portraits of worthies, be made available more rapidly and more cheaply than before without any loss of elegance, but even small jobbing work such as illustrated bill headings became easier to provide. The great attraction of the method, for both artists and printers, was that creating an image on the lithographic stone was an action almost as natural as drawing on paper. Gone was the need to grapple with those comparatively intractable materials, wood or metal.

The versatility of lithography has meant that a lithograph offers few characteristics so readily identifiable as those of a woodcut, engraving or aquatint, apart from the relatively unremarkable quality of flatness in both the paper and the lie of the ink. Moreover the variety of ways in which the image can be created, plus the possibility of transfer from other printing methods (20), prevents the nature of the individual line from providing reliable clues. However it is useful to have an account of the more likely possibilities, so they are treated separately in the following sections.

a Pen-and-ink style

The easiest form of lithographic drawing is with a pen, using a special greasy ink. On a highly polished stone the pen will write almost as easily as on paper. The only complication is that the hand must be held off the surface to

72 Detail of a pen-and-ink style lithograph of 1859, showing lines similar to those drawn with pen and ink on paper (actual size).

72

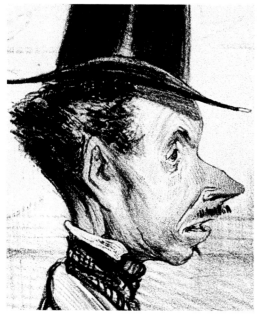

73, 74 Details of a chalk lithograph by Daumier (Figure 9), *c.*1840 (actual size and 9×). The enlargement shows that variation of tone is achieved more by the size and density of the ink marks than by any change in intensity.

avoid unwanted smudges (the skin contains enough grease to cause a mark on the stone which will print), so a small wooden bridge resting on the stone was normally used to prevent any contact. For broader printing areas the ink would be applied with a brush. The lines drawn with the pen and the areas painted with the brush will print a solid black, so the resulting image is similar to one done directly on paper with Indian ink.

b Chalk style In the long run a far more congenial medium for artists was to be chalk lithography. Lithographic chalk, also called crayon, is in consistency somewhere between an ordinary crayon and a chinagraph. It would slip on the polished stone suitable for pen drawing, so the stone was roughened by grinding fine sand over its surface. The finer the sand the finer the grain, the difference being reflected in the finished print. The reason for the characteristic chalk effect was precisely the same as when drawing on paper. On a semi-rough paper the conventional crayon will rub off on many small peaks and give a finely toned line. On a fully rough handmade paper it will touch fewer and larger peaks, giving a line which is coarse and strong. So it is with the peaks of the lithographic stone. Moreover with both paper and stone a heavier pressure will give a darker line, because more of the crayon will be forced down into the valleys between the peaks. Wherever the lithographic crayon touches the surface of the stone, the ink will print. So the printed line becomes exactly like the crayon or chalk line on paper.

Figure 73, looking like a conventional chalk drawing, is a typically free and strong image by one of the greatest of lithographers, Honoré Daumier, and it reveals a basic characteristic of the lithographic medium. The outline of the nose, which Daumier has achieved by pressing hard on his

73

lithographic crayon, looks far darker than the shading of the nose itself, done with a series of light strokes. But when enlarged, it can be seen that the light area is composed of separate dots which are as black but not as densely grouped as those in the dark areas. The crayon has merely touched less of the surface of the roughened stone.

74

In principle every spot where the crayon has stuck to the surface of the stone will print the same tone, and this evenness of printed tone is a most useful guideline when distinguishing between a lithograph and an intaglio print. But it should not be taken too literally when looking at the smallest particles of printed ink through a strong glass. In practice a few of these tiny marks will always be fainter than others.

c Mezzotint style

It is possible to create in lithography an effect similar to mezzotint (16). The whole surface of the stone is covered in lithographic grease so that it will print, if left in this state, a solid black. Lighter areas can then be achieved by removing the grease from the stone in various ways, ranging from gentle rubbing with a piece of flannel (for dark greys) to wire-brushing the surface of the stone, or even scraping it clean away for a pure white highlight. This was a very roundabout approach in a medium which gave such opportunities for natural drawing technique, and lithographs in this style are in the nature of curiosities (they had a vogue in Paris in the 1830s). They are easily distinguishable from their intaglio cousins in that they are certain to contain at least some extremely abrupt white lines where the surface of the stone has been scraped away, and an abrupt white line is the one impossibility in a true intaglio mezzotint.

75 The characteristic scratched white lines which can be found in many lithographs (6×).

The mezzotint style itself was short-lived, but the same tonal techniques would later be widely used for creating the subtle background tints in tinted lithography (27b). Scratched white lines in dark areas have remained a useful device for lithographers and can be listed as one of the identifying characteristics of the medium – differing from similar white lines in dark areas of a wood engraving by their freely drawn quality, and looking like marks scratched with a sharp point on any darkened stone surface.

75

d Lithotint

The techniques described above had all been developed by about 1830, but the one element still missing in lithography was an equivalent of the painter's wash. This was a distinct lack in a medium which was otherwise well suited to imitating the effect of watercolours, and it was finally developed in 1840 under the name lithotint. The method involved painting onto the stone lithographic ink diluted to varying degrees with water, the result being washes of differing intensity in the final print. It had been possible since the first discovery of lithography to paint oily lithographic ink onto the stone with a brush, but each brush stroke flooded that part of the stone with grease and so printed a solid black. It was the variation in the strength of the washes which was the breakthrough. The new technique even shared to a marked degree the main characteristic of a watercolour wash, that of the pigment forming a darker rim at the edge of the brush

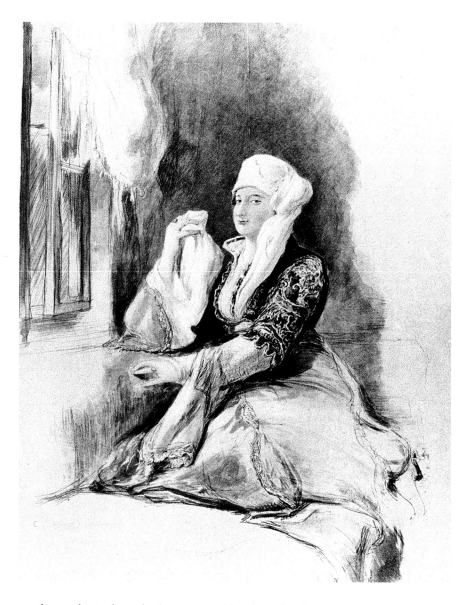

76, 77 A technically very accomplished lithograph of Madame Giuseppina after David Wilkie, 1843 (0.4×). The detail shows lithotint lines – with pale centres – coexisting with rough, crayon-like chalk lines (7×).

stroke, and it is this which most readily identifies those parts of a lithograph achieved by lithotint.

Figure 76 is a lithograph of 1843 which uses most of the available techniques and which shows Madame Giuseppina, landlady of a hotel in Constantinople, who is described titillatingly as a 'celebrated beauty, known to and admired by all European travellers who have voyaged to the banks of the Bosphorus'. The detail shows how lines drawn in the chalk style (19*b*) and others painted in lithotint coexist in Madame Giuseppina's robe. Lithotint was used to a considerable extent in England in the 1840s by its inventor, Charles Hullmandel, but was then neglected until it became popular with artists in the final decades of the nineteenth century.

The lithotint area sometimes has a mottled texture, reminiscent of aquatint and apparently caused by the way in which the combined water and ink dries after being painted onto the stone. Small shavings and specks of lithographic crayon are sometimes mixed with the wash to give a deliberate spotted effect within the lithotint area. A much more extreme mottled effect is deliberately created by some modern lithographers, who mix turpentine with the lithographic ink before painting it on.

The word lithotint is often wrongly used to mean tinted lithograph (27).

e Spatter

Senefelder, the inventor of lithography, foresaw almost all the possibilities of his technique, including even the method – somewhat unlikely in nineteenth-century art – of spattering the ink onto the stone in a random pattern of various-sized dots by drawing a blade across a toothbrush charged with lithographic ink. It was most notably used at the end of the century by Toulouse-Lautrec for his famous lithographic posters. A much more controllable modern version has been the use of an airbrush. Either technique will produce a spray of fine dots in the print, hard to achieve in any other manner. 78

78 Spatter providing tone, in a detail from a chalk lithograph by Toulouse-Lautrec, 1897 (actual size).

f Stone engraving

79 A stone engraving of 1859 (1.25×).

Senefelder also made much of the idea that his invention could be employed in a method similar to intaglio, and the use of a fine needle on the stone did indeed make possible more delicate lines than could be achieved with pen- 79 and-ink lithography. Stone engraving became a standard technique for the printing of maps and scientific drawings.

The method was similar to the use of a wax ground in etching (10a). The lithographer covered his stone with a water-soluble ground, through which he drew the lines of his image with a sharp point. When grease was then applied to the stone, it would only reach those lines exposed through the ground. The two signs of a stone engraving, therefore, are a precision and delicacy of line bringing to mind an etching or steel engraving, combined with the unchanging density of ink between thin and thick lines which is characteristic of lithography and is recognizably unlike the variations of ink tone to be found within an intaglio print (51b).

A few modern artists have included engraved lines in lithographs, and a considerable use was made of the technique on the Continent during the

second half of the nineteenth century for images in commercial letter headings. However, a more convenient method for such work was to print lithographically by transfer from existing or newly commissioned intaglio plates (20c). This was extremely common in Britain in the 1860s and 1870s, and these transfer lithographs are sometimes wrongly identified as stone engravings. Both will give some hint of intaglio, for the image in each case was created by intaglio means. But the final appearance will be very different. By contrast with the genuinely delicate lines of the stone engraving, those in the transfer lithograph are likely to have been coarsened, broken or blurred in the transfer process.

g Zincography

The Bavarian limestone traditionally used for lithography is heavy, fragile and expensive, and for many years has been in short supply. (Modern lithographs printed from stone are in most cases achieved by re-using old stones, ground down until the previous image has vanished from the surface.) Nearly all lithography is now done on metal plates, either zinc or aluminium. These are not naturally porous, as limestone is, so the surface has to be roughened and treated to become receptive both to water and to grease.

As with so many other developments in lithography, this alternative type of printing surface had been foreseen by Senefelder. His own recommendation was zinc, and throughout the nineteenth century a small minority of planographic prints were being produced from this material. The difference in the finished print is minimal, and a print is usually known to be from zinc only because it says so. The word zincograph came into use in the nineteenth century to make this distinction, but it is now conventional to give the name of lithograph (in spite of its specific mention of *lithos*, stone) to any planographic print, including in our own century prints from aluminium plates, paper plates and various other substances.

20 TRANSFER LITHOGRAPHS

The final advantage of lithography over the other manual printing processes was that the image could be created on another surface and transferred to the stone. This brought added convenience in many different ways. The image could be drawn the right way round (it would become reversed when transferred, and reversed back again in printing), which greatly simplified the printing of handwriting; the bulky stone did not have to be brought to wherever the artist or calligrapher was working; ink patterns or tonal devices achieved more conveniently in some other medium could be applied to selected parts of the stone; the use of transparent transfer paper allowed for almost exact printed copies of manuscripts and drawings long before photography achieved the same purpose; and for the jobbing printer production could be speeded up by transferring many versions of a small printed item to a single large stone.

a Method
The transfer paper was coated with a soluble substance, usually based on gelatin, and was provided either smooth for pen-and-ink work or grained like a rough stone for use with lithographic crayon. The artist drew on the appropriate paper exactly as he would on the stone. The paper was then wetted, and was placed face down on the stone. The greasy ink of the image stuck to the stone, but the paper backing and the soluble gelatin could together be washed away. A smoothly polished stone was always used. This was true even for a subject in the chalk style, relatively rare in transfer work, because in such a case the grain that was printed would be the grain of the transfer paper and it was necessary to have a smooth stone to receive this as accurately as possible.

Senefelder did not publish his treatise on lithography until 1818, twenty years after his discovery of the process, but he reported then that transfer lithography was already popular with jobbing printers for handwritten lettering on bill headings and circulars. It seems to have been little used at that stage by professional artists, or by the printers and publishers of images, the reason no doubt being that there is an inevitable slight loss or blurring of fine detail during the transfer process. However it became very popular in the mid-nineteenth century for the reproduction of pen-and-ink work by amateurs, under the name of anastatic printing (20*b*).

b Anastatic printing
Anastatic printing was a process, developed in the early 1840s, for the facsimile reproduction of existing printed material, whether pages of letterpress or intaglio engravings. The printed piece of paper was subjected to a chemical process which released the fatty content in the original ink, which could then be transferred in the normal way to the stone to provide the new printing surface. The obvious danger, as an early book on the subject disarmingly admitted, was that the process 'is uncertain in its results and sometimes destroys an original without producing a copy'. Clearly the anastatic printer was going to find it increasingly hard to borrow originals of sufficient interest to warrant a facsimile.

The process was to become famous in a less hazardous cause. Anastatic drawing societies sprang up all over the country, fostered especially by local antiquarians keen on recording and distributing their finds. They would draw in special ink on specially provided paper, and their efforts would be multiplied by an 'anastatic printer'. This was merely transfer lithography under another name, and the anastatic printer was using nothing more mysterious than a lithographic press. A lithograph of this kind is almost impossible to distinguish from one drawn directly on the stone, for no original version exists to provide a comparison or to reveal the loss of quality resulting from the transfer.

c Transfer from intaglio
The greatest single use of transfer lithography came in the second half of the nineteenth century, and the immediate reason was that during the 1850s steam power had been adapted to lithographic printing. Lithography was already a more rapid printing process than intaglio because the stone could

be inked much more quickly than a plate, but the introduction of steam increased the advantage to a staggering degree. A printer will be working very hard to produce more than 12 prints an hour from an intaglio plate; depending on the subject he will get perhaps up to 50 per hour from a manual lithographic press; with steam the figure leapt to nearer 1,000, and some printers claimed 3,000. Existing intaglio images, such as the small steel-engraved views which were in increasing demand in the age of railway tourism, could now be produced at an unprecedentedly rapid and cheap rate by the simple device of printing from the intaglio plate onto lithographic transfer paper and thus acquiring the same image on stone. Moreover if a small commercial item was required, such as a label, twenty separate impressions from a single steel plate could be transferred to one larger stone, like a sheet of stamps, and the rate of printing would move up towards 20,000 an hour. A print which has the linear characteristics of a conventional line engraving but the flat ink quality of a lithograph will almost certainly be intaglio transferred to stone.

50

d Enlargement and reduction

It was even possible to reproduce an image by transfer at a size somewhat greater or smaller than the original. The process was ingenious. The printer was equipped with a frame inside which a rubber sheet was stretched, on evenly spaced hooks. He transferred his image onto this rubber. If he wanted an enlargement, he was able to move the hooks outwards and the image grew. The opposite achieved a reduction. The newly scaled picture could then be transferred to stone for printing.

e Transfer of textures

Again, with the transfer process, it was possible to obtain on stone a wide variety of textures or tones. Drawings were done on transfer paper with patterned fabric beneath, on the principle of brass rubbing, and later transfer papers were manufactured with their own built-in patterns of texture. In our own time, with the interest of artists in natural textures, surfaces such as fabric, leaves or deeply grained wood have been inked for transfer to the modern zinc printing surface. The transfer process has meant that almost anything is possible in lithography.

f Diazo lithography

Modern lithographers often use a technique known as diazo lithography in place of transfer lithography. Instead of drawing on transfer paper, the artist draws on a sheet of transparent film, textured or smooth depending on the type of image to be created. A sensitized lithographic plate is then exposed beneath this transparency and is developed as in process printing, the term diazo merely reflecting the fact that modern plates are sensitized with diazo compounds rather than the earlier dichromate materials (73a). In such prints there is said to be less loss of fine detail than in the traditional transfer method, and it is not likely to be possible to tell from the finished print that the image was not drawn directly on the plate.

80 *opposite* A detail from a chiaroscuro woodcut of 1745 by John Baptist Jackson after Titian (2.5×). The image is built up from four shades of brown. Each colour is printed from its own wood block and the pressure of the blocks leaves visible indentations in the paper. See 21b.

81 *below* A chiaroscuro print combining relief with intaglio, by Arthur Pond after a drawing by Parmigianino, *c.*1735 (actual size). The brown is from a single intaglio plate – the lines etched, the tones aquatinted; the blue is from a single wood block. See 21*c*.

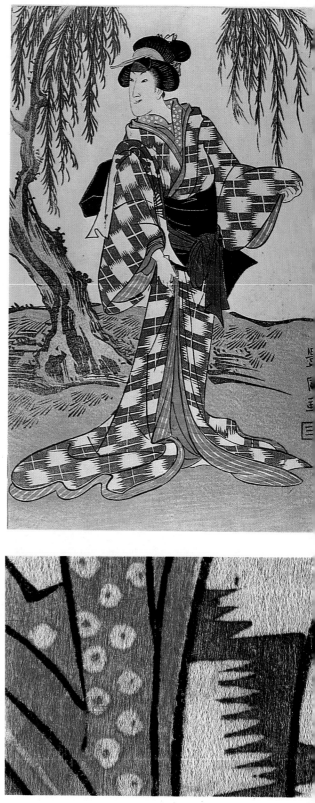

82, 83 *above right and right* Colour woodcut by Toyokuni, *c.*1805 (0.4×), and a detail (4×). Nine separate blocks are used, one for each colour. The detail, from near the top of the robe, shows the white shapes cut from the blocks and the build-up of ink at the edges of the printing areas. See 22*a*.

84, 85 Chromoxylograph after Walter Crane for a children's book of 1878 (0.9×), and a detail (7×). The colours are limited to black, red, yellow, blue and a flesh tint. The detail shows the colour-separater's use of four inks to create the part of the image around the balustrade on the right. See 23*c*.

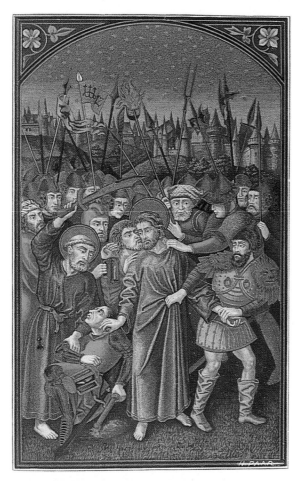

86, 87 Chromoxylograph of 1867 reproducing a fifteenth-century miniature (actual size), and a detail (8×). At least twelve blocks were used. The detail shows how the different inks are combined and superimposed to provide an almost inexhaustible range of colours. See 23*d*.

88 *right* A colour relief etching of 1841 (0.9×). The free-flowing shapes of the printing areas are less linear than the ink patterns of engraved wood blocks in the chromoxylograph (facing page). See 24*a*.

89 Detail from a relief compound print of 1821, printed from blocks separately inked and then fitted together (4×). Register could never be so perfect if the two colours had been printed separately, nor could inking on a single block be so precise. Traces of black ink along the edges of some red areas provide a strong indication of a compound print. See 24*b*.

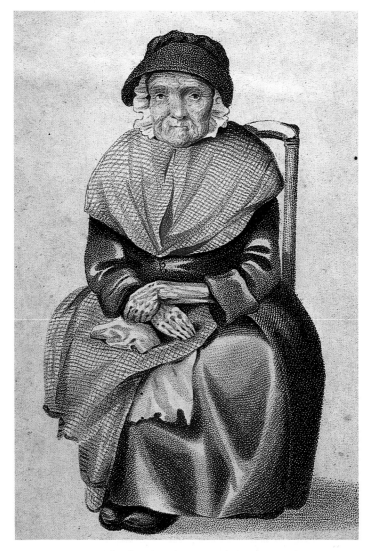

90, 91 Single-plate intaglio: a stipple engraving of 1807 inked *à la poupée* (actual size) and a detail (3×). Note how the colours merge where two inks join, a sure sign that the plate was inked in this manner for printing at a single impression. See 26a.

92 Multiple-plate intaglio: a print by Terence Millington, *c*.1980, using three separate aquatint plates inked in dark brown, blue and pale greeny-yellow (0.5×). See 26c.

93 *opposite* Single-plate intaglio: an aquatint by Bevis Sale, *c*.1980, inked *à la poupée* in only two colours but using the variable depth of the aquatint bite to suggest a wider range (0.9×). See 26c.

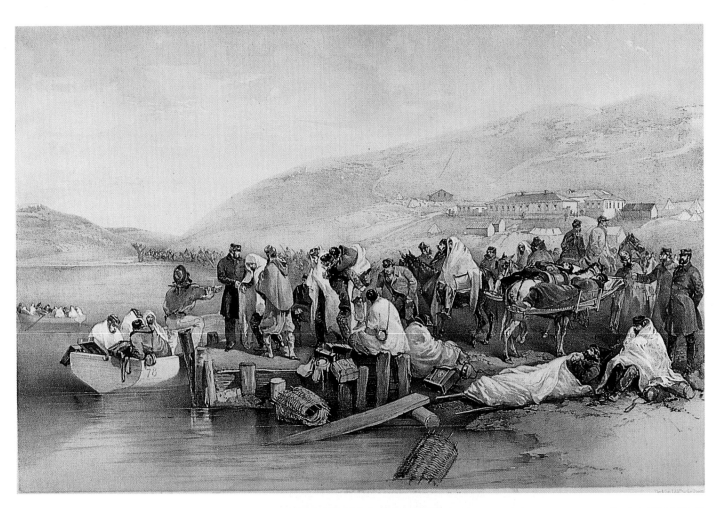

94 Double-tinted lithograph after
William Simpson of a scene in the
Crimea, 1855 (0.4×). The grey and the
fawn tints were printed from separate
stones. See 27b.

95 Detail from a typical late
chromolithograph, c.1890, showing
how the image is built up with
extensive use of stipple on separate
stones for each of the colours (10×).
See 28d.

96 Chromolithograph of 1868 in the style of an illuminated manuscript (actual size). See 28d.

97, 98 Chromolithograph of 1858 using chalk lithography to build up a brilliantly realistic portrayal of ceramics (0.5×), and a detail showing the delicate crayon shading of several stones to achieve the effect (10×). See 28d.

101 *opposite* A detail from a later Baxter print, of 1867, showing the relationship between the delicacy of the intaglio plate (engraved lines together with stipple and aquatint tone, using brown ink) and the broad patches of colour from wood blocks (4×). See 29.

99, 100 An early Baxter print of 1837 (actual size) and a detail (10×). The fine lines and the delicate tonal areas come from an intaglio plate with aquatint grain, and the other patches of colour were added from wood blocks. The detail shows *à la poupée* inking of the aquatint plate, from blue top left to brown bottom right. See 29.

MARISCHAL COLLEGE — ABERDEEN.

102, 103 A typical Nelson print, c.1870 (actual size), and a detail (4×). The image is a pen-and-ink lithograph with the blue and fawn tints added from engraved wood blocks. The detail shows the engraved white lines in the sky and the lines drawn in lithography for the foliage. See 30.

104 *right* A detail from a mixed-method compound print by Carmen Gracia, c.1980, with some of the inking on the viscosity principle (0.3×). The print is composed of several different plates, of varying shapes, laid together on the bed of the press. Of these some have been inked in the grooves and others on the surface, for simultaneous intaglio and relief printing. See 31c.

105 Nature print of a leaf, 1854, achieved by using the different thicknesses of the leaf itself to form corresponding grooves in a copper plate (0.8×). See 35.

Opposite

106 *above left* A detail from a chromotypograph of 1882 (5×). The red is printed from a wood-engraved block and the blue from a textured metal block. See 42*a*.

107 *above right* A detail from a colour line block of 1952 (3×). The black consists of hand-drawn work in line, supported by a mechanical tint, and the red adds areas both of mechanical tint and of solid tone. See 42*b*.

108 *below left* A detail from a relief duotone of 1913 (4×). The characteristic of the method is that inks of two colours, in this case black and fawn, are printed from the same monochrome original with the variable-sized dots of a true halftone instead of the even-sized dots of a mechanical tint. See 42*d*.

109 *below right, above* The soft-edged look of an enlarged detail (10×) from a watercolour, printed on a desktop inkjet printer. The colours merge almost as freely as in a colour photograph.

110 *below right, below* The same detail (also enlarged 10×), printed on a laser printer. In the laser version the toner lies thicker than ink in the darker areas and the screen (usually but not always linear, as in this version) becomes very evident through a strong glass.

111a, b Screenprint by Bob Sanders, *c*.1980 (0.8×), showing the expanses of flat or evenly graded colour which are a frequent but far from invariable characteristic of the method. The detail (6×) shows the overlapping skins of ink. See 45*c*.

112 *left* Hand-colouring: detail from an etching by Rowlandson, *c*.1800, showing the uneven tone and dark rims of individual patches of colour, and the tendency for colour to spill out beyond the image, which are characteristics of hand-colouring (1.5×). See 64*b*.

113 *above* Hand-colouring by stencil: detail from a line block, *c*.1930 (actual size). The mauve is out of register in the same direction on the ring and on the large area to the left, suggesting the use of a stencil. See 64*c*.

114 *left* Printed colour with hand-colouring: detail of the bottom margin from a chromoxylograph of 1860 (4×). The red is added by hand, and has a characteristically uneven appearance, different from the printed colours. The other colours come to a clean edge at the bottom of the image in a manner very difficult to achieve with hand-colouring. See 64*b* and *d*.

Relief

21 CHIAROSCURO WOODCUTS

a Renaissance

The earliest colour-printed images date from the beginning of the sixteenth century and were designed to imitate Renaissance wash drawings. Drawings of this kind made great use of highlights, either added in white gouache or left unpainted on white paper, and such effects were easily imitated in the medium of relief printing where highlights could be scooped from the wood block, leaving that area unprinted. The term 'chiaroscuro' ('light-dark' in Italian) was used for such prints precisely because of the contrast between the highlights and the surrounding areas. They were usually printed in two or three closely related shades of colour, sometimes with a black outline for emphasis. Each colour was printed from a separate wood block.

b Eighteenth century

The heyday of the chiaroscuro print was the sixteenth century, in Germany, the Netherlands and Italy. There was a revival of the style during the eighteenth century by a few eccentric printmakers, particularly in England. The most ambitious among them was John Baptist Jackson, who applied the technique to the reproduction of paintings. Figure 80 is a detail from a 80
Titian. Although literal in style compared to the best sixteenth-century examples, it shows all the characteristics of the medium. Jackson has used four blocks: the pale fawn and the brown of the background, the slightly darker brown of the man's head (not easily recognizable as a separate colour, but the heavy indentation around his head reveals that it is from a separate block), and the very dark brown which carries the main linear design. The white is startlingly bright, a characteristic of chiaroscuro prints, and the hatching on forehead and cheek shows the basic white-line effect of an engraved relief print. The other telltale relief signs, most easily visible in the dark brown modelling of the cape, are the deep impression of the printed areas into the paper and the forcing of the ink to the edges.

c With intaglio

The large Jackson print from which this detail comes is printed purely from 80
wood blocks, but from the sixteenth century through to the eighteenth some chiaroscuro printers combined an intaglio key plate with colour from wood. A late example is Figure 81 by Arthur Pond. In this case the brown lines and 81
the brown wash are from a single intaglio plate (etched and aquatinted) and the blue tint is from a single wood block. Again the chiaroscuro highlights cut from the wood are much in evidence, and the white lines of wood-block cutting or engraving can be seen in the top right corner. Such a print is normally called a chiaroscuro woodcut because it shares the style of such prints, and indeed the chiaroscuro element does come from a wood block. However in the terms of this book it is essentially a mixed method print, and is described as a chiaroscuro woodcut with intaglio.

22 COLOUR WOODCUTS

a Japan Apart from specialized chiaroscuro work (21), the earliest broad tradition of the colour woodcut was that of Japan. Beginning in the eighteenth century, Japanese colour woodcuts rapidly achieved an unsurpassed perfection, and it was the discovery of them in Europe in the late nineteenth century which stimulated a belated movement in this field by Western artists.

A colour woodcut requires a separate block for virtually every colour, the only exception being small patches of two different colours which are sufficiently far apart to share the same block and to be inked separately for simultaneous printing. Each block is cut with knife or gouge on the plank edge as for a monochrome woodcut (5). In Japan the normal practice was for the key block to be cut first, giving the outlines of the image drawn by the artist. From this several proofs were taken. Each proof became the guide for one block, being marked up by the artist to show which part of the design was to print in that colour. All the remaining parts of each block's surface would then be cut away. Figure 82, a very simple subject by Japanese 82 standards, uses up to nine blocks for the following colours: the black of the hair, the pale grey and the dark grey of the tree trunk, the purple of the sash, the pale green of the ground, the olive green of the leaves, the blue and the red of the robe. That makes eight colours. The final block, something of a luxury, is a second red printing which enables a patchwork of darker red to appear in the robe where the two blocks have been printed over each other. The paper was placed face down on each block in turn and had its back rubbed with a hard round pad known as a *baren* to transfer the ink.

The detail shows how the blockmaker's knife has boldly cut round the 83 triangular patterns of the robe in the blue block and has scooped white circles from the red on the patterned under-robe. The blue areas show the build-up of ink at the edges which is characteristic of relief printing. For the same reason – the pressure on the paper in the printed parts – the white in the red pattern rises up at one (an effect not visible in reproduction). This embossing effect, known as *gauffrage*, was a favourite device of Japanese printmakers, who would often use an extra uninked block to give an embossed pattern to the fabric of a robe.

b The West The modern tradition of colour woodcuts in the West, which began with Gauguin, Munch and others, deals in images very different from those of Japan, but the technique is basically the same and such a print will show the usual characteristics of relief printing. The difference is likely to be in the cutting of the blocks, more primitive or even brutal in keeping with modern artistic preferences, and in the grain of the wood itself often being deliberately emphasized as a tonal device.

Meanwhile, during the nineteenth century, Europe had developed its own different traditions of colour prints from wood blocks (23), based on wood engravings rather than woodcuts.

23 TINTED WOOD ENGRAVINGS AND COLOUR WOOD ENGRAVINGS

a Tinted

Early in the nineteenth century European printers discovered how much a simple tint in a neutral colour can enhance a monochrome image. The lead in this field was given by the lithographers (27), but the relief printers were capable of responding with their own equivalent. Tinted wood engravings never became as common as tinted lithographs, but they will quite often be found. The monochrome image will show the characteristics of any wood engraving (6). The tint, from a separate block, will differ from its lithographic equivalent in possibly having indentation and squashed ink rims at the edges (though the latter are hard to see in a pale ink), or straight lines and sharp edges in the highlights which will reveal that they have been scooped from the wood by the graver rather than stopped out or scraped away on stone.

b Chromoxylographs

It was in the field of full colour printing that the relief process was to play an important part from the mid-nineteenth century, in the form of the colour wood engraving. Like its monochrome equivalents, the colour wood engraving used blocks engraved on the end grain rather than cut with a knife on the plank edge, and the fineness of end-grain work made possible an intrinsic difference of approach. Instead of producing the broad patches of colour which are characteristic of a colour woodcut, the makers of colour wood engravings tended to break up their colours into ever more intricate overlapping patterns of finely engraved hatching.

Because of the painstaking nature of this process, the colour wood engraving, unlike the colour woodcut or colour lithograph, has hardly ever been used as an original medium by artists. The vast majority of colour wood engravings are reproductive work of the second half of the nineteenth 84–century, at which time they were often referred to as chromoxylographs – 87 meaning colour from wood, just as chromolithograph means colour from stone. The word is both accurate and useful, forming a natural pair with the chromolithograph. These were the two methods which dominated nineteenth-century colour printing, and 'chromoxylograph' is therefore used in this book for any reproductive colour wood engraving.

c Simple colour separation

The distribution of colour, an integral part of the artist's concept in a colour woodcut, became in a chromoxylograph the responsibility of a master craftsman who sat with an original painting in front of him and worked out which areas of the image should be printed in which of the available colours to achieve the desired effect. In Figure 84, for example, he decided that the 84 coat of the man on the left should print pure yellow. On the outline proof transferred to the yellow block he marked that area as solid and the engraver left it intact.

This chromoxylograph was for a children's book, an important part of

the market but one where no money should be wasted. So only five blocks would be available in this case – black, red, yellow, blue and the flesh tint, which most colour printers used because they found it too hard to achieve a convincing skin colour by a mixture of red and yellow. The detail shows 85 how the colour-separater set about increasing the range of his palette from this limited repertoire. For the bright blue of the water he has marked parallel white lines to be engraved from the blue block in the gaps between the balusters. For the greeny-grey on the dark side of the stone pillars he has mingled yellow diagonal lines with blue lozenge dots, and for the darker green of the far bank he has used solid yellow with horizontal blue stripes (becoming solid near the bottom) and diagonal red lines. In spite of appearances, no green ink was used. So the master craftsman was in fact analysing colours by eye into their ingredients, just as photographic filters do in modern colour printing (67). For a children's book he was attempting only a limited range of effects, each no doubt familiar to his engravers. He would not have to mark every exact pattern for each block, but could merely indicate what intensity of the colour should print in each given area and whether the white lines should be engraved vertically, horizontally or diagonally. His blockmaker would then know whether to engrave thin white lines (for an almost solid tone), medium white lines (a mid-tone) or crosshatching (leaving larger or smaller lozenges of colour to achieve sometimes little more than a faint tint when seen at normal viewing distance). In many ways the characteristic lines of the graver are more easily recognizable in a chromoxylograph than in a monochrome wood engraving, because with the profusion of colours there was less need to conceal the mechanical appearance of routine engraving.

d Complex colour separation

The bright colours and strong design of Figure 84 are perfectly suited to a children's book, and it was in this field that chromoxylographs first became commercially successful. They were used in the same way, with this simple approach to the mingling of colours, to illustrate popular works of botany, zoology and the like. But they also achieved much greater technical brilliance in the realistic reproduction of paintings. Figure 86, printed here to the original size, is a perfect example. It is an exceptionally skilful rendering 86 of an illuminated miniature of the fifteenth century. This time the colour-separater was confronted with a work of art to which he could not do justice with a few bold patches and crosshatches of colour. Not for him a mere five blocks. At this degree of complexity it is always hard to be certain exactly how many blocks have been used, but in this case there are at least twelve – two reds, two blues, grey, green, red, orange, flesh, yellow, gold and silver. Onto the outline proofs for his twelve small blocks the colour-separater marked the intricate patterns of lines and shapes which he hoped, with the effect of multiple overprinting, would approximate to the appearance of his late medieval original. The finished result is a magnificent vindication of his skill. The detail shows the complex intermingling of colours, each from its 87 own block. But even among so many competing colours the characteristic

white lines and patterns of the wood-engraved relief printing surface are still easily recognizable when magnified.

e Towards process printing

By about 1870 the chromoxylograph seemed well placed to defeat its rival the chromolithograph as the standard form of colour print, at any rate in the field of book illustration and in the trade work of the jobbing printer. Meanwhile the relief printer was also developing a new range of tones for his colour work in the form of the chromotypograph (42a). By the end of the century chromolithography seemed to have reversed the position, for it was firmly established as the normal means of hand-originated colour printing. By then, however, the relief method had found a new lease of life in process printing, the natural successors to the chromoxylograph and the chromotypograph being the colour line block (42b) and the three- and four-colour halftone (42f), which together would dominate the field through the greater part of the twentieth century.

24 RELIEF COLOUR FROM METAL BLOCKS

a Relief etchings

During the first experimental period of colour relief printing, in the first half of the nineteenth century, there were various attempts to apply the principle of etched metal blocks (7c) to colour work – most notably in books published in England by Charles Knight. The method was exactly the same as for colour woodcuts or wood engravings, with a separate block for each colour, the distinction being that the areas of each colour would be stopped out on the metal plate and the white spaces would be etched down instead of being engraved away. The only visible difference is that patches of colour may have more flowing and relaxed outlines (being defined by a brush 88 painting on varnish, rather than by a knife or graver cutting away wood). However the main identifying characteristic of such a print will remain the squashed ink rim and the embossed effect of relief printing. Occasionally a surface texture will prove that the print must be from metal rather than wood, as when an aquatint grain has been added to break up and lighten the printing areas.

b Compound prints

The discovery of end-grain boxwood as a material for relief engraving (6a) meant that there was no longer any advantage in engraving relief blocks in metal (7b). But the early nineteenth century provided an interesting exception in the form of relief compound prints, using a block formed of two 89 elaborately interlocking metal sections which could be taken apart for separate inking and reassembled for printing, thus achieving colour work at a single impression. A similar technique seems to have been used as early as 1457, in the isolated case of a psalter printed in Germany at Mainz, with decorative initials in two colours. The idea was developed further in Britain in the early nineteenth century as part of an attempt to print two-colour

banknotes which would defy forgery. And artists in the past hundred years have occasionally cut up blocks for separate printing.

Prints of this kind are sometimes called Congreve prints, from the name of a leading participant in the anti-forgery attempts, but they are more commonly known as compound-plate prints. The inclusion of 'plate' in the name derives from the fact that Congreve and others engraved their patterns in metal plates but then printed them relief, with the engraved lines appearing in white. However 'plate' is not elsewhere commonly used for a relief process, and a less misleading term would seem to be compound print, covering equally well those occasions where separate blocks have been locked together in a printer's forme or where an artist has cut up a woodcut or wood engraving for this method of inking.

The characteristic of a compound print, as opposed to a normal colour relief print from two or more blocks, is that the colours can at no point overlap. They may touch, where the join is sufficiently tight and the pressure of the impression has squashed the two inks together, but there will more often be a characteristic white line separating the colours. There is one infallible sign that a block has been reassembled for the differently inked sections to be printed simultaneously, and this is when ink of one colour appears along the edge of an adjacent area of a different colour. During the preparation of the block for the press a small amount of ink has been transferred from its own raised surface to the adjacent raised surface, thus printing along the edge of that part of the block. If the colours had been printed separately, such an exact fit with the other colour would be impossible.

25 MODERN RELIEF METHODS IN COLOUR

The wide range of materials used for relief printing in the twentieth century has been described in 8. All can be used for colour printing. Once the usual characteristics of squashed ink and embossing have identified a colour print as being relief, the only chance of identifying the materials used for the blocks will be some recognizable grain or patterning. Evidence of the reduce method (31*b*) will suggest a linocut.

Intaglio

26 COLOUR MEZZOTINTS, AQUATINTS, STIPPLE ENGRAVINGS

Although line engravings are sometimes printed in colours, it is the tonal intaglio processes which have been found more suitable for the purpose. A colour mezzotint, aquatint or stipple engraving will reveal its identity through the ink patterns of any of the single colours, on exactly the same principles as for a monochrome print of each type. But there is one further classification worth identifying in colour intaglio, for such prints have been made in two quite distinct ways.

a *A la poupée* colouring

The more common of the two methods has been to ink up separate parts of a single plate in different colours. Such prints are described as being *à la poupée*, meaning 'with the doll'. The phrase derives from the doll-shaped bundle of fabric which is used to dab the ink of differing colours into the grooves and dots recessed in the surface of the plate. In this method the printer is in effect painting the picture on the plate for each impression, and however much care is taken to achieve uniformity each print will be unique in its colouring. Although mezzotints and aquatints were often inked in this way, stipple was found to be the most effective medium, giving a bright and clean look in the printed image because the dotting provides distinct areas for the different colours. Figure 90, dating from 1807, is an extremely primitive print by the best standards of its time but it demonstrates the style very clearly. It contains no hand-colouring. A close-up of the old lady's head (the caption declares her to be 109 years old) shows how the printer has been able to confine the reddish brown ink very neatly to her face. He has even managed a dab of a darker ink for each eye. The areas where the ink does overlap, as in the red on her chin and the black on her shoulder, are entirely acceptable and indeed may be deliberate merging of the tones. But the care required for even such a simple print is obvious.

93

90

91

More elaborate *à la poupée* inking was employed in the genre scenes of pretty milkmaids in cottage farmyards, or of their social betters in titillating *décolleté*, which were fashionable in the late eighteenth century and which became briefly so valuable in the late nineteenth century that new prints of the same type were produced to meet the demand, using a pastiche eighteenth-century style but the genuine *à la poupée* method of inking.

An altogether more straightforward use of the *à la poupée* technique was normal from about 1790 to 1830 in the larger landscape aquatints, particularly those which were intended to be finished with hand-colouring. Here it was an easy matter to ink the area of the sky in a pale blue while using perhaps a warm brown for the rest of the print.

b Multiple-plate printing

The other way of intaglio printing in colour is to use more than one plate. In the eighteenth century there were many brilliant experiments along these lines, beginning with Jacob Christoph Le Blon who anticipated modern

achievements in three-colour work by printing red, blue and yellow from separate mezzotint plates. Theoretically, as he was aware, the entire spectrum would have been at his disposal if he could have graded his three plates with perfect balance – something achieved photographically in modern printing.

In a multiple-plate print it is essential that overlapping colours blend to the eye, and for this purpose the clarity of stipple was not so appropriate. Aquatint was entirely suitable, though harder to control in the fine details of the image than mezzotint. As a result, in its eighteenth-century origins, this very limited field of multiple-plate intaglio printing was largely the preserve of mezzotint.

c Modern colour intaglio

Colour printing in intaglio has had something of a revival in recent years. Excellent and quite cheap prints can be bought in both the traditional methods, *à la poupée* and by multiple plate. Figure 92 is a superb example of a colour print from three aquatint plates, blue, dark brown and a pale greeny-yellow. In spite of its overwhelmingly dark green appearance, no ink of that colour is used – such is the mystery and excitement of colour printing from more than one plate. Several modern printmakers use a rather more humble version of the multiple-plate method, with an etched image in one colour on one plate and aquatint tonal areas in another colour from a second plate.

Modern printmakers make much more use than their predecessors of the fact that a coloured ink in an intaglio print will seem to provide several different colours owing to the differing depths of the etched lines (black ink will do the same, ranging from deep black to the palest grey, but we tend not to think of this as a colour difference). A good example is Figure 93. It is an aquatint with etched lines printed from a single plate, and its entire colour range is achieved with two inks, applied *à la poupée* to easily defined areas. The man's hat, his body and the baskets are all tones of the same dark brown ink. The rolls of bread in the baskets, the ground behind, the wall and the window are all printed in a reddish brown ink. In both these modern prints, one multiple-plate and one *à la poupée*, the traditional intaglio colour print is proving to have potentialities not previously much explored. Meanwhile other artists have combined relief and intaglio printing from a single plate in the totally unprecedented technique of the viscosity print (31c).

d Compound prints

To simplify the fiddly process of inking *à la poupée*, intaglio plates have occasionally during this century been cut up in the manner of a jigsaw puzzle, the result sometimes being known as a jigsaw print. The separate pieces are inked, each with a single colour, and the whole plate is reassembled before being passed through the press. The method is precisely that of the relief compound prints of earlier centuries (24*b*), except that the printing is intaglio. The characteristics of such a print will be no overlapping of the colours (as will be found in multiple-plate printing) and no gradual merging of the colours in the engraved or etched lines (as in *à la poupée*

inking), but a clear division between patches of colour, accentuated by a narrow white line between any tonal areas which reach to the edges of their separate pieces of jigsaw.

The term is also useful for certain modern intaglio prints where separate 104 small plates (usually of eccentric shape, but not interlocking as a jigsaw) are placed together on the bed of the press and are printed at a single impression.

Planographic

27 TINTED LITHOGRAPHS

a Flat tints

The nineteenth century was to be the great period of experiment in new methods of colour printing, and the story had begun soon after 1800 with the development of tinted lithography. One advantage that lithography had over intaglio (its only rival at the time in the production of high-quality material) was its ease in printing a solid tone, achieved by covering the entire printing surface of the stone with grease. Moreover highlights could be reserved, to print pure white, usually by stopping out part of the stone before applying the grease or by scraping and rubbing the surface of the stone after application, thus removing the grease from specific patches. By this method, akin to the old chiaroscuro technique of woodcut printing, lithography rapidly proved its ability to imitate those drawings on tinted paper that have highlights added in gouache or white chalk. Scraping away the highlights with a sharp blade on the surface of the stone was found to have two advantages over stopping them out. It gave more uneven and more convincing edges to the white areas, and the resulting recess in the stone caused the paper to stand up slightly where it remained white – strongly suggesting an added layer of paint or chalk.

It therefore became quite common to print lithographs from two stones – 257 one for the black image which imitated the drawing itself, and one with a second ink, most often fawn-coloured, suggesting a background wash or tint. The neatly rectangular shape of the lithographic tint immediately reveals to the eye that this is not a hand-painted effect. The tint stone is also sometimes used to provide a linear border and lettering in the same colour. There will often be small holes at two or four corners of the tint area, from the lithographer's use of pin holes in the stones and in the paper to ensure accurate register of the two printings – important at this stage chiefly for ensuring that the highlights fell in the right places, but to become increasingly crucial as the technique developed towards full chromo-lithography.

b Variable and double tints

Up to about 1835 the highlights in tint stones were pure white gaps in an otherwise solid and even tint. The breakthrough towards the full subtleties of tinted lithography came during the 1830s with the discovery of how to achieve varying tones within the tint stone. This brought its most visible benefit in the representation of skies, where clouds could now take on the

gradations of reality. The new flexibility made worthwhile the use of another ink in addition to the ubiquitous fawn, and so there developed the double-tinted lithograph – printed now from three stones, being black for the image, fawn for the earth and blue or pale grey for the sky. Either of the tints might transgress into the general territory of the other, the blue perhaps providing a reflection in water, the fawn adding density to smoke from a chimney or to the underside of a cloud, and the two of them combining in foreground details. Figure 94 comes from one of the finest of publications using this technique, *The Seat of War in the East*, being William Simpson's views of the Crimea. Such prints were usually sold with the traditional choice offered to the customer, cheaper as printed or more expensive with hand-colouring. Even today they are still considered by many people to be more desirable with the additional colouring, though this has the effect of obscuring the extremely subtle printing.

94

28 COLOUR LITHOGRAPHS

a Multiple tints

A natural development of tinted lithography was an increase in the number of stones, providing more colours in flat tints on the way towards full colour lithography. The earliest colour lithographs, using many colours to reproduce such images as wall friezes from ancient Egypt, were in fact multi-tinted lithographs – in the sense that the colours were used separately rather than being overprinted to extend the range of the inks. The rather subjective borderline between tinted and colour lithography is discussed in 65. For the purpose of this book a print is classified as a colour lithograph if it uses more than the three stones necessary for a double-tinted lithograph (the image and two tints) or if it mingles even two colours in a manner more complex than tinting.

b Chromolithographs

In the heyday of reproductive colour lithography (the second half of the nineteenth century) the term chromolithograph became firmly attached to all such prints. Later it was used in a derogatory sense, contrasting these commercial prints with colour lithographs by artists. The term is of no use for defining a specific category of print, since the distinction between chromolithograph and colour lithograph can never be anything other than a value judgment, the printing method being the same. It is clearly out of the question to describe a colour lithograph by Picasso as a chromolithograph, so the only general solution is to call all prints of this kind colour lithographs. However, the term chromolithograph remains useful to describe a historically significant and easily recognizable tradition of commercial colour lithography, and it is used in that limited sense in this book.

c Colour separation

Although there are some examples of original and artistic colour lithographs in the mid-nineteenth century, the medium was at that time largely used

for reproductive or illustrative purposes. In this it was a rival to chromoxylography (23c), over which it had a decided advantage in large subjects (stone being available in larger pieces than end-grain boxwood) but not in the smaller format of book illustration.

As with a chromoxylograph, the colours of a chromolithograph had to be separated by eye. An outline version of the image in red chalk, easily visible but not receptive to grease and therefore non-printing, would be transferred to each of the necessary stones, one for each colour. The colour-separater would then use any of the normal lithographic techniques for drawing on each stone. For the yellow, for example, he would very likely use areas of solid tint – since it is a pale colour able to underlie others – which could be quickly applied as for a tint stone. For blue he would probably need areas of varied tone, in the sky or overlapping with yellow to form shades of green, and for this purpose he would most likely use a chalk technique (19b) on a rough stone. A dark brown would be chosen perhaps for architectural details or distant figures, and here the pen-and-ink technique (19a) on a polished stone might prove most convenient.

Each colour would be provided in this way from the stone best suited to the purpose, and in any good chromolithograph of the mid-nineteenth century there are a great many colours. Apart from anything else, two varieties of most colours were needed – the reason being that the conventional way of shading within an area of a single colour was to use two tones of that same colour, the lighter being solid and the darker printing in patches over it. A few enterprising lithographic printers were experimenting in the 1860s with more sophisticated colour theories, and were achieving passably realistic effects with a linear image coloured by stipple combinations of yellow, blue and red with an extra flesh tint for faces and hands. But an authoritative manual on chromolithography in 1885 (*Colour and Colour Printing*, by W.D. Richmond) asserts the need even at that late date for at least nine separate stones. 'An arrangement of blue (light and dark), red (pink and deep rose), yellow (golden and lemon), two greys and a dark brown, nine workings in all, will produce a fairly finished picture of flowers, drapery etc. If there are figures, a flesh colour will be required as well.' And, he adds, several more stones will be needed if the client desires a facsimile effect. The number used was sometimes more than twenty.

d From chalk to stipple Chromolithography was ideally suited to the reproduction or imitation of pages from medieval illuminated manuscripts, with areas of flat colour and extremely fine lettering (easily drawn with a pen and lithographic ink, but almost impossible to cut around in a wood block for chromoxylography), and in its early years it benefited from the strong Victorian appetite for such delicacies. But the real challenge lay in the more everyday areas of representational printing, whether landscape, interiors or reproductions of paintings. These were subjects which chromoxylography could also achieve, with its mechanical but very delicate systems of crosshatching, and chromolithography fought here on more equal ground. Indeed it was

96

initially at something of a disadvantage, for in the 1840s tonal effects were usually achieved in chromolithography through shading in the chalk style on roughly ground stones. This method gives a delightfully natural and irregular texture, but requires considerable artistic skill. By comparison, a woodblock craftsman could more easily be told precisely what degree of tint to engrave in a particular area (23c–d). The chromolithographers were to find their answer in the use of stipple. A full range of tones could be achieved on the stone, with very little need for artistic skill, by the device of dotting more or less densely with a pen and lithographic ink, and from the 1880s it was even possible to achieve these textures in a semi-mechanical manner with the prepared tints known as Ben Day mediums (63b). Whether hand-originated or from a shading medium, stipple became the dominant characteristic of chromolithography in the later nineteenth century.

97
98

95

e Artists' lithographs in colour

While stipple carried the day in reproductive colour lithography, a more artistic use of the medium was gaining ground in another equally commercial field – that of the poster. The great theatrical posters of the late nineteenth century (those of Toulouse-Lautrec being merely the most famous among many) were created in the traditional lithographic manner, with each colour of the image being drawn or painted onto a separate stone either by skilled craftsmen or by the artists themselves, without the benefit of manufactured tones. Monochrome lithography had long achieved the status of a serious medium for artists, with Goya and Géricault among its early practitioners, and colour lithography was at last catching up. It is in this tradition that all modern colour lithographs stand, and they will be found to contain any or all of the methods and textures of similar work in monochrome (19a–f).

Mixed method

29 BAXTER PRINTS

The earliest colour prints to achieve wide commercial success were by a mixed method, combining relief printing with intaglio. From the middle of the 1830s George Baxter began producing in London his celebrated prints which used an intaglio steel plate, usually in aquatint, for the image, with colour from up to twenty wood blocks. Although this combination of intaglio and relief had been used on occasion over the previous three centuries (21c), Baxter was able to patent it and his patent lasted from 1835 to 1854. During the last five years of this period he licensed his method to various printers, and the process was quite commonly used by them and others up to the 1870s.

Baxter's original patent also specified that he might use a lithograph for the image, instead of an intaglio print, and on a few occasions he seems to have done this.

Baxter prints are recognizable by the characteristics of each separate process, the aquatint grain and the encrusted look of the ink in the darker lines of the intaglio plate (51*b*) and the squashed ink rims to areas of colour from the relief blocks (51*a*). Baxter himself often achieved great delicacy in his prints. A good example is Figure 99, from *The Pictorial Album, or Cabinet of Paintings*, a book which he published with eleven prints as early as 1837 and in which he showed off the merits of his process. This view of a waterfall in India seems at first glance to use two aquatint plates, for the sky is blue and the earth brown. The reason is that Baxter has inked his single intaglio plate *à la poupée* (26*a*).

99

100

The use of the intaglio plate, with its special potential for fine but deeply inked lines, gave a dramatic quality to the Baxter process which was lacking in pure chromoxylography or chromolithography. This is often even more noticeable in the later Baxter prints, done at first by his licensees and then by others after his patent had expired. These imitators tended to use the process in a less subtle form than Baxter himself, relying on fewer colours from the wood blocks and using more heavily etched intaglio. Prints of this sort can be found illustrating books of the 1850s and 1860s, often not credited to any printer. Figure 101 is a detail from one such book of 1867. It shows recognizable intaglio characteristics in the engraved beards, stippled necks and hands, and lightly aquatinted background. All the brighter colours are from relief blocks. Baxter himself helps immeasurably in the identification of most of his own prints by the prominent display of the phrase 'Printed in Oil colours by G. Baxter, Patentee', though this was often on the mount and so may have become separated from the print.

101

30 NELSON PRINTS

The term Baxter print, as used in 29, is one of long standing. By contrast 'Nelson print' is an expression coined by me to describe certain very recognizable prints published in the late 1850s and 1860s in London and Edinburgh by Thomas Nelson and Sons.

These prints were for the most part small topographical views, produced cheaply and in great numbers to supply an ever-growing market, that of the railway tourists. Many small steel-engraved vignetted views were also being produced for this purpose, but it was slow and expensive to print each one of these by hand on the rolling press. Nelson and Sons cut the printing cost dramatically by substituting lithographs (probably stone engravings, 19*f*) which could be printed on the new steam presses. Though very finely drawn, these inevitably had less delicacy than steel engravings. The firm compensated by adding two colours from cheaply engraved wood blocks, pale blue for the sky and fawn for the ground. For good measure they also usually printed the image in a purplish ink.

50

Figure 102 is a typical example of the resulting type of print. In a sense it is a downmarket version of the brilliant double-tinted lithographs of the

102

94

1850s, for it uses in a similar way the blue of the sky, which descends to earth to do service in the lady's dress, and the fawn of the earth, climbing to give weight to obelisk and turrets. Both these tints are achieved on the wood blocks by the simple and ancient device of varying the width of the engraved lines. This can be seen clearly in the detail (compare Figure 34 for the same technique in traditional engraving).

A full description of such a print is a lithograph coloured from two wood blocks, for which the term Nelson print is a useful shorthand. It should be added, though, that not all similar views published by Nelson were prints of this kind. The firm was a great pioneer in cheap colour printing and they were trying several other methods at the same period. During the 1870s they increasingly replaced the wood blocks with tints from stone (the results, though similar in appearance to Nelson prints, fall into the category of double-tinted lithographs), and during the 1880s and 1890s they were producing cheap and brightly coloured views by normal chromolithography. Nelson prints, as described here, were a relatively brief but charming experiment in one particular form of mixed-method colour printing.

31 NEW METHODS IN COLOUR

The revival of interest in printmaking in recent years has largely been concerned with work in colour. The traditional methods have been extended and often brought together in new combinations, while screenprinting (45) has introduced an entirely new element. For the most part the individual characteristics of the differing types of traditional print can be separately recognized within even the most complex of modern prints, revealing which processes have been used. However there are one or two entirely new techniques which need describing.

a Relief *à la poupée* Certain printmakers in the twentieth century adapted the intaglio *à la poupée* technique (26a) to relief printing from a single wood block. This is appropriate only to a subject with clearly defined areas of colour, each of which will be separately inked – probably by painting with a brush. To keep these areas apart, the technique has been to cut a small groove between the patches of colour. The result is a white line in the final print between the colours, a characteristic also of the closely related compound print (24b). Each separate area of colour will show the relief characteristic of the ink being squashed to the edge, against the white line.

b Reduce method A type of modern colour print which may be hard to recognize is a reduce-method linocut, a technique employed to great effect by Picasso in his later years. In this process the artist uses a single block as a basis for multiple printing. For the first impression he carves away only those areas which are to remain white. He then inks up the block with the lightest colour, perhaps

yellow, and prints every sheet of his edition. This done, he removes from the linoleum surface all those areas which are to be pure yellow in the finished print. He then prints the next lightest colour for the whole edition, reduces the block again, prints another colour, reduces again, and so on until the darkest colour of all is printed from the small amount of the block then remaining. The characteristic of such a print – and the only way in which it may be distinguished from an ordinary colour linocut – is that each colour has every lighter colour printed beneath it. The slightest error in register will cause a faint rim of an unexpected lighter colour to appear round one edge of a darker one, and this clue can usually be found somewhere within the image.

An ordinary colour linocut, using the same number of inks but printed from separate blocks, will in fact be capable of more colours and tones, for the inks can be mixed and overlapped in any combination rather than in this rigid sequence. It is of course also possible to print some colours from a reducing block and others from normal blocks.

c Viscosity

An entirely new type of colour work is the viscosity print, developed in the 1930s, which involves printing intaglio and relief at the same impression from a single copper plate. Ink is deposited in the grooves of the plate and the surface is wiped clean in the normal intaglio manner (1*b*), but before printing a second ink is rolled over the smooth copper plate. Normally this would merge with the ink in the intaglio lines, giving a muddy result, but the crux of the discovery was that inks of different viscosities would not mix on the plate. The resulting print will have an even tone of one colour (in effect printed relief) in all those areas normally remaining white in an intaglio print, while the intaglio image will show up clear and unsullied in the other colour. A further refinement lay in creating two separate relief levels by using deep etch (18*d*) to lower the entire area of the plate in which the intaglio image would be created. It then became possible to work ink of one viscosity into the intaglio lines, to dab another colour of another viscosity onto the flat surface of the deep-etched area, and to roll a third colour onto the remaining surface of the polished copper plate. The whole plate could then be printed at a single impression, and the colours would remain separate – consisting of the intaglio image in one colour, areas of tone in a second colour showing the slight roughness of open etch with a heavy build-up of ink at the raised edges, and other areas of tone in a third colour of an even quality. Such complexities are hard to suggest in words and will not often be met with, but in attempting to recognize such a print it helps at least to have an idea of how it may have been achieved.

Viscosity printing can be seen in a modern print by Carmen Gracia, where the yellow appears against the pale green and pink backgrounds. This thick yellow ink was printed intaglio from grooves in the plates, which were then inked on their surfaces with thinner green and pink inks to print those colours relief. However, the print itself can only be described as a mixed method compound print, for the artist has used differing techniques for the

104

separate plates, which are themselves cut or constructed in a variety of shapes. For example the yellow line on the left is intaglio (it can be seen within its own small plate mark), while the broader yellow line to the right of it is relief (the yellow area itself indenting the paper).

d Dye transfer A few modern printmakers, most notably Richard Hamilton, have produced colour prints which are described as dye transfer prints. A gelatin matrix is made photochemically for each colour; each matrix is then saturated with dye and is printed by being pressed against a specially absorbent paper. The tendency of the dye to spread within the paper gives each patch of colour in the finished print a soft appearance through a glass, refusing ever to come sharply into focus, which is normally the characteristic of a photograph (57a).

PROCESS PRINTS

32 CATEGORIES

a What counts as a process print?

The word 'process' is commonly reserved nowadays for those prints in which photography has been involved. However, an older usage applied the term to any print in which the final printing surface had not been worked upon manually by the artist or craftsman responsible for preparing the image. This is a more useful distinction, for in the mid-nineteenth century there were many attempts to speed up block-making by mechanical or chemical means and it was only later that photography became the predominant characteristic of the various processes. The following sections therefore group together all types of non-manual print, whether mechanical, chemical or photochemical. Certain crucial techniques – electrotyping, for example, or the use of light-sensitized gelatin – are common to many of the processes, and to avoid repetition they are described separately in later sections (71–73) with appropriate cross-references.

b Types of process print

The profusion of nineteenth-century experiments in the field of process printing means that the subject can easily seem impenetrably complex, but many of the techniques described with excitement at the time resulted in so few prints that they have no place in the text chapters of a book such as this, though some are included in the Glossary (107). I have concentrated instead on those which can be seen in retrospect to have been the first steps towards useful results. If even these seem confusing, it is important to remember that for purposes of identification the broad categories will be sufficient, and the types of print can be reduced to:

> **Relief**: line blocks (33), relief halftones (34)
> **Intaglio**: nature prints (35), photogalvanographs (36), line photogravures (37), tone photogravures (38), machine-printed gravures (39)
> **Planographic**: collotypes (40), line photolithographs (41*a*), halftone photolithographs and offset lithographs (41*c*).

c Transfer lithographs

A borderline case between a manual print and a process print is the transfer lithograph. Where the image, or a part of it, has been drawn on transfer paper by artist or craftsman for immediate transfer to the printing surface of the stone, the result seems naturally classified as a manual print; the lithographic ink which will form the image on the stone is the very ink drawn on the transfer paper by the artist. At the other extreme a tiny label, engraved on steel and then transferred to a large stone to print dozens at a single impression, may seem to fall more naturally among process prints. The distinction is not important, since each is accurately described either as a lithograph or a transfer lithograph, and for convenience all transfer lithography is dealt with in a single section among the manual prints (20).

PROCESS PRINTS Monochrome

Relief

The term line block is used both for a printing surface and for the resulting print. As a printing surface a line block is any relief block on which the image has been achieved other than manually but without the use of a halftone screen (74). Such blocks will perform in printing exactly like a wood-engraved block, so the recognizable difference is only in how the lines of the image were created. This difference is essentially that between a drawn image and an engraved one, and examples are given in 33g and 55c. Meanwhile, in keeping with earlier parts of the book, the historical background of each process is given in sections a–f below. For the purposes of identification all these prints can be described simply as line blocks.

a Stereotyped

During the 1830s there were various attempts to create relief blocks by drawing in hardened plaster. A metal plate would be coated with a layer of plaster perhaps a millimetre thick. The artist would draw through the plaster, down to the metal surface, with etching needles of varying width. Hot type metal would be poured over the plate to provide a stereotype (71) and when the plaster was removed the image would be seen in relief, with a flat raised surface suitable for printing. The rest of the metal would be only a millimetre below this surface, but could be gouged away by hand until it was sufficiently deep for the roller to pass without depositing ink in these blank spaces. One such process was called gypsography (gypsum is the basis of plaster of Paris), which can stand as a generic name for them all.

b Electrotyped, without photography

Processes of this kind were quite often used from 1840, the main English version going by the name of glyphography but a generic name for the type of process being wax-engraving, or cerography. As in 33a, the process began with the image being drawn through a substance spread on a metal plate. However this ground could now be in a more workable material, such as wax, for the final relief block would be achieved without heat as an electrotype (72). The difficult part of the process was in building up the untouched areas of wax to a greater height once the drawing was complete, to give enough depth to the non-printing areas in the final electrotype; but the advantages were that the deposited copper gave a better printing surface in the fine lines than the hot type metal of the stereotype process, and the original drawing in wax was not destroyed during electrolysis and could be used to make a second block. Glyphography achieved the distinction of being used by George Cruikshank for some of his illustrated books, though mainly for his cautionary tales on the perils of alcohol.

The glyphograph was followed in the 1860s by a related process known as graphotype. In this the artist drew on a block of hardened chalk, using an ink rich in glue which formed a binding surface on the chalk. The chalk between the drawn lines was then brushed away, leaving the image in relief. A double process of electrotyping was needed to turn this into a relief block in metal.

c Etched, without photography

This process, patented in Paris by Firmin Gillot in 1850, was the first form of line block to achieve anything approaching perfection of technique. In method it was similar to the relief-etching experiments of William Blake (7c) which were too eccentric and too artistic to be classified under the commercial category of line blocks, though this is the family into which they logically fall. In the Gillot process the artist drew in a greasy ink on a version of lithographic transfer paper (20a). The image was transferred to a zinc plate and the greasy lines were made fully acid-resistant by dusting on a coating of asphalt or resin. The uncoated parts of the metal could now be etched down, leaving the image in relief and ready for printing. The use of transfer meant that it was not necessary to draw or write in reverse, an advantage which had been important also to Blake. In its central concept, of the lines of the image forming an acid-resist on the plate, this method contained the germ of all twentieth-century process printing in relief.

d Electrotyped, with photography (warm rinse)

All the line block processes so far described freed the artist from the necessity of being interpreted by a wood engraver, but it was desirable to be freed also from the limitations inherent in drawing through plaster or wax or on a special transfer paper. This freedom was in the gift of photography. Oddly, though, the earliest use of the photographic principle in the making of line blocks seems not to have involved the camera but to have been based on a hand-drawn negative. The printer of a book of 1865 (Samuel Rogers, *The Pleasures of Memory*) explains, rather obscurely, the process used – known as hyalography ('glass-writing'). It seems that the artist drew his design with a needle on a glass plate coated with an opaque substance. His lines became the only transparent part of the plate, exactly as with a glass negative, and at this stage the process was identical with that known as *cliché-verre* (46b). A rigid surface, coated with a thick layer of light-sensitized gelatin, was then exposed through the glass. The lines of the image hardened (73a), after which the unexposed gelatin could be washed away in warm water (73b), leaving the image in relief. Double electrotyping (72) could now provide a facsimile of the image, in the form of a metal block ready for printing. The same process could be worked with a photographic negative of a line subject instead of a drawing on coated glass, and line blocks of this kind were made until replaced by the more subtle method of electrotyping with cold rinse (33e) or by the cheaper and more rapid method of etching (33f).

115, 116

e Electrotyped, with photography (cold rinse)

In the last two decades of the nineteenth century the best method of making a line block was considered to be another combination of electrotyping with photography. It had been invented soon after 1870 and was based on the fact that unexposed gelatin swells when soaked with cold water (73a). A photographic negative of a line drawing was laid on a plate coated with light-sensitized gelatin. The transparent lines of the image caused the gelatin beneath to harden and these areas therefore remained unaffected by water when the gelatin was wetted. But the unexposed gelatin swelled up around the exposed lines (73d), providing in effect a reverse cast of a relief block

which could be realized in metal and in a positive form by a single process of electrotyping. What was so attractive, compared to other forms of line block, was that this version would print the more delicate lines paler than others – something of which wood engravings were capable through the technique of lowering (51*d*). The reason was that a line not fully black in the artwork would become not fully transparent in the negative and so would not entirely harden the gelatin. The gelatin below that line would therefore swell a little when dampened, providing in the printing surface a level slightly lower than the other lines – precisely the effect of lowering in a wood block. But the technique was complicated and expensive, and its extra subtlety was no longer of interest once the halftone block had been perfected (34).

f Etched, with photography (warm rinse)

The line block which was to hold sway in ordinary commercial printing for almost a century had been introduced in about 1870 and was in effect a photographic adaptation of the earlier Gillot process (33*c*). A zinc plate was coated with light-sensitized gelatin and a negative of the artwork was placed upon it for exposure. The transparent lines of the image hardened the gelatin on the plate, but the unexposed gelatin could be rinsed away in warm water (73*b*). When the lines had been coated to make them fully acid-resistant, the white areas were etched down to the necessary depth. Once the acid-resist was cleaned from the raised surfaces, the block was ready for printing – though for some time improvements were usually made by hand with the engraving tool, for this was a replacement for wood engraving and the old crafts of handling the block and printing from it remained the same.

g The appearance of line blocks

The element which distinguishes all these versions of the line block from their predecessor and continuing competitor, the wood engraving, is that the draughtsman has been freed from the restricting discipline of the graver. Basically, then, line blocks will show a drawn line instead of an engraved line. This distinction is less helpful than it might be, for the reproductive wood engravers were striving to imitate the drawn line of their original artwork and were often astonishingly successful in doing so, while in early line blocks the need to draw with a needle through plaster or wax made the line less free than it might be.

116

19-
24

Once photography was on the scene, the artists could draw normally with pen and ink on paper and their freedom was total. Most of them found it irresistible, and the line blocks of the 1880s and 1890s are usually a mess of squiggles. It was Aubrey Beardsley, in the 1890s, who reintroduced restraint and elegance and showed that the line block was capable of outshining the best reproductive wood engravings if the design was good enough. Paradoxically his areas of solid black, crossed by fine white lines, were precisely the type of image which the wood-engraved block had been well suited to providing.

117

115, 116 Line block from a hand-drawn glass negative, from Samuel Rogers's *The Pleasures of Memory*, 1865 (0.75×), and a detail showing the freely drawn lines, of a different character from those in a wood engraving (2.8×). See 33*d*.

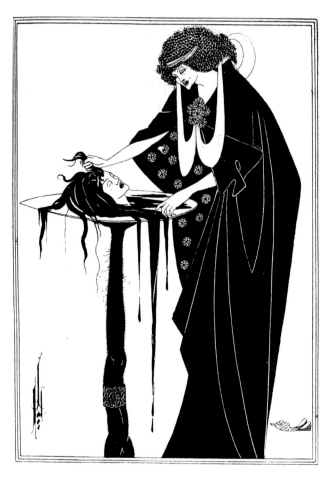

117 Line block from a drawing by Aubrey Beardsley, 1894 (0.6×).

h Artists' false halftones

It was not until the very last decade of the nineteenth century that the screened halftone block (34) became a practical reality. In the preceding years there had been frantic efforts to use line blocks for tonal effects. The technical requirement for a line block was that every tiniest detail of the artwork should be either pure black or pure white, and the solution was found to lie in the use of specially grained and lined papers. The most satisfactory kind was white paper, embossed with a pattern of lines or dots. The artist drew on it with a soft black crayon. With light pressure just the peaks would be blackened, printing a very pale tone, and with more pressure increasingly large areas of the troughs would be filled and the tone would darken. The principle and the procedure were exactly the same as when drawing with lithographic crayon on a roughly grained stone (19*b*).

On embossed white paper each printed mark was at least drawn by hand, giving a tolerably natural look. The black-lined papers, using the same

118, 119

118, 119 Line block from a drawing on ridged white paper, 1889 (0.9×), and a detail (*below*, 4×) showing how the artist's crayon has blackened the ridges and on occasion has filled in the troughs between them.

120 Detail of a line block of 1894 from black-lined paper, scraped in places to white and filled in elsewhere to black (3×).

i Printers' false halftones

principle as modern scraper boards, had the peaks of the lines already coloured black. This led to a much more mechanical effect, but the black paper seem to have attracted artists because tones could be achieved in both directions, scraping away to pure white or using crayon and finally ink on the way to pure black. In Figure 120 the dark sky is the lined paper without alteration; the two tones of the cloud are partial and complete scraping; the church is drawn in with crayon, and the seated figures in ink. The result is abysmal but the agony was to be brief, for artists and printers were about to be released from such subterfuge by the invention of the halftone block.

Once the principle of the halftone block (34) had been discovered, it was easy for the printer to keep a range of prepared sheets, each giving an even tone which varied in density from the tone of other sheets according to the size of the individual dots – the exact equivalent of the dotted sheets available in Letratone and similar products today. Patches of these could be laid on the existing artwork before the block-making process or could be combined

with the negative, so the system grew up of the artist indicating in which areas of his line drawing he would like tone added and of what density. During our own century comics, strip cartoons, advertisements and the cheaper illustrated books have often used this technique. Any image in which areas are shaded with an evenly spread tone of identically sized dots is a print of this type, and is technically a line block rather than a halftone because no photographic screen has been used to achieve the halftone areas. An equivalent technique in the pre-photographic period had been the use of prepared tints which were applied directly to the surface of the block, before etching, as acid resists. The name Ben Day, or sometimes 'Benday', long remained in use for any such application of prepared tone (63b–c).

j Letterset In recent years a form of relief printing has been developed which uses the offset principle, meaning that the paper receives the ink not from the raised surface of the line block but from an intermediate rubber roller. This roller being flat, the appearance of the ink on the paper will be that of planographic printing; it is possible for the ink rim of relief printing to survive the transfer but it will not usually provide a recognizable clue on paper (for an exception see 77a), though it may do so on plastic (79b). The advantages to the printer are that the process avoids the planographic need for water to dampen the plate and benefits from the crisp edges of relief printing. It is also possible for all the colours to be transferred one after the other to the offset cylinder (the design preferably being one where they do not overlap) before being transmitted at a single impression to the final printing surface, thus eliminating the usual problems of register.

k Flexography This is a modern relief process used for cheap printing, particularly in packaging but also now for wallpapers (79a). The printing surface is of rubber or a composition material, less costly in origination than the metal used for conventional rotary relief printing for such products as newspapers, and capable of use with water-based inks, since there is no metal to corrode. It is much used for printing on plastic (79b), where it will show the characteristic ink squash of relief printing. Until recently flexography, introduced in the early years of this century for printing on paper bags, has been too coarse a process for any but line work. However the new composition blocks are capable of taking a 130 screen (74c) for halftones, and flexography will no doubt increasingly come to resemble traditional relief work from metal blocks.

34 RELIEF HALFTONES

The term 'relief halftone' is in a sense a misnomer, since the halftone block is exactly the same as a line block in being able to print only pure black with white spaces. It is also created by an identical process of etching (73b). The

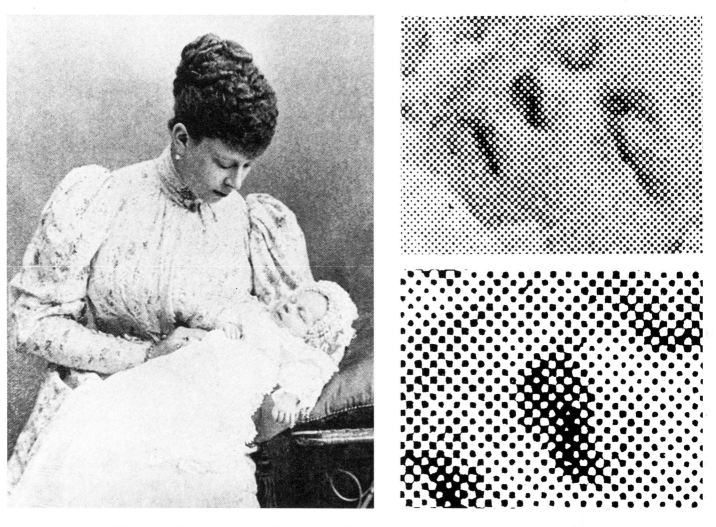

121–123 Relief halftone of the future Queen Mary from the *Richmond and Twickenham Times*, 1894, and two details (actual size, 6× and 12×).

difference is that in making a halftone block a tonal subject, with a range of greys, is turned into pure blacks and whites photographically by the use of a screen. Before the discovery of how this could be done, a similar result was achieved at the artwork stage by means of grained and lined papers (*33h*). The breakthrough was in the achieving of that same end by wholly photographic means, and the device shared by all the successful solutions was a screen through which light passed on the way from the original artwork to the photographic plate or film. The types of screen and their methods of operation are described in 74.

The earliest regular use of a screened image was in the 1880s and by 1890 halftones were common, in newspapers as well as books. A photograph appeared in the *Richmond and Twickenham Times* in 1894 showing the future Queen Mary with her first child (the future Edward VIII), a matter of local as well as national pride for she lived in Richmond Park. Thanks to the halftone screen it was possible, for the first time in history, 121

to disseminate raw images of reality which had not been interpreted and altered by the hand of artist or craftsman and which could be churned out by the presses at the rate of thousands an hour. The average Richmond reader would have been unaware of this momentous change, for wood engravings based on photographs had previously seemed sufficiently like reality (6*d*), nor would such a reader have noticed the fact that the royal child would mysteriously vanish from sight, dissolving into a pattern of larger and smaller dots, if inspected through a magnifying glass.

25

122, 123

Relief halftone remained the normal way of reproducing photographs in books until the 1960s, and in many newspapers until the 1980s. In each field it has fought a losing battle against the more modern and economic technique of offset lithography (41*c*). This also uses the cross-line screen and our printed photographs are still composed of dots. But although the nature of the image is identical in the two processes, the way the ink lies on the paper as seen through a strong glass will make it plain which type of printing has been used (55*r*).

Intaglio

124, 125 Nature prints of lace, respectively intaglio (*top*, 0.8×) and relief (2.2×), 1854.

35 NATURE PRINTS

The earliest process method of making intaglio plates was a delightful oddity known as nature printing, which was patented in Austria in 1852. It made possible the almost perfect reproduction of a narrow range of natural objects – literally narrow, for suitable objects had to be flat and thin, with sufficient but not exaggerated contours. By far the best candidates were leaves and lace, though snakeskin and even a bat's wing were given a turn.

105

The object was placed between two plates, one of lead, the other of steel, and was subjected to great pressure so that a perfect impression of it was formed in the lead. By double electrotyping (72) the lead plate could be turned into a facsimile in copper which was ideally suited to normal intaglio inking and printing – in that the stronger elements, such as the central spine of the leaf, would have made the deepest recess and the delicate traceries would have left only very fine lines in the copper. An object such as lace, although most often printed intaglio, with the ink filling the indentations, could also be printed relief, with the surface of the copper plate inked and the lace featuring as a natural white. A lithographic version was also occasionally used, the lace being soaked with a greasy substance and laid on the stone to provide, as in transfer lithography (20*a*), the image that will print.

124 125

During the eighteenth century, and on occasion as far back as the fifteenth, prints were sometimes made by direct impression from natural objects. A leaf, for example, might be lightly oiled, then blackened over a lamp and pressed against paper to provide an image. But this is intrinsically different from nineteenth-century nature printing, where the image resulting from the natural object was printed by conventional means, whether intaglio, relief or planographic.

126–128 Photogalvanograph of 1857, a very early example of a traditional intaglio print reproducing a genuine photograph (0.7×), and details showing how the image is formed from the characteristic reticulation of gelatine (3× and 9×).

36 PHOTOGALVANOGRAPHS

The earliest prints to be published directly from photographs were by a very delicate and complicated process, patented in 1854 and called photogalvanography by its Austrian inventor, Paul Pretsch. A few such prints were produced by him in London in 1856–7 under the title *Photographic Art Treasures*. They seemed to be normal intaglio prints, as indeed they were in their final method of printing, yet they achieved the convincing appearance of a photograph. Letters engraved below the image hinted at the mysteries involved: 'Produced on Copper by Voltaic Electricity & Printed in the ordinary manner'. Voltaic electricity meant that the eventual printing surface was an electrotype (72), but this gave no clue as to how the image had been created for electrotyping.

126

In fact photogalvanography was the first commercial use of the reticulation of gelatin (73e). Since the cracks in the gelatin became broader and deeper in the darker areas of the image (the parts where the negative allowed most light through), the gelatin surface was itself much like that of a conventional intaglio plate, such as an aquatint, where the ink-bearing reticulation will be broader and deeper in the dark tones. By double electrotyping, the gelatin surface could be turned into an exact facsimile in copper, and it was this copper facsimile which became the plate for printing 'in the ordinary manner' in the intaglio press. The close-up details show the pattern of the reticulated gelatin, very similar to an aquatint grain and fulfilling the same ink-retaining function. The old man sitting beside his boat was one of the first human beings to have been preserved for posterity in this direct manner in printer's ink.

127,
128

Photogalvanography was too laborious and expensive to be a success, and very few prints were produced. Moreover, few details in the lighter areas reached the copper plate – the sky and the topmost branches of the tree, for example, have had to be etched in by hand as in any traditional landscape line engraving. Yet this process, ambitiously far ahead of its time, did contain elements of two of the most successful among modern printing methods, anticipating photogravure (38) in its intaglio reproduction of tonal material, and collotype (40) in its use of the reticulation of gelatin.

37 LINE PHOTOGRAVURES

The process known as photogravure, which uses a light-sensitized acid-resisting ground when etching a copper plate, is in fact older than photography. As early as 1827 the Frenchman Nicéphore Niepce achieved an intaglio plate by this method. His starting point was an existing engraving, which he waxed to make the paper translucent. He had now the equivalent of what we could call a positive transparency (the black lines of the image remaining opaque), and he laid this down on a copper plate coated

with bitumen – a natural tar which is light-sensitive. After hours of exposure in the sun (hence the original name for this process, heliogravure) the bitumen had been hardened by light under all the white spaces but was still soluble where protected by the lines of the engraving. It was then only a matter of using an appropriate solvent to dissolve these lines in the bitumen, after which the copper plate could be etched in the normal way with the hardened bitumen acting as a resist.

This process remained unused for many years, apart from anything else because it involved virtually destroying an engraving in order to reproduce it. But all that was lacking to make it useful was a transparent photographic positive in place of the waxed engraving. As soon as that became available the process was seen to have great potential – particularly since it coincided with the revival of interest in etching in the second half of the century and there was now a demand for good reproductions of old master etchings. Experiments began in the 1850s and reproductions of rare prints by this method become quite common from the 1870s.

By the use of gelatin as a variable resist (73c) it was even possible to reproduce the difference between deeply etched and lightly etched lines in the original, because the paler lines in the positive transparency would allow the gelatin beneath them to become slightly hardened – and this, during the etching process, would delay the action of the acid in these lines, causing them to be less deeply etched than others and therefore to print lighter. The accuracy of the technique was such that the age and appearance of the paper (70) will provide an easier method than the etched lines themselves for distinguishing a nineteenth-century photogravure reproduction of an etching from, say, a seventeenth-century original.

38 TONE PHOTOGRAVURES

Around 1880 there began the development of the most brilliant and faithful monochrome reproductive technique yet known in the history of printing. It applied photography to the making of intaglio plates for the reproduction of tonal images. Some very successful private experiments in this line had been made by Fox Talbot in England in the 1850s, but the process did not go into commercial use until the 1880s. In its various forms and in the modern development of it known as gravure (39), it has provided reproductions of paintings and of photographs with an accuracy of detail and depth of tone unlikely to be surpassed in monochrome printing.

a Aquatint photogravures An exceptionally fine aquatint grain, achieved by mechanical grinding of the resin or asphalt, was laid on a normal copper plate. The tonal subject to be reproduced was turned into a positive transparency, and a sheet of light-sensitized gelatin was exposed through this before being given a warm rinse to produce a relief map of the image which could act as a variable resist (73c). The gelatin sheet, when laid on the plate with its fine aquatint ground, was

impenetrable to the acid in the highlights of the subject, easily penetrable in the darkest areas, and more or less penetrable to an exactly appropriate degree in all the intervening tones. So a spell in the acid bath would enable the acid to bite deeply round the aquatint grains in the darkest areas, and progressively less deeply all the way to the clear highlights. Whatever the original, whether it be landscape, portrait or painting, the plate could be printed in the usual way in the intaglio press and would provide the normal appearance of a photograph with the extra richness of an aquatint.

That was the theory, and for the most part it worked very well in practice – though in the early years it was often found necessary to strengthen the darker areas with added hand work, and the dotted lines of the roulette can frequently be found. By the first decade of the twentieth century, when a large number of expensive books had at least a portrait frontispiece and often a complete set of plates in aquatint photogravure, the technique was entirely reliable and needed no retouching. It was much used with a brown ink for illustrating catalogues of paintings. Sometimes the familiar aquatint grain can be seen through a normal glass, but often it is so fine that only the 30 × microscope will track it down. The best place to look is in the paler areas, where the ink marks have separated from each other but are not yet so faint as to be indecipherable. Plates of this type can be found in books up to the 1930s, and more recently artists have used aquatint photogravure as one element of their repertoire in creating an intaglio print.

b Sand-grain photogravures

These were claimed by the few firms producing them in the 1880s (notably Goupil and Boussod, Valadon in Paris) to be superior to aquatint photogravures. In fact they were far more complicated to achieve, often gave a less accurate facsimile of the original, and had to be more fully worked over by hand. The process used the cold rinse and swelled gelatin method (73d), resulting in another sort of relief map of the image, the dark areas being raised and moist while the light areas were depressed and relatively dry. An electrotype of this relief map would already have something of the natural characteristic of an intaglio plate, in that the dark areas would now be deeply recessed and the pale grey areas comparatively shallow, but there was as yet nothing to hold the ink. This was solved by using the relative moisture of the various areas. The gelatin was dusted with grains of sand or emery of various sizes. All the sizes of grain stuck to the moist areas, but only the finest became fixed to the less tacky highlights. In the electrotype these grains would become the necessary ink-retaining pits, and the dark areas would have such pits both in greater quantity and in a larger size. The process is sometimes known as mezzotint photogravure or photomezzotint, and at their best the prints do have the look of a mezzotint (16), though all too often this is because the process has not given enough richness to the dark shadows and they have been improved by hand with the traditional tools for touching up a mezzotint, the small rocker and the roulette. By the 1890s sand-grain photogravure was rightly yielding the field to the aquatint variety.

39 GRAVURES (MACHINE-PRINTED)

a Development from photogravure

Gravure is merely a shortened form of the word photogravure, which itself includes all intaglio processes using photography. The abbreviation has been applied mainly to the machine-printed version, in constant use throughout this century, and the full name is more commonly reserved now for the original hand processes in which modern printmakers have shown a revival of interest. This, therefore, is the convention followed in this book – photogravure for a photo-intaglio print produced on the traditional hand press, gravure for anything printed by machine. Such a machine is invariably a rotary one, with the image etched on the surface of a revolving cylinder.

In practice almost every photo-intaglio print with a cross-line screen (39b) will be gravure, though a flat plate can also be created with such a screen for printing on the hand press. Artists have occasionally used the cross-line screen for intaglio prints, which would be classified therefore as screened photogravure (for the problems involved in telling the difference see 55l).

b Grid and cylinder

Machine printing of intaglio images was only made possible by the adaptation in the 1890s of the cross-line screen (74d), which was already familiar in the making of halftone blocks for relief printing. Its original use in intaglio printing was not to divide the image into dots, as with relief printing, but to enable a machine to wipe the plate clean before printing. On the hand press this wiping was done in the traditional manner by a succession of fabric pads, followed by the edge of the printer's own hand. On a rotary press, with a curved printing surface, it had to be done in one sweep by a steel blade, known as the doctor blade. A much thinner and more fluid ink was therefore required, and the blade would tend to scoop this out of any line running in the direction of its own movement. The solution was to divide the surface of the plate into tiny separate pits, each with a flat level rim to guard it against the passing blade. To achieve this grid on the etched cylinder it was necessary to protect from the action of the acid a fine mesh of lines running at right angles to each other. This was done by exposing such a pattern of lines on the light-sensitive gelatin sheet before beginning the normal warm-rinse method (73c). The acid would eat through the different depths of gelatin exactly as for an aquatint photogravure (38a), except that at no point could it attack the grid of protected lines. So varying depths, corresponding to the full range of tones, were separately etched away within each square pit. The surface of the etched cylinder, if greatly magnified, would look much like the iron on which a waffle is cooked. And the printed result, best seen in the pale grey areas, is a neat pattern of tiny ink squares separated by a white grid.

129 The characteristic cell pattern of gravure (12×).

129

c Uses Gravure printing was originally used for textiles, in the early 1890s, and around the middle of the decade was adapted to paper. During the next half century it was to find its greatest commercial application in long runs of magazines. Its advantages over other methods in this respect were, and remain, that the intaglio cylinder is very hard-wearing at high print speeds and that it can print effectively on paper cheaper than the coated papers desirable for relief printing or offset lithography.

d Individual prints While establishing itself as a competitive method of printing on cheap paper, gravure also proved its worth as the most subtle of all forms of monochrome printing at the expensive end of the market. In the early part of the twentieth century many superb prints were produced which appear to be photogravure (38), complete with the plate mark of the hand press, but which in fact are gravure from rotary presses with a plate mark added by blind embossing to satisfy the customers' prejudices. A glance through the glass will reveal the cross-line screen of gravure, but such was the perfection of the new technique that the results were usually even more impressive than aquatint photogravures printed by hand.

e Use in books Gravure had a second flowering after World War II in the printing of high-quality art books. From the 1950s to the 1970s there poured from the rotary presses a sequence of ordinary commercial books of unparalleled richness in their monochrome illustrations. If a book of this period seems unusually warm in its blacks, or surprisingly subtle in its greys, look at one of the monochrome illustrations through a glass. In the lighter areas it is likely to show the grey squares and the criss-crossed white lines of gravure.

During the 1970s publishing costs soared and print runs tumbled, with disastrous results for gravure – for the expense of the process is very largely at the cylinder-making stage, which is what has made it economic for a long run but ruinous for a short one. Gravure-printed books can often be found in second-hand bookshops and they are worth pursuing. It should be added that the glories of gravure only reveal themselves on paper which is not heavily coated, and a matt but rich appearance to the page will be a reliable first indication. Books can occasionally be found where gravure is used on shiny paper more suitable for relief printing. The great depth of ink in the dark areas then slithers about on the surface to disastrous effect.

f Invert halftone and stylus engraving From early in the twentieth century certain printers were cutting costs by making gravure plates with the cross-line screen used for relief halftone blocks, that is to say with dots which differed in size to suggest variations of tone instead of differing in depth. (They thus avoided the need for a variable acid-resist, using the method described in 73b rather than 73c). This process, known as invert halftone (74e), lacked the tonal richness of true gravure but was adequate for certain magazine purposes.

More recently the making of gravure cylinders has been increasingly taken over by a combination of electronic scanning and stylus engraving; a computer scans the image for levels of light and dark, and programmes a stylus to drill a regular pattern of holes variable both in size and in depth. This brings back the true quality of gravure, but the cells will be round rather than square. The doctor blade often scoops the ink from the middle of the shallower cells, leaving either an empty O or sometimes even a C-shape. In many such cases the most immediate evidence of gravure will be the broken edges to the letters of any accompanying text (49*d*). The original form of gravure, and the only version of the process to achieve exceptional quality in monochrome, remains easily recognizable by its pattern of ink squares and white grid in the pale grey areas (53*k*).

Planographic

40 COLLOTYPES

Of all the tonal printing processes using photography, the earliest to achieve commercial viability was also one of the most delicate. It was known at first by a bewildering variety of names but settled down eventually as collotype (from *kolla*, the Greek for glue, because the printing surface itself is gelatin). Based on a French discovery patented in 1855, and in full commercial use by the 1870s, collotypes remained an important element in fine printing until recent years. However, they were suitable only for short runs, since each plate would print no more than a few hundred impressions and the presses were comparatively slow. The last English firm to practise this exacting but very rewarding process closed down during 1983, though at the time of writing collotypes can still be printed in a few places on the Continent.

The process is based on the fact that sensitized gelatin exposed to light will harden and become non-absorbent, whereas unexposed portions will remain soft and receptive to water. This contrast between water-receptive and water-repellent areas mirrored the familiar nature of a lithographic stone, and the hardened gelatin could be made receptive to grease. The essential idea of the process therefore was to treat the gelatin itself as the printing surface, and for this the gelatin had an extra quality which made possible the very exact reproduction of tonal photographs. After a thin coating of light-sensitized gelatin had been spread on a firm base (originally glass, more recently metal), it was left to dry out. In doing so, its surface puckered and reticulated into a network of extremely fine curving cracks, similar in kind to aquatint grain. After exposure to light it was these cracks which first hardened, and it was they which received the printer's ink and transmitted it to the paper. The more an area of gelatin had been hardened by the light, the broader became each grease-receptive crack and the darker that area printed. So the gelatin itself provided the first entirely natural light-sensitive tonal printing surface, and the exact reproduction of photographs in ink became a practical possibility.

The great delicacy of the collotype process derives from the fact that the reticulation of the gelatin is both genuinely random and extremely fine. Through a glass there is nothing of the mechanical look of a process screen, with its rows of dots. Instead the ink structure will look much more like an aquatint. (The identifiable differences between the two are described in 53*h*.)

130–
132

The tonal subtlety of collotype has made it the perfect medium for the reproduction of drawings, watercolours and prints, and the process has traditionally been used for art books reproducing material of that type. In recent years, one might add, it has often been used in Britain by local libraries to provide superb and modestly priced reproductions of prints in their collections, which appear to the unwary eye so like the real thing that they will often turn up round the corner coloured, framed and multiplied fifty times in price. The relative flatness of collotype in the dark areas has made it less suitable than intaglio methods for the reproduction of oil paintings, and it is in that heavyweight league that collotype must finally yield the crown to photogravure and gravure (38–39) as the most perfect reproductive processes so far discovered.

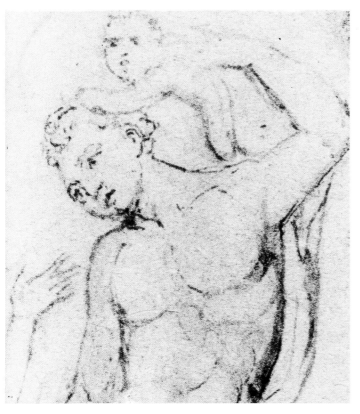

130, 131 *top and above* Details from a collotype reproduction of a very delicate drawing by Blake, a subject perfectly suited to this process (18× and 4×).

132 The collotype grain in a tonal subject, reproducing a photograph of a beach scene, *c*.1900 (17×).

41 PHOTOLITHOGRAPHS

Experiments began at least as early as the 1850s to achieve an image photographically on the surface of a lithographic stone. It was a natural development, for lithography had proved itself the most versatile of all printing processes and photography was the latest scientific marvel in the business of image-making. With the development of offset printing (41c) photolithography was to become the predominant method of printing in the late twentieth century.

a Line photolithographs

From the first years of lithography it had been possible to draw in lithographic ink on coated transfer paper and to transfer the image to stone (20a), and this existing technology was quite easily adapted to photography. An image drawn in ink on ordinary paper could be photographed, as indeed could any existing document, and a negative could be used to expose a sheet of light-sensitized gelatin. The lines of the image would become hardened gelatin, receptive to greasy ink, while the white spaces remained receptive to water. The gelatin surface could then be inked and the image transferred to stone or zinc for printing in the normal way.

From the early 1860s through into the twentieth century this process was much used for reproducing old documents, maps, engravings, architects' and archaeologists' drawings and similar material. Unless a print mentions photolithography (or frequently photozincography), it will be almost impossible to tell whether a newly created image has been drawn by hand on transfer paper or drawn on another material and transferred photographically to sensitized gelatin. However, it becomes increasingly likely in the last decades of the nineteenth century that photolithography has been used. It was much more convenient for documents emanating from architects' offices and the like to be on ordinary paper, since lithographic transfer paper had to be treated with as much care as the stone itself to avoid greasy marks, and any already existing work, such as an engraving, would naturally be photographed for transfer to the stone.

The flatness of the ink will reveal such a print to be a lithograph, though the original image itself may have been created in any of numerous ways – always allowing that this elementary form of photolithography was suitable only for material in line, i.e. composed of marks in pure black among spaces of pure white.

b Ink-photos

As with relief and intaglio printing, there were constant experiments to achieve tonal effects mechanically in lithography. The earliest to reach commercial viability was the so-called 'ink-photo', developed by a London firm, Sprague and Co., in the early 1880s. This was a transfer lithograph using the reticulation of gelatin (73e) to break up the tonal areas into dots and squiggles which would print black against the white background of the paper. Once the image had been achieved photographically on the gelatin

133 The coarse grain of thick reticulated gelatin, transferred to stone for an ink-photo (5.4×).

surface, it could have been printed direct onto paper as a collotype (40). Instead it was transferred to stone or zinc for printing lithographically. The advantage over collotype was the vastly increased speed and the reduced cost of lithographic printing, and the advantage for the lithographic printer was that the collotype grain gave him the required tonal texture on his own printing surface. The disadvantage was that all the shimmering delicacy of a normal collotype would be lost in the transfer process, and so a much coarser reticulation was required (achieved by using a thicker layer of gelatin). The result is that ink-photos show an enlarged version of the grain of collotypes, but nothing of their real quality. They can be found from about 1885 to the end of the century and identification is often made simple by the credit printed below the image, 'Ink-Photo, Sprague and Co., London'.

Other experiments in photolithography, relying on the grain of the stone itself to provide the range of tones (as in a manual chalk lithograph), resulted in some attractive but expensive colour work in the first half of this century and in the modern attempts at screenless offset lithography (41e).

c Halftone photolithographs and offset printing

The ink-photo was in use as a photolithographic process in the very decade, the 1880s, when the halftone relief block (34) was beginning to make its way in the world with the first commercial use of the cross-line screen (74c). This screen method of achieving a tone, by reducing the image to dots of varying size, was just as applicable to planographic printing as to relief but it came into use very much later in lithography. The reasons were perhaps two: the halftone block has the built-in advantage of being able to be printed in the type press with the text; and the transfer process which was normal in early photolithography caused each ink mark to spread a little, a serious drawback in a technique which depended on the precise size and spacing of the dots. From early in the twentieth century it became more usual to sensitize the lithographic printing surface itself, avoiding the need for transfer, and so this second objection was removed. But by then the relief halftone block was a standard feature of commercial printing. Its dominance would not be threatened in the printing of books until it made sense to print the text lithographically along with the illustrations.

Until after World War II the only economic way to originate text for printing was in the form of raised metal type. This was a time-honoured and effective printing surface, so there was usually no incentive to transfer the paragraphs of text to a zinc plate for planographic printing. The breakthrough for lithography came with the development of photographic methods of typesetting. At that point, from the early 1960s, the balance of advantage began to tip towards lithography, particularly for the so-called 'integrated' books (like this one) in which both line and halftone illustrations are printed alongside the text, instead of the halftones being in a separate section of their own. The change was made more desirable by the fact that relief printing required a shiny paper for the halftone illustrations. Lithography, by contrast, could make do with a more gentle surface to the paper, of a kind generally considered more pleasant for reading. Recently the dominance of the planographic process has become so complete that even unillustrated books are now printed lithographically.

Although the modern process remains in essence the old photolithography, it is known nowadays as offset lithography, commonly abbreviated to offset litho – a term covering both line work and halftones. The difference from the old photolithography comes at the moment of printing. It was discovered in the early years of this century that the ink could be more reliably controlled if it was printed by the offset method, as originally developed for printing on tin (79b). This means that the ink is not transferred in the normal way from the plate to the paper, but is set off from the plate onto an intermediate rubber roller and from that is transferred to the paper.

It is not possible to identify from the printed image whether the lithographic impression was by direct or offset means, but in recent decades nearly all commercial lithography has been printed offset on rotary presses. Many artists' lithographs are also now printed offset from flat plates (1c), but the term offset lithography is conventionally reserved for commercial work on a rotary machine, using a plate wrapped round a cylinder.

d Duotones

Although duotone (42*d*, 44*d*) is traditionally a form of colour printing, the principle has sometimes been used in recent years to give a greater range of tones to monochrome halftone images in offset lithography, in an attempt to recapture something of the richness of monochrome gravure (39). The method is exactly as for a duotone in inks of two colours, except that the same ink is used for each impression. The two plates, made from the same monochrome original, will be given very different exposures, one of them designed to preserve detail in the pale areas and the other to give maximum strength in the shadows. The tell-tale signs will be a dot pattern much more complex in some parts of the image than a single cross-line screen would provide, and there will be at least a hint of the circular patterning which results from the use of two or more screens set at different angles.

e Screenless offset lithographs

These are the products of a process developed in the 1980s. It was the adaptation to photomechanical principles of the traditional lithograph in the chalk style (19*b*). There the ink is held on larger or smaller peaks of the irregular surface of the stone, giving a darker or paler tone depending on how many of the peaks are touched by the lithographic crayon and how far down their sides its grease extends. In the screenless process the zinc plate is grained with peaks and valleys of differing depths and random patterning. The light-sensitive emulsion is spread evenly over them. Depending on how much light falls on an area, the emulsion will wash away to a greater or lesser degree, leaving more or less of the peaks exposed. In practice it is the peaks which will appear white in the finished print and the emulsion, left in the valleys between them, which receives the printer's ink. But an analogy would be a ploughed field which has been covered with an even fall of snow and is then exposed to the heat of the sun. The tonal range of the field from dark exposed earth to white snow will depend at the end of the day on how much of the sun's light has fallen on different areas. In the same way the tonal range of the printed page will depend on how the light exposed the ridges and furrows of the lithographic plate. The resulting pattern of printed marks will be seen to be identical in kind to the pattern in a traditional chalk lithograph.

134 The random grain structure in a screenless offset lithograph, 1977 (45×).

135 The random grain structure in a traditional chalk lithograph, 1826 (30×).

134, 135

Proponents of screenless offset lithography hoped that it would become the tonal method of the future. But delicate random screens were at the same time being developed, as improvements on the old-fashioned metzograph screen (74*b*). And the finer cross-line screens are in any case invisible to the naked eye, as well as being easier and cheaper to control. The screenless variety of offset lithography seems likely to be another brilliant oddity in the complex history of printing.

It should be added that screenless offset lithography had certain distinguished predecessors earlier in the century, now largely forgotten (see 'photochrom' and 'Derby Print Process' in 107), the results of which were even more remarkable for being somehow achieved without the diazo compounds (73*g*) which make the modern variety relatively simple.

42 RELIEF

a Chromotypographs

The eventual replacement of the wood-engraved block by the metal line block (33) was as gradual and inevitable a development in colour printing as in monochrome work. In the creation of varied tones, a matter of particular importance in colour prints, metal offered many advantages over wood. Large areas of solid tone, for example, could be broken up and made more interesting by the simple device of etching the surface of the block through a traditional aquatint ground (17a). The aquatint pattern can often be seen in relief colour work of the nineteenth century, showing up as a network of fine white lines when the surface has been only lightly etched (the squiggles which would hold the ink in intaglio remaining clear of ink in relief printing), but reducing to a less immediately recognizable pattern of dots when the sideways action of the acid has been sufficient to reduce the printing surface to small surviving islands.

An unlimited choice of textures was available once the Gillot method of creating a line block by transfer (33c) was in common use. The surface of the block could now be etched through a resist formed of any pattern, whether drawn by hand, rubbed on from a textured surface, or achieved through the action of light. In the last category the reticulation of gelatin (73e) provided perhaps the most useful and popular textural pattern for the printer. This reticulation could be used in many different ways – as a direct ink resist for a line block, for example, or as a pattern for embossing textured transfer paper. The opportunities available to the printer were now too many and too complex to be described here. The practical result was that it became increasingly common during the second half of the nineteenth century for relief prints to include colours in textures and patterns which were clearly impossible to engrave by hand.

From the 1860s to the end of the century such textures often coexist in a print with other colours showing the unmistakable signs of a wood-engraved origin (6). During this period the term 'chromotypograph' (implying colour printed from raised metal, as type is) was used for a wide variety of colour prints which made use, partly or exclusively, of metal relief blocks. With its implied contrast to another great hand-originated colour tradition in commercial printing, that of the chromolithograph, it seems too valuable a word to waste. It is used here for any colour relief print in which some or all of the colours are printed in variable tone from metal blocks. Such prints may include colours engraved on wood in the traditional style of the chromoxylograph, or they may be entirely composed of the more random tones made possible by etched metal blocks. A detail from a chromotypograph of 1882 combines traces of both wood and metal origin. 106 The red block reveals the traditional marks of the graver (parallel white lines sometimes crossing to leave a pattern of dots), while the texture of the blue block derives from the reticulation of gelatin.

b Colour line blocks

By the twentieth century, tonal subjects in colour were most easily achieved as three- or four-colour relief halftones (42*f*), which therefore replaced the chromotypograph. But there remained a place for a cheaper form of colour printing, in which a line block was coloured by mechanical tints (63*c*). Colour line blocks of this kind have remained familiar through much of the twentieth century in such areas as children's comics. The example illustrated uses hand-drawn artwork for the image in the black block, supported by a mechanical tint in certain areas, while the red block adds a mechanical tint with areas of solid tone. The red tint is laid so that the dots do not overlap the black dots but fall between them, providing the circular pattern which is characteristic of relief and planographic process colour.

107

c Tinted halftones

The old chromoxylographers had known how to build up a realistic image in colour from a succession of blocks, but the makers of colour line blocks in the late nineteenth century were less ambitious – perhaps because processes such as collotype and the halftone relief block had raised the standard of what looked realistic in print. A natural compromise was to use an image printed in black from a screened halftone block (34) and to add colour to it from one or more line blocks. Prints of this kind can be found from the 1880s. By the twentieth century the tints were usually mechanical (63*c*).

d Duotones

A halfway house towards full three- or four-colour printing (42*f*) has been the use of two almost identical halftone blocks, made by normal monochrome photography from the same monochrome subject (with the screen moved to a new angle between exposures to avoid overlapping of the printed dots). The blocks are then printed in two different inks. This was the process known to relief printers as duplex halftone or duograph, but now commonly called duotone. The second block would often be printed in a tint-like neutral colour, such as fawn, but there remains a basic difference from the tinted halftone (42*c*). The lighter colour is now itself a halftone and is composed of dots of varying sizes, becoming smaller in the pale areas and enabling the highlights to remain pure white. The second block adds a considerable extra richness to the printed result, though the image will often seem to be in monochrome until inspected through a glass. As an extension of this idea, the printer could use two brightly coloured inks in place of the modest black and fawn. The colours could be chosen for naturalistic reasons – a monochrome seascape, for example, could be turned into a convincing colour view of a sunset over the sea if printed in orange and blue – or they could be intended to be bizarre and eye-catching. The essential characteristic of a duotone is that both colours shall be halftone blocks from the same monochrome original.

108

A triplex halftone would be technically possible – three colours by three exposures from the same monochrome original – but in this case the printing cost would be the same as for a full three-colour halftone (42*f*), which is likely to have been preferred.

e Doubletones

This is a cheaper form of print, imitating the effect of duotone (42*d*), achieved by the use of an ink which spreads a little after printing, giving a halo of a paler tone to each dot in what is otherwise a quite normal monochrome halftone.

f Colour halftones

Ever since Newton's discovery of the primary colours, it had been the dream of printers to achieve full colour work with such limited and cost-effective means as a red, a blue and a yellow impression. Photographic separation by colour filters (67) made the dream scientifically possible. Colour prints from three separate halftone blocks began appearing during the 1890s, and by the turn of the century the results were extremely creditable, the best examples being at least as bright and convincing as the average colour printing in books today. Printers found that they could make a very passable black – as theory insists – from an overprinting of red, blue and yellow.

A minority of printers in the early decades used a fourth block, in black, to give extra weight to the shadows, and from the 1930s four-colour work became the more common method.

Relief colour printing proved a spectacularly successful process. Its brightness derived from the dots of colour in the lighter parts of the image lying beside rather than above each other – conforming, as it happened, to the previous discoveries of Seurat and the pointillists about the brilliance retained by separate specks of pure colour. But the process showed at its best on shiny paper, considered tiresome for reading, and so colour prints of this kind are often found cut out and stuck loosely at two corners ('tipped in') onto matt pages of more attractive texture. As with monochrome relief printing, each dot or group of dots will tend to have the characteristic ink squash (51*a*).

43 INTAGLIO

a Single-plate photogravures

The development of photogravure (38) coincided, in the last two decades of the nineteenth century, with a collectors' craze for the colour-printed intaglio prints of the late eighteenth century (26*a*). It became a simple matter to photograph an old print and to produce a photogravure copper plate of it, for inking up *à la poupée* and for printing on the hand press in the normal way. The result will be extremely hard to distinguish from the original print, though there are certain clues (55*k*). It was also possible to use photogravure for the creation of new colour prints, enabling the artist to draw in stipple on paper instead of through the wax ground of the copper plate. In these cases the pastiche style will often provide the first clue that the print is not an original stipple engraving.

b Multiple-plate photogravures

Separate photogravure plates, to print two or more colours on the hand press, were being produced commercially from at least the early 1880s. At that time they were achieved by the traditional methods of colour selection,

separate artwork being drawn by hand for each plate that would add a colour to the basic image. Around the turn of the century experiments were made in applying photographic colour separation (67) to the photogravure process, but there were special difficulties where such precise register and such fine detail was required. Each plate had to be etched through a separate gelatin resist (73c) and gelatin is not the most stable of substances. Moreover, intaglio sheets have to be printed damp, with the result that the shrinkage of the paper as it dried out between colours provided another variable element. So, apart from its intrinsic expense, photogravure on the hand press was technically ill-suited to three-colour work.

c Gravures

Screened gravure, although the most impressive of monochrome printing methods (39), was also comparatively ill-suited to colour. The quality of its excellence in monochrome work – that the entire surface of the paper, apart from the highlights, is covered in varying depths of ink – becomes a disadvantage when three or four colours are being overprinted. Falling on top of each other they run the risk of giving a muddy appearance, often showing a marked reduction in brilliance compared to the same colours printed as small dots side by side in the other processes. The problem has been largely overcome in the recent development of stylus-engraved gravure (39*f*) with its variable-sized dots which leave plenty of white showing through in the lighter tones, and there is a new brightness in much colour gravure today. It is widely used in the large-circulation magazines and in packaging, its separate ink-retaining pits giving a jagged edge to any area which is printed in a single solid colour, though this too is less pronounced with the new round cells than with the traditional square ones.

44 PLANOGRAPHIC

a Collotypes, hand-originated

Collotype (40), with its own natural gradations of tone, offered the printer an easy way of achieving those variations of colour density which chromolithographers had managed through a varying density of stipple (28c). In the 1870s and 1880s a certain amount of colour printing was done in collotype by a method exactly parallel to that of the chromolithographers. The colour-separater, provided with outline drawings of the subject on paper, would paint a separate sheet for each colour, using five differently graded washes which ranged from black to the palest grey. Through the collotype process this range of greys would be turned into five degrees of reticulation on the gelatin surface, resulting in five tones of each colour on the printed page. The choice of inks was usually similar to that settled on by manual colour printers as the minimum – red, blue, yellow, flesh and sometimes a neutral tone such as grey. Such prints were known, after the German inventor of the process, as Hoeschotypes. Certain artists, Henry Moore for example, have used this method of hand-originated collotype as a form of printmaking.

b Collotypes, photographically originated

Towards the end of the nineteenth century collotype was being printed in the three primaries by photographic colour separation. It shared with colour photogravure (43*b*) the difficulty of relying on gelatin for a task requiring accurate register, though it did not have the added problem of printing damp sheets. Although a difficult and expensive process, it proved itself capable of superb results on occasion and colour collotype played a small but distinguished part in modern printing up to the last quarter of the twentieth century. It has also been used with two inks in the form of duotone (42*d*, 44*d*).

c Offset lithographs, hand-originated

Achieved by artwork done separately for each process plate, material of this kind can be found at any time since the first decade of the twentieth century. As in similar relief work (42*b–c*), the image may be composed of any combination of drawn line, flat tone or manufactured tint, or it may use these to colour a monochrome halftone.

d Offset lithographs, duotone

As in relief printing (42*d*), this is the use of two halftone plates taken from the same monochrome original and printed in different inks. It is used by publishers today to give an extra richness to an apparently monochrome image. Sometimes the second ink may be of a different colour – a pale brown being used, perhaps, to give a warmth to a black image. A strong glass will immediately reveal that there are two colours and so will identify a duotone.

The second ink may also be just a different shade – grey with black, for example, or fawn with brown. A reliable indication of duotone in such a case is a hint in the mid-tone areas of the circular patterning which is caused by the use of two screens set at different angles.

e Offset lithographs, filter-separated

These have been technically possible at any time from early in the twentieth century, though the process suffered originally from the same disadvantages as monochrome offset lithography in competition with relief printing (41*c*). In the years since World War II it has become increasingly common, finally overtaking relief during the 1970s as the standard method for printing illustrations in full colour. The dots which make up the colour image are in principle exactly the same as for relief printing, though very different in appearance under a strong glass (55*r*). It has always been usual in offset lithography to use the four-colour method, adding black to the red (strictly now magenta), blue (cyan) and yellow inks.

45 SCREENPRINTS

a Origin

Screenprinting is the first major new arrival in the printmaker's repertoire since the development of lithography. Its origins lie in the early twentieth century among processes used for the speeding up of hand-colouring and of sign-writing by the use of stencils. We are all familiar with the most mundane use of the technique in the letters which are roughly painted through a stencil on the side of wooden crates, but those simple letters also reveal one intrinsic problem – a capital O, for example, has to have two little unpainted bridges at top and bottom, for without them the middle of the O would fall out of the stencil and the stenciller's brush would paint a solid circle.

Hand-colouring of prints by stencil has been practised since the earliest days of printmaking, and there was a fashion for book illustrations coloured by this method from around the turn of the century to the 1930s. In such cases the artist either had to limit himself to a stencilled design where no colour ever completely surrounded a plain area, or he had to use some such device as that of the Japanese, who have traditionally attached floating parts to the main body of the stencil by hairs too fine to obstruct the paint.

b The screen

It was an extension of this idea, replacing the individual hairs with a complete and pre-existing mesh of very fine strands, which made possible the new technology of screen printing early in the twentieth century. At first the material was silk, and its uses were limited to the production of packaging material and cheap advertisements. More recently man-made materials have been adopted for the screen, such as terylene mesh, and a wide range of techniques has been developed for achieving the design on the stencil. At the simplest level it can be literally attached, with cut-out shapes of material stuck to the mesh, but the more sophisticated methods incorporate the stencil within the mesh. This can be done in a negative manner, by painting the white areas of the image with a substance which will harden and so prevent the paint passing through. Or it can be done in a positive process, similar to a lift-ground technique in traditional printmaking (60), using the lithographic principle of the antipathy between grease and water: the image is painted or drawn in a greasy substance, and the entire screen is then painted over with a thick water-based material; once that is dry the stencil is washed with turpentine, dissolving the grease and leaving those shapes which were hand-painted as the open part through which the ink will pass. Or again, the design can be created photographically by a version of the methods used by process printers (73b), causing a light-sensitive substance to harden on the mesh in all the white areas of the image while dissolving out in those places where the ink is to be allowed through. This process is just as feasible for the dots of a screened transparency (74) as for a subject in line, provided that the mesh of the screen is finer than the smallest dots.

113

Screenprinting is most often used for colour rather than monochrome work. A separate screen will normally be made for each colour, exactly as in the relief or planographic methods (74f).

c Method

Lithographic plates can be made in all the same ways as the screenprinter's screen, so there is nothing in the nature of the image to distinguish one type of print from the other. However, the appearance of the ink on the paper is usually different, and the method of printing will explain why.

Once a screen is complete, it is placed in its frame above the piece of paper or other material to be printed. A thick layer of ink is ranged along the far edge of the screen and is drawn across by means of a squeegee, which forces it through all the open areas of the mesh. The squeegee consists of a long flexible blade, originally of rubber but now of synthetic materials, which in essence is like the windscreen wiper of a car. The blade pushes the ink into the many tiny interstices of the mesh, but at the same time wipes away any ink which remains above the mesh. The result, when the mesh is lifted, is a complete flat skin of ink on the paper, often showing a ridge where one colour overlaps another.

d Blending

One ancient technique of the colour printer, that of rainbow printing (66c), has been much adopted by screenprinters, who call it blending or melding. An imperceptibly gradual change from one colour to another is achieved by mixing the inks into the required gradation at the far edge of the screen and then drawing them across the print in the normal way with the squeegee. If blue ink, for example, is placed at one end and yellow at the other, and if the two are blended in a careful sideways movement, then a single pull of the squeegee will print pure blue at one edge of the paper, merging into green and then becoming yellow at the other edge.

e Characteristics

Figure 111 is a basic example of a screenprint, being a type of subject which is naturally suited to the medium and which has proved very popular. The rainbow effect can be clearly seen from top to bottom (mauve to pale yellow in the sky, fawn to pale grey in the right foreground), and the overlapping layers of ink are evident. As will be seen in the detail, the colour is literally a skin of pigment which coats the paper – something essentially different from the appearance of ink as deposited in any of the three traditional printing processes. However, with modern inks this can no longer be relied upon as a negative indicator; the absence of visible layers of ink will prove nothing, though their presence will still be decisive.

Screenprinting was first taken seriously in the 1960s by Pop artists, attracted by its flexibility, its ability to incorporate all kinds of existing images, and no doubt by its exclusively commercial pedigree. The last is no longer the case, for it has now become a standard and extremely useful part of the artist-printmaker's repertoire.

f Screenprint reproductions Sophisticated modern screenprinting is an ideal process for reproducing paintings, with the ink often seeming to lie on the surface like paint. Such images will fail to reveal any of the ink patterns described in this book as characteristic of manual prints. They are not artist's prints (since the artist has not been physically involved in the printmaking process), but they are often nowadays signed by artists – as also are four-colour offset lithographs printed on art paper. Such prints raise an important question: what is the basic distinction between an artist's print and a reproduction? Another question will provide the answer. Did an identical image (identical in colour and design, but not necessarily size) pre-exist the print? If so the result, however beautiful, is a mechanical reproduction.

46 MONOTYPES AND *CLICHÉS-VERRE*

There remain two oddities which are usually included in books about prints, though one is in fact a transferred painting and the other a hand-drawn photograph.

a Monotypes Since the seventeenth century artists have occasionally used a process in which the image is painted onto an otherwise unprepared 'printing' surface, for which substances as different as copper and millboard have been used. An oily pigment was normal, traditionally printer's ink, and this was transferred to paper either by rubbing or by being passed through the intaglio press. The pressure gave a special look to the spread of the colours, and the design remained visible on the original plate and so could be repainted for another impression if required. Nevertheless, each printed image remained unique, hence 'monotype'. Blake used this technique to superb effect, producing up to three impressions of some subjects, and Degas was another major artist to turn his hand to the medium.

b *Clichés-verre* This is a technique of far less interest than the monotype. It was pioneered by Corot in the 1850s, and involved creating by hand a glass photographic negative. For a line subject, the glass was coated with an opaque white paint. Lines were drawn in this ground, as in the wax ground for an etching, and they showed up black against the white. Drawn glass negatives of this type would later become part of a genuine printing process (33*d*), but Corot chose to use them for ordinary photographic purposes, treating them in the darkroom as conventional negatives. A tonal effect could be achieved in a similar manner by painting on the glass negative in varying intensities of white pigment, ranging from slightly to fully opaque.

47 IMAGES WITH PRINTED TEXT

'Text' here is taken to mean paragraphs of prose or lines of verse, whether on the same side as the image or on the back of the sheet of paper. Images with a more limited number of words accompanying them, relating to the print itself and giving such details as title, artists, engravers, publisher or date, are dealt with in 48.

136 A wood-block illustration in a broadsheet of *c*.1795 (0.7×).

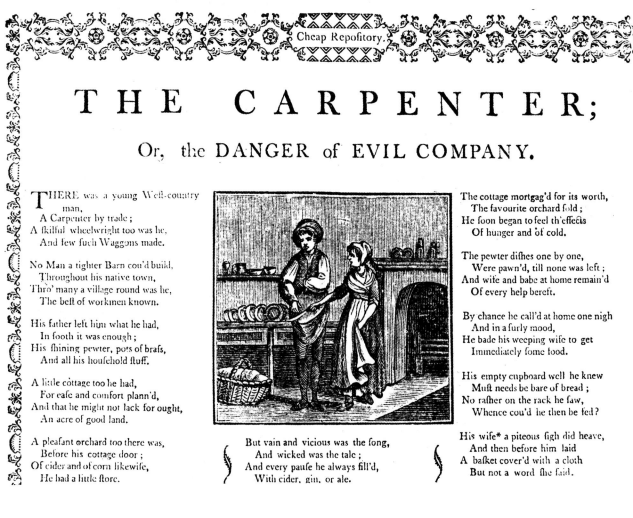

Cheap Repoſitory.

THE CARPENTER;

Or, the DANGER of EVIL COMPANY.

THERE was a young Weſt-country
 man,
 A Carpenter by trade ;
A ſkilful wheelwright too was he,
 And few ſuch Waggons made.

No Man a tighter Barn cou'd build,
 Throughout his native town,
Thro' many a village round was he,
 The beſt of workmen known.

His father left him what he had,
 In ſooth it was enough ;
His ſhining pewter, pots of braſs,
 And all his houſehold ſtuff.

A little cottage too he had,
 For eaſe and comfort plann'd,
And that he might not lack for ought,
 An acre of good land.

A pleaſant orchard too there was,
 Before his cottage door ;
Of cider and of corn likewiſe,
 He had a little ſtore.

But vain and vicious was the ſong,
 And wicked was the tale ;
And every pauſe he always fill'd,
 With cider, gin, or ale.

The cottage mortgag'd for its worth,
 The favourite orchard ſold ;
He ſoon began to feel th'effects
 Of hunger and of cold.

The pewter diſhes one by one,
 Were pawn'd, till none was left ;
And wife and babe at home remain'd
 Of every help bereft.

By chance he call'd at home one nigh
 And in a ſurly mood,
He bade his weeping wife to get
 Immediately ſome food.

His empty cupboard well he knew
 Muſt needs be bare of bread ;
No raſher on the rack he ſaw,
 Whence cou'd he then be fed ?

His wife* a piteous ſigh did heave,
 And then before him laid
A baſket cover'd with a cloth
 But not a word ſhe ſaid.

8 Silver Penny.

E Elephant, e

The ELEPHANT has bones as brass ;
A castle on his back can bear,
Just like an ox he eateth grass,
And drinketh at the river clear.

137 A wood-block illustration to a children's alphabet of *c.*1820 (actual size).

138 A wood engraving in a book of 1842 (actual size).

PUTNEY is now at hand ; and as there is much to interest us, the traveller will have the goodness to disembark, while we consider what are the chief objects of note in this place, and in its opposite neighbour, Fulham.

PUTNEY.

And first, of Putney. This pleasant village, from its situation a place of

a Relief If an image is set among text in a book from before the mid-twentieth century, the normal expectation is that it will be a relief print because of the special convenience to the printer in using relief blocks, capable of being set type-high with the text and printed in one operation. Up to the late eighteenth century such a print will almost certainly be a woodcut (5). Woodcuts were used quite commonly in expensive books till the end of the 11
sixteenth century; thereafter they continued to appear mainly in cheaper books (alphabet books for children, for example) and in the more popular 137
forms of printing (broadsheets). In expensive books of the seventeenth and 136
eighteenth centuries large illustrations tended to be printed separately by intaglio, and woodcut blocks were for the most part used only as vignettes to decorate pages, particularly chapter endings. During that period a few such vignettes were from metal blocks (7*b*). At the end of the eighteenth century there began the use of wood engravings (6) as text illustrations which would 138
lead to their becoming the most widely disseminated form of printed image, culminating in the numerous illustrated magazines of the second half of the nineteenth century.

From the late nineteenth century up to the 1960s this combination of relief image and text continued as the basic printing method for illustrated pages of books, whether the illustrations were line blocks (33) or halftones (34).

b Intaglio with relief text

During the seventeenth and eighteenth centuries the intaglio print held sway, and illustrations were usually bound into books as separate plates. However, it was often desirable to integrate the picture with the reading matter, and there were various ways in which this could be achieved while retaining the improved detail of the engraved image.

The simplest solution was to print the text letterpress in the normal manner but with a space left blank for an intaglio illustration. The sheet of text would then be passed through the rolling press with the copper plate in exactly the correct position to print the image in the space awaiting it. Usually the entire plate just fitted into that space, with the result that a plate mark appears round the image. Placing the small copper plates correctly on the bed of the press was a tricky business, particularly if there were several to

139 A tiny aquatint, with its own plate mark, illustrating a text page in 1802 (1.2×).

by the great Skyrrid, generally attired in misty blue; an elegant bridge steps across the stream,

and through one of its arches the river is seen retiring behind its verdant banks; a long range of pebbles divides the transparent waters, which not only sparkled at the separation, but murmured at the interruption.

VENICE.

THERE is a glorious City in the Sea.
The Sea is in the broad, the narrow streets,
Ebbing and flowing; and the salt sea-weed
Clings to the marble of her palaces.
No track of men, no footsteps to and fro,
Lead to her gates. The path lies o'er the Sea,

140 A steel engraving, without its own plate mark, illustrating a text page in 1830 (1.1×).

go onto the same printed sheet. The sheet, before folding and binding, is far larger than the printed page – eight times as large, for example, in the most common size of book (known from this ratio as octavo) – and so an easier method in the printing, though more expensive in the plate-making, was to engrave all the illustrations for a given sheet on one large plate, larger than the entire printed area of the paper. The small individual illustrations would be widely separated on the plate's surface, with half of them upside down because the sheet would subsequently be folded. In such a case the plate mark will be outside the final pages of the book and will be trimmed away in the binding, so that each image will appear to have no plate mark even though being intaglio. 140

141 Illustration and text both intaglio in a book of 1733 (1.2×).

c Intaglio An even more expensive and correspondingly rare way of achieving intaglio plates and text together on the pages of a book is to engrave the words on the copper plate instead of setting them up separately in printer's type. Such was 141 the skill of the engravers of lettering that they were able to achieve their individually cut letters with a regularity which makes it almost impossible to believe that metal type has not been used. When this has been done there will be a plate mark embracing illustration and text together, and the printer is extremely unlikely to have trimmed his page to within the plate mark. He will be eager for the plate mark to remind the connoisseur of how much exquisitely skilled labour has gone into the making of each page.

d Lithography with relief text Just as a conventional letterpress page can be separately passed through the intaglio press for an illustration to be added, so it can also be passed through the lithographic press. But lithography established itself at a period when 142 wood engravings were reaching a very sophisticated level of reproduction, so there was no longer the same incentive to achieve extra quality by a second printing. Such books are therefore unusual.

e Lithography

Just as a page can be entirely engraved, both for the image and the text (47c), so it can be entirely achieved by lithography – indeed with considerably less labour than in the intaglio method. A lithographic page was a likely solution during the early nineteenth century when a hand-written appearance to the text was considered desirable, and becomes not uncommon in the second half of the century when text and illustrations are integrated in books illustrated with chromolithographs.

f Twentieth-century methods

During the twentieth century illustrated books and magazines have been printed in all three methods (relief, intaglio, planographic) and in combinations of them. Books with illustrations on the text pages are likely to have been printed relief up to the 1960s and by offset lithography (41c) thereafter. Magazines, on the other hand, will often be found to be printed entirely gravure (39). The matter is quite easily solved in most cases by looking at the appearance of individual letters in the text (49d) and at the screen of any halftone image (74c–d).

142 A lithograph illustrating a text page in 1846 (0.4×).

48 WORDS BELOW THE IMAGE: WHAT THEY SAY

a Terms and abbreviations

Of the many words conventionally used on prints I have listed here only those which can help in identifying the type of print. Other phrases, concerned with matters such as copyright or size of edition, are therefore omitted. They can be found in Antony Griffiths' *Prints and Printmaking*, 1980, p. 133.

Printmakers were often careless about these words, which in intaglio prints were usually added by specialist craftsmen in a different firm, so they should never be relied on as gospel in relation to the print they adorn.

a.f., aq., aquaf., aquaforti, aquaforti fecit 'made with strong water'. *Aquafortis* is the New Latin for nitric acid, so this was the conventional term to mean 'etched'. It was commonly used by a craftsman etching someone else's image.

aq: tinta, aquatinta Used of the person who achieved on the plate the tonal aquatint areas in the image – usually, but not always, the person responsible for the whole plate.

cael., caelavit 'engraved'. Used on engravings until the seventeenth century, and a reliable indication that the image was indeed engraved.

del., delt., delin., delineavit 'drew'. Used of the artist from whose drawing the craftsman prepared the printing surface. Compare *pinx*.

dessiné 'drawn'. See *del*.

eng., engd., engraved Used mainly on line engravings, which combine etching with engraving, but sometimes even on aquatints which are unlikely to contain any engraved lines. Unlike the equivalent *sc.*, this was not much borrowed by the wood engravers of the nineteenth century and so is at least a fairly reliable indication of an intaglio print.

engraved on stone Up to the mid-1820s this could mean merely drawn on stone for a conventional lithograph, but thereafter it is likely to indicate a stone engraving (19f).

exc., exct., excudit 'struck out' or 'made'. Conventionally used of the publisher of a print, but can also be found referring to the man who more literally 'made' it, in the sense of creating the printing surface, where someone else is credited as the publisher.

f., fec., fect., fecit, fac., faciebat 'made' or 'did'. Widely but vaguely used on prints. It can be found on lithographs as well as on every type of intaglio print. It is most often used where the originator of the image has also created the printing surface, but this is far from invariable. Can also be used of a specific task – for example *aquatinta fecit*, meaning 'aquatinted', where another craftsman is credited with etching the outline.

gez., gezeichnet 'drawn'. See *del*.

gravé 'engraved'. See *eng*. for normal meaning; but also sometimes used in France on lithographs.

imp., impressit 'printed'. Almost exclusively used of the rolling press and so an indication of an intaglio print; but see also *imp. lith*.

imp. lith. The lithographer's version of the intaglio printer's *imp.*, meaning printed on a lithographic press.

inc., incidebat, incidit 'incised'. Used of an engraver, and a more reliable indication than *sc.* that the print is indeed an engraving.

in., inv., invt., invenit, inventor 'invented' or 'inventor'. Used of the original artist whose image is being reproduced.

lith., litho., lithog. [etc.] An unreliable term, which can refer either to the person who created the image on the stone or to the person who printed it from the stone.

on stone by Used of the artist or craftsman who drew the image on the stone for a lithograph.

ph. sc., photosculpsit 'photo-engraved'. Occasionally used in the late nineteenth century of the craftsman or firm responsible for the complex task of creating a process plate or block.

pinx., pinxt., pinxit, ping., pingebat 'painted'. Used of the artist whose original painting the print reproduces. If a draughtsman is also credited (see *del.*), he will have copied the painting to provide the more portable image from which the print was actually made.

sc., sculp., sculpsit, sculpt., sculpebat 'carved'. The most unreliable of all terms on a print. Originally used for pure engravings, it was continued on line engravings which were usually more etched than engraved. It was adopted, almost invariably in the shortest form of *sc.*, by wood engravers in the nineteenth century; and since these were the craftsmen who later took on the production of line blocks and halftone blocks, the commercial successors of the wood engraving, the term can still be found on these process prints into the early twentieth century, in three-colour work as well as monochrome. Such blocks were admittedly finished with the graver, but by then that was the only element of 'carving' which remained. At another extreme the term was sometimes used to indicate genuine carving, and prints reproducing Renaissance sculpture can be found which boast '*Michelangelo sc.*'.

b Names on their own Where one name is on the left below the image and another on the right, with no further indication of function, the convention is that the name on the left is that of the original artist while that on the right is the craftsman who has created the printed image.

c Reversed letters In an artist's etching reversed letters will merely indicate that he has overlooked the reversal involved in printing and has written the letters the correct way round on his plate. Indeed in artists' lithographs it became for a while fashionable to have the artist's signature printed in reverse, proving that it had been a genuine signature on the stone.

There are also many eighteenth-century prints with letters deliberately reversed, usually above the image. These were prints designed for viewing in

optical machines which gave an illusion of depth; the machine reversed the image, and so the viewer saw the lettering the right way round.

The taking of a counterproof (see 107) would also reverse any letters, but the need for a counterproof is relatively unlikely after the letters have been added.

49 WORDS BELOW THE IMAGE: HOW THEY LOOK

a Relief

143 Letters left in relief in a wood engraving (2.3×).

144 The artist's name left in the wood to print black and the engraver's name cut out to print white (2.2×).

Since the great advantage of the relief block has always been that it can be printed with normal letterpress text, words accompanying a relief print are most often from conventional printer's type, which will usually reveal one of the relief characteristics through a glass. Either the letters will appear to have been punched into the paper, or there will be some sign of the ink being squashed to the edge of each letter.

With certain wood blocks the words will have been cut in the block itself. If the words appear in black, the letters will show the uneven quality which results from having to cut or engrave around them. If the words are in white they will be more successfully written, for the letters themselves will be cut or engraved. Even in the making of halftone process blocks, engravers still often cut their name in the block with the graver in the traditional manner. 143, 144 145

145 Letters carved away to print white in a relief halftone (5×).

b Intaglio

VENER

146 Engraved capital letters, early seventeenth century (2.2×).

Boydell Engraver

147 Traditional 'copperplate' engraved lettering, late eighteenth century (1.6×).

New-Forest

148 Etched handwriting, written backwards on the plate, early nineteenth century (1.6×).

149 Etched capital letters, mid-nineteenth century (1.6×).

From the sixteenth to the early nineteenth century the majority of prints with words below were from copper plates, with the words engraved on the plate. In the earlier period each scoop of the burin is often short and brutal, but by the late seventeenth century the letter-engravers had perfected the graceful flowing lines, swelling and diminishing in a manner entirely appropriate to the burin, which established 'copperplate' as a lasting ideal for handwriting. Such writing provides, indeed, a perfect example of the nature and potential of the engraved line. 146 147

Words were not usually added to artists' etchings, though a few etchers – particularly in the late nineteenth century – would sometimes provide a short title and a date. Since this involved writing backwards, lettering of this kind usually looks like the effort of a young child; alternatively such titles can on occasion be found more fluently achieved but in mirror writing, where the artist in his enthusiasm has forgotten the need for reversal. Professional lettering was sometimes added to reproductive line engravings of the nineteenth century by means of etching rather than engraving. The result is much duller in appearance, since etched lines, unlike the engraved version, are of an even thickness; a common solution was to concentrate on capital letters and to use more elaborately blocked versions. 148 149

c Planographic

150 Lithographic capital letters, in imitation of etched capitals, showing signs of having been written awkwardly in reverse on the stone (1.4×).

Madame Josephina

151 Fluent handwriting transferred to stone, smudges and all, from lithographic transfer paper (2×).

ABERDEEN

152 A simple form of lithographic lettering, from Figure 102 (2×).

d Screened process prints

153 *below* Gravure letters, with their broken edges (21×).

154 *below centre* Relief or letterpress letters, with their squashed ink rims (17×).

155 *below right* Letters in offset lithography, with a level ink tone, flat on the paper (17×).

The lithographer can achieve on a smooth stone any shape which can be drawn on paper, so every variety of lettering was available. With a pen he could imitate the swelling lines of engraved letters. With a sharp lithographic crayon he could produce something closer to the etched version. In these cases planographic lettering will be distinguished only by the basic test of how the ink lies (51c). Lettering from existing intaglio plates can also be found printed lithographically, by transfer, and the availability of transfer paper meant that original handwriting could be achieved much more naturally than in other methods, since the need for reversal was removed. But the quickest form of lettering for a lithographer was stumpy capitals with a medium-thick lithographic crayon, and this gave a result – akin to capital letters written with a soft pencil – which differs in appearance from either engraved or etched originals. Such writing can be seen in the titles below many conventional nineteenth-century lithographs and chromolithographs.

Collotype, the most delicate of the planographic tonal processes, has always been avoided for extensive lettering because the subtlety of its grain is precisely the opposite of what is needed for a clean appearance in text. If there are a few words in collotype below a print, they will show the same characteristic grain as the image (53h), but they are more likely to be letterpress added in a second printing.

Text below a modern process print provides one of the easiest ways of distinguishing between relief (commonly called letterpress), gravure and offset lithography. The squared gravure screen has to cover the entire printing area, and this means that gravure letters always have a jagged edge where the ink-retaining cells overlap the exact shape of each letter. By contrast, the screened areas in relief printing or offset lithography can be limited to the halftone illustrations, leaving line illustrations and text with clean edges. Through a glass, letterpress letters are likely to show the squashed ink rims of relief printing (particularly on modern coated paper), while the ink within each letter in offset lithography will be flat.

150

151

152

153

154

155

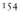

156–158 A full stop enlarged 100× in each of the methods: gravure, prevented by the cell structure of its screen from printing a circle; letterpress, with its ink rim and clear edge; offset lithography, with a level tone but a visibly soft edge at this enlargement.

Gravure text invariably means that the accompanying illustrations are also gravure, and offset litho text will almost certainly imply illustrations printed by the same method. Letterpress text is a less reliable indicator of the nature of the illustrations, because the unsatisfactory quality of gravure text means that it was little used in expensive books with gravure illustrations. It was normal, instead, to provide a letterpress text in a second printing.

50 THE PLATE MARK

a Intaglio

The plate mark is a natural result of intaglio printing. When the dampened sheet of paper has been laid on the inked copper plate, and the two are together subjected to pressure on passing through the press, the paper is squashed with great force against and around the plate. The edge of the plate, bevelled to prevent its cutting into the paper, will leave a clear mark in the paper; and, less noticeably, the surface of the plate will flatten the fibres of the paper, leaving them smoother within the plate mark than outside it. The copper plate is usually rectangular, but it need not be so. A contemporary etching by Kathleen Caddick shows how she has used a very 159 deep plate mark from a curved plate to echo and enhance the shape of her image. Where there is more than one plate mark on a print, two or more plates have been printed on the same sheet of paper. In the colour print by Carmen Gracia, Figure 104, the copper plates are side by side. But in three 160– images from a book of 1786 the smaller plate (the scene) has been placed on 162 the unetched centre of the larger plate (the border), to be printed together at a single pull through the press. The tilt of the inner plate in Figure 161 has meant that the adjacent strip of border is not printed, because the change of level between the copper plates has prevented the paper from reaching the inked recesses of the border.

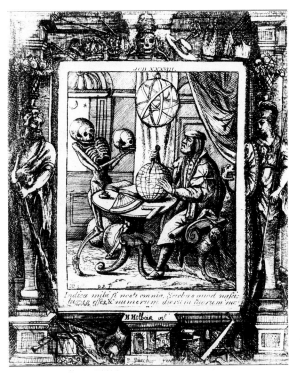

159 *above* A plate cut and bevelled to a pleasing curve round an etching by Kathleen Caddick, 1980 (0.5×).

160–162 *above and below* Three small copper plates aligned on a larger one with varying success, 1786 (0.9×).

b False intaglio

In the majority of cases the presence of a plate mark shows that the print has been made by an intaglio process. This is true even where the image is on a separate sheet of India paper, mounted within the plate mark impressed on the heavier paper (70c).

However, it is easy to create a false plate mark – either by passing a smooth copper plate through the press with a sheet of paper on which the image has already been printed by other means, or by mechanically blocking it (59) – giving the deliberately misleading impression that it is a hand-crafted intaglio print rather than a process print. Usually the false plate mark will look too perfect – too regular in its edges and angles, too smooth, too clean. A revealing place to look is where the bevel of the plate comes. In the messy business of wiping and printing a genuine intaglio plate, small traces of ink are often overlooked on these bevelled edges; they will then show up as occasional dark spots or smudges at the extremities of the plate mark, particularly in the corners. By contrast the blocking of a false plate mark has been done in a machine far removed from inky matters, and there will be no such impurities.

Something resembling a plate mark can often be seen on prints bound into books and provided with protective tissues. The tissue is usually larger than the printed area but smaller than the page, with the result that after years of pressure in the bookshelf it may cause a rectangular indentation in the paper which will look very like a plate mark.

A plate mark will not necessarily be false if a different sheet of paper is securely glued within it (70c), but it is certain to be false if the inner sheet is only tipped in loosely at the corners.

c Trimmed intaglio

Just as the presence of a plate mark does not guarantee an intaglio print, so the absence of a plate mark does not prove the opposite. The print may have been issued in the normal way with a plate mark, but a binder or framer may have trimmed it. Smaller intaglio prints were often printed several on a plate, requiring one working of the press for the set instead of one for each. The plate mark would then come outside the entire group. If they were intended to be cut up and sold separately, or used as book illustrations, each would from the start have lacked a plate mark though being a normal intaglio print.

d Lithography

There are two circumstances in which lithographs can show an impression mark similar to an intaglio plate mark. The printer may not have changed his scraper to fit a smaller size of stone (1c), with the result that the paper is pressed down round the edges of the stone. Or the artist may have drawn his image close to the edges of the stone, making the wider scraper a necessity and providing an impression mark just outside or even coinciding with the image. In either case the edges of the impressed area may show one characteristic different from an intaglio plate mark, having small irregularities along their length which result from chips in the stone. By contrast the copper plate is likely to have a perfectly straight edge, providing a regular and unbroken line in the plate mark.

51 HOW THE INK LIES

This remains one of the two basic methods for deciding whether a print is relief, intaglio or planographic. The other is the nature of the individual line (52).

a Relief Ink characteristics are most easily recognizable in a relief print, assuming that it is a good impression on good paper, because of the unmistakable way in which the pressure of the raised printing surface pushes the ink into a rim round each printed area – a feature known to printers as ink squash or simply squash. This rim will be most easily seen where a small patch of printed ink is surrounded by a large area of white – the relative pressure on that small printing surface being correspondingly greater because of the surrounding emptiness. By the same token there is greater pressure at the extreme edges of the image, and if there is a printed black frame just outside the image its corners will be a good place to look. The image illustrated has almost the appearance of an etching, but details seen through a glass, such as the chimney or the corner of the black border, reveal that it is printed relief. 163–165

There are a few occasions in other methods of printing where the centre of a line may become white, with ink building up at the edge (51e), and some inks used in nineteenth-century lithography had a tendency to separate towards the edges on smooth paper, or on top of other inks in chromo-lithography, leaving a rim of pigment comparable to that which forms at the edge of a brush stroke in watercolour. But these examples will lack the specifically squashed or stamped look of relief printing.

For occasions where a lithograph may show signs of squash see 51c.

163–165 A wood engraving of 1887, almost as spidery in its draughtsman-ship as an etching (0.6×). Details of a corner (23×) and a chimney (15×) show the relief characteristic of ink squashed to the rim.

b Intaglio

The characteristic of the ink in an intaglio print is best seen in the darkest lines, or in any area where the ink seems most heavy. It is heavy because the recesses in the copper plate were deep at that point, and the result is two characteristics impossible in relief or planographic printing. One, there is a greater physical depth of ink in the darkest lines; and two, the ink is further carried up from the surface by the paper beneath it being pressed into the groove in the plate. The result, when a good impression is viewed through a glass, is that the darker lines will often appear as quite visible ridges of ink.

c Planographic printing and screenprinting

Whereas relief and intaglio prints provide recognizable characteristics of their own, planographic printing and screenprinting have only flatness to offer – for that is indeed the essential quality of each. Such flatness is less easy to describe and, to begin with, less easy to recognize, though both a lithograph and a screenprint soon acquire a readily identifiable look. With a lithograph the ink can have a great intensity of blackness but even so will seem, through a glass, just to sit on the surface of the paper, deposited smoothly and without pressure. The flatness of ink in most screenprints is more absolute than in lithography, largely because until recently the ink used has been very much thicker. Often it is more comparable to a layer of emulsion paint, with a matt and slightly porous-looking texture.

A lithograph may occasionally show a build-up of ink at the edges of printing areas which is misleadingly similar to the squash of relief printing (51a). The reason is that some lithographers, particularly in the early years, etched the non-printing areas so strongly as to cause an appreciable lowering of those parts of the stone, leading to extra pressure at the edges of the printing areas exactly as in relief work. (See 107 under 'etch' for the specialized meaning of the term in lithography.)

d Lowering and overlays

A differing intensity of ink in lines of similar width (e.g. black in one line, pale grey in another) will suggest an intaglio print, the thicker layer of ink coming from a deeply engraved or etched groove in the plate and the thinner ink from one which is shallower.

Although a natural characteristic only of intaglio printing, a similar change of intensity can be produced in relief prints through the practice known as lowering. This involves slightly cutting down the height of some of the printing areas in a block, so that they stand a little below the general surface and receive less pressure at the moment of printing. Less ink is therefore transferred to the paper at that point, so giving a paler line in the printed result. This was frequently done at the sides of wood-engraved vignettes, so that the design faded away all round instead of coming to a stark edge. An illustration to demonstrate this point was printed in a book of 1839. A coin of the period was inked and printed relief. The raised lines printed solid black, and the areas of lower relief came out grey.

A similar effect could be achieved by the printer, without altering the block, by the use of overlays. These are small pieces of paper set on the layer of padding (the tympan) which is placed above the inked block and the sheet

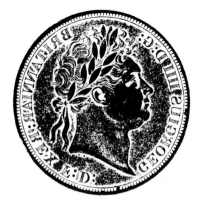

166 A coin of George IV printed as a relief block to show the effect of lowering (1.4×).

166

to be printed, thus ensuring that the pressure is greater on those parts of the block and that the image prints darker there and lighter elsewhere.

e Uninked areas

167, 168 White within the printed line in drypoint (25×) and engraving (15×).

A white or pale area in the middle of black lines is an occasional and accidental characteristic of various processes. One is drypoint, where the burr thrown up by the point may be so strong that it shields from the ink a narrow strip of the plate between itself and the scored intaglio groove, resulting in a pale space between two black lines, one strong and clear (the groove), the other soft and furry (the burr). Similarly, where engraved or etched lines are too broad for their depth, as is often the case with worn plates, the wiping process may remove most of the ink from the centre of the line, causing it to print paler.

46

167

168

52 VARIETIES OF LINE

This section deals in very broad terms with the characteristic appearance of a line in each of the main types of print.

a Woodcuts and wood engravings

The printed line is in effect that part of the block's surface which remains when the spaces to either side have been scooped away. The two sides of such a line will have no necessary relationship to each other, and the line is likely to have much more arbitrary variations in width than in other types of print (where the line itself has been drawn). A useful test, therefore, is whether one can imagine anyone drawing or engraving the more oddly shaped individual black lines in a print. Figure 169 looks to the eye as though it is composed of white lines, and it is easy to see how each has been scooped out by a graver. Figure 170 seems at first sight to be composed of black lines, yet it is hard to imagine such lines being drawn. Figure 171 is the area in a wood engraving from which both details were taken and reveals how the graver has continued from one to the other, merely widening its cut as it goes.

169

170

171

169–171 White and black lines (each 6×) in a wood engraving (see Figure 27), and the part of the image where they meet (2×)

b Engravings

172 Engraved lines deriving from broader or narrower incisions by the burin, with characteristic pointed ends (6×).

The burin, with its sharp V-shaped cutting section, must be pressed gradually down onto the surface of the copper as it begins its cut; it can then be driven more or less deeply through the metal; and it will have to rise up again at the end of the line. This sequence gives the engraved line its two basic characteristics, tending to be pointed at each end, and to swell or diminish quite freely during its length. The sharp tool passing easily through the metal, and lifting out a curling sliver of copper, gives the line an unusually clean edge. The controlled and demanding physical act of engraving also gives the line a formal and somewhat inhibited character, any curve being as cautious as that of a railway line. The absence of a pointed end to a line will not in itself be significant, for there are methods of deliberately achieving a blunt end with the burin.

172

30–34

c Etchings

The rounded needle passing through the hard wax ground will tend to give a more blunt end to the line than the engraving tool. And the very slight crumbling of the wax to either side of the line, combined with the somewhat uneven action of the acid, results in a less precise edge to the line than in an engraving. These factors, together with the freedom of draughtsmanship possible in etching, result in lines of a much less formal and more expressive quality. Usually etched lines will be of the same width along their length (unless stopped out, 10b), unlike the swelling shapes of the burin in an engraving. However, etchings can also include variable lines. These were sometimes achieved with an etching needle known as an *échoppe* which was oval rather than round, so that turning it while drawing altered the width of the line (a device used by some seventeenth-century etchers specifically to imitate engraved lines). But it is also possible to widen a line merely by going over it several times. In a detail of a caricature by Gillray the swelling forehead and chin of the face on the left are so assured that these lines may perhaps have been drawn by the artist with the *échoppe*; but at the bottom it can be seen where he has used several separate strokes with a normal etching needle to achieve the extra width.

173

35

174

173 Lightly and deeply etched lines, of the same width along their lengths and with blunt ends (12×).

174 Etching with aquatint: a detail where Gillray has used the etching needle, and perhaps the *échoppe*, to imitate the swelling line of the engraver's burin (0.8×).

d Drypoints

175 The slashed quality of the drypoint line, with ink held on either side by the burr (12×).

The line is scored with a sharp point directly in the surface of the copper, giving it a more nervous and violent look than in engraving or etching. With the burr scraped away such a line will print as something between a scratch and a slash, depending on the depth of the incision. But it has been traditional in artists' prints to leave the delicate burr in position. This holds the ink above the surface of the plate and prints a soft furry tone to one or both sides of the slashed line, giving a quality which cannot be imitated in any other form of printing.

175, 45, 46

e Crayon manner engravings

176 *below* Roulette tracks forming the line in a crayon manner engraving (7×).

The lines suggest to the eye the strokes of a piece of chalk, composed of small powdered dots. This effect is achieved by the use of a roulette to puncture a linear pattern of holes in the wax ground on the plate. These clear pathways of dots are an easily recognizable characteristic.

176

177 *above* The broken chalk-like lines of a soft ground etching (5×).

f Soft ground etchings

This gives a broad and broken line, looking much as if drawn with chalk or crayon on rough paper and yet at its best showing the encrusted-ink look of the intaglio process. The reason for the broken nature of the line is that the soft and tacky wax ground lifts unevenly under the pressure of the artist's pencil. The result is easily confused with the very similar line of a chalk lithograph. For the differences see 55*i*.

177

g Lithographs

Two different types of line are common in lithography, depending on whether a smooth or a roughened stone is used. On a smooth stone a firm line can be drawn with a pen or brush and lithographic ink. The printed

178 The firm lines of pen-and-ink lithography (5×).

179 The variable lines of chalk lithography, depending on the hardness of the lithographic crayon and the amount of pressure applied (7×).

results will have the shape of the same type of lines drawn on smooth paper. On a roughened stone a piece of lithographic crayon will touch the raised parts of the stone (only the peaks with a soft stroke, more with a harder stroke), and will print a line which is very close to that of a normal black crayon on rough cartridge paper.

178

179

53 VARIETIES OF TONE

This section describes the more recognizable tonal areas, or attempts at tonal areas, in the different types of print. It is limited to those in which the relevant tones can usefully be enlarged and reproduced. The best place to look for signs is in the pale grey areas. Genuinely tonal prints are discussed first (a–d), then tonal attempts in linear prints (e–g), and finally process prints (h–l). Light, medium and dark areas are illustrated for each of the genuinely tonal techniques.

a Mezzotints

The pale grey areas will show the criss-cross pattern of thin lines made up of elongated dots which are the residual traces, almost entirely burnished away, of the heavier lines scored by the mezzotint rocker. The tone consists of dots and dashes of black ink surrounded by white, as opposed to the aquatint grain which is made up of patches of white surrounded by black.

180

182

180–182 Mezzotint (5×).

b Aquatints

This is the most unmistakable of the tonal patterns, with its meandering 183–
network of fine lines comparable to the effect of black lace. The pattern is 188
fairly regular in spirit-ground aquatint and more erratic in dust-ground
aquatint. In either case the essential characteristic is that of white spaces
surrounded by ink, in contrast to mezzotint's black dots and dashes. A
reticulated grain which is much finer than aquatint and yet extremely clear
through a glass may be collotype (53h), while a very fine aquatint grain
which nevertheless remains obstinately blurred or soft through the glass is
likely to be aquatint photogravure (38a).

183–185 *upper row* Spirit-ground
aquatint (5×).

186–188 *lower row* Dust-ground
aquatint (5×).

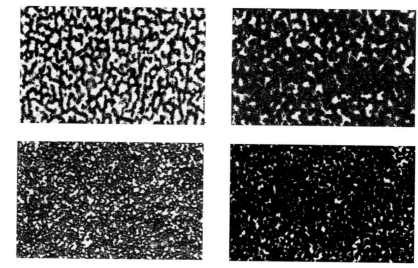

c Stipple engravings

The basic method of varying tone in a stipple engraving is to have the 189–
stippled dots smaller and further apart for the pale areas, larger and closer 191
together as more depth of tone is required. By this simple means,
anticipating the smaller and larger dots which create the process halftone
images of the twentieth century, the engraver or etcher could achieve quite
rapidly the most delicate gradations of tone. In the pale areas he would often
use single dots, but for darker tones the surface of the plate could be covered
more quickly with the larger and visibly repeated pattern of blobs laid down
by the mace-head or *mattoir*.

189–191 Stipple (5×).

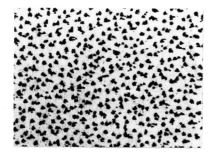
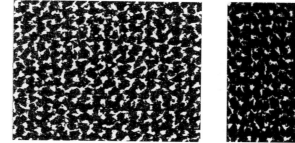

192–194 Chalk lithograph (5×).

d Lithographs

195 Lithotint (4×).

Light and shade have usually been created in lithography by using the rough surface of the stone to provide lighter or heavier stippling, the difference depending on how hard and for how long the lithographer works his crayon into the surface of the stone. Although the ink pattern in chalk lithography may in some ways resemble stipple engraving, it will never have the regular quality of the intaglio method. However a true stipple technique was also sometimes adopted in lithography, using pen and ink to dot the surface of a smooth stone, and this method was to become a popular way of creating tone in chromolithography. But the soft rounded quality of lithographic stipple is easily distinguished from the more angular dots of the intaglio version.

192- 194 95

Lithography is also capable of one comparatively rare tonal technique, lithotint (19d), which is unlike anything else in printing, being close in appearance to patches of wash painted on in watercolour.

195 77

e Woodcuts

Of all printing methods the woodcut (together with the linocut and others of the family) is the least well suited to suggesting tonal areas. Its nearest attempt was in a version of the engraver's crosshatching, but to achieve this a diamond of white had to be scooped from each intersection to suggest the crossing of diagonal black lines. Such was the skill of the craftsmen who cut the blocks that areas of this kind do often look to the eye like true linear crosshatching. The trick, through the glass, is to follow a single line and to see whether it does have a convincing linear sweep or whether it contains unexplained excrescences, gaps or sudden changes of width and direction.

196 197

196 *below* Crosshatching in an engraving (25×).

197 *below right* Crosshatching in a woodcut (25×).

Any of these will suggest that it is a woodcut or wood engraving rather than an intaglio print or a lithograph, where the black lines really have been created as single strokes of the burin, needle or pen. Even at an enlargement both examples look quite like true crosshatching if one concentrates on the white spaces. But try following the diagonal lines instead. They are genuine lines in the engraving, but are broken fragments in the woodcut.

f Wood engravings

198 The tonal solution in interpretive wood engraving, from variation in the width of parallel white lines to variation in the size of dots left between intersecting white lines (5×).

The wood engravers of the nineteenth century continued, with great skill, the laborious procedure of imitating linear crosshatching, but they also added their own version of stipple. This was better suited to the medium, for it involved cutting parallel white lines in two directions across a tonal area in such a way as to leave larger or smaller squares of wood in the block's surface, to print as larger or smaller dots. Once the eye is refocused, to see the engraved white lines instead of the untouched black dots, it becomes clear that this is a technique entirely in keeping with the method of wood engraving. Though mechanical in appearance, it enabled the relief printers to produce a more finely graded range of pale tones in book and magazine illustration than had previously been possible.

198

g Engravings, etchings and drypoints

199 The characteristic tone from the burr thrown up by the lines in drypoint (6×).

Crosshatching was the nearest approach to a tonal method available to engravers and etchers. It was at least a method natural to their linear medium, and was capable of anything from pale grey to almost solid black. The so-called dot-and-lozenge technique, with a stippled flick of the burin in the middle of each diamond, was an early attempt to break up the stark monotony of crosshatching.

196
200–
202
32

Drypoint, though a purely linear medium, is capable of an extremely rich tone, deriving from ink held in the burr of lines scored close together. It is an effect which will last for only a few impressions, because the burr becomes worn away in the process of inking, wiping and printing.

199

Equally vulnerable is the pale tone sometimes achieved in a drypoint by lightly scratching the surface of the copper plate with a bundle of fine needles or other such delicate abrasive.

200–202 Tone achieved in line engraving by crosshatching (5×).

h Collotypes

The reticulated collotype grain is very like aquatint except that it is much 203 finer, rarely being visible to the naked eye. That in itself is enough to distinguish it from the traditional aquatint, but through a strong glass certain other differences become evident. In the pale areas of an aquatint the 183 entire mesh of lines will still be visible but they will be uniformly faint. By 186 contrast, in similarly pale areas of a collotype (here, the left side) the network itself will vanish, leaving only a few small but quite dark fragments of line to provide the tone; in the darker areas the full pattern of lines will appear, but the intensity of the lines will vary suddenly within tiny patches, an effect impossible with an aquatint stopped out by hand. The reason is that collotype is a photochemical process and so is capable of reflecting every tiny shift of tone in the original which is being reproduced. The only other process capable of this while using a fine aquatint grain is photogravure (38a). However, the subtleties of aquatint photogravure depend upon the reticulation remaining somewhat blurred and unclear in all parts of the image, contributing to gradual changes of tone, whereas the collotype ink pattern is nearly always clear. If a collotype is looked at through the 30 × microscope, with its own built-in light, the ink will gleam with exceptionally bright highlights which make it look almost like enamel. This seems to be a characteristic shared by no other process.

203 Collotype grain (20×).

i Photogalvanographs and ink-photos

Photogalvanography uses an extremely coarse collotype reticulation as the 204 basis for an intaglio plate. Photogalvanographs will rarely be found, but the emphatic quality of the grain combined with intaglio characteristics will make them recognizable. A similar grain printed as a transfer lithograph, and usually therefore more blurred and spotty, will be an ink-photo. 205

204, 205 *below and below right* The coarser version of the collotype grain used for a photogalvanograph (intaglio) and for an ink-photo (planographic) (6×).

206 *above* Tone achieved by means of black-lined paper (6×).

j Line blocks and line photolithographs

These photochemical processes, in common with all other purely linear methods of printmaking, had to use subterfuge if they were to suggest tones, for they were capable of printing only black or nothing. The earliest solution was grained paper (33h), enabling artists to seem to draw tonally while in 206 fact using no greys. Later, the more common method was the addition of manufactured tints, available in varying intensities (63b).

k Relief halftones, halftone offset lithographs, gravures

These halftone photochemical processes were made possible by the cross-line screen (74). In relief and planographic printing this resulted in dots of differing size on the printed page, and the two methods can be easily distinguished by the firm edge and the squashed ink rim of each dot printed relief, as opposed to the soft edge and flat ink of the planographic version. The much more subtle process of gravure does without the variable size of dot but uses instead the special intaglio capability of having differing depths of ink. A pale grey area is once again the best place to find the pattern of grey squares separated by a grid of white lines, resulting from the separate etched pits and from the ridges which keep the pits apart and enable them to retain the ink.

207

208

209

207 Relief halftone dots (30×).

208 Photolithographic halftone dots (30×).

209 Gravure halftone cells (30×).

l Mechanical tints

In both relief printing and offset lithography an area of tone will sometimes consist of evenly sized and spaced dots. This is a mechanical tint (63c), in contrast to the true halftone which has been achieved photographically with the cross-line screen and where the dots vary in size according to the tones of the image being reproduced.

210, 211

Anyone inserting a background tone in a computer document (selected from the grey-scale) is using a modern version of the mechanical tint. If printed by inkjet, the patterns most commonly used for the purpose are delicate and irregular, similar to the grain of collotype (40). Laser printers tend to produce tints of a more traditional kind, with rows of evenly sized dots. Each will have a slightly spiky edge, and the laser characteristic of small specks of black toner in the white areas (57g) will usually give the game away.

212

213

210 Relief (30×).

211 Photolithographic (30×).

212 Inkjet (25×).

213 Laser (25×).

54 VARIETIES OF FACE

Among the traditional methods of printmaking, the most likely choices for portraiture have been engraving (Figures 214, 215), mezzotint (Figures 216, 217), stipple engraving (Figures 218, 219) and lithography (Figures 220, 221). During the nineteenth century portraits on the text pages of books or magazines will usually be wood engravings (Figures 222, 223).

214, 215 Line engraving (1.1× and 4.7×).

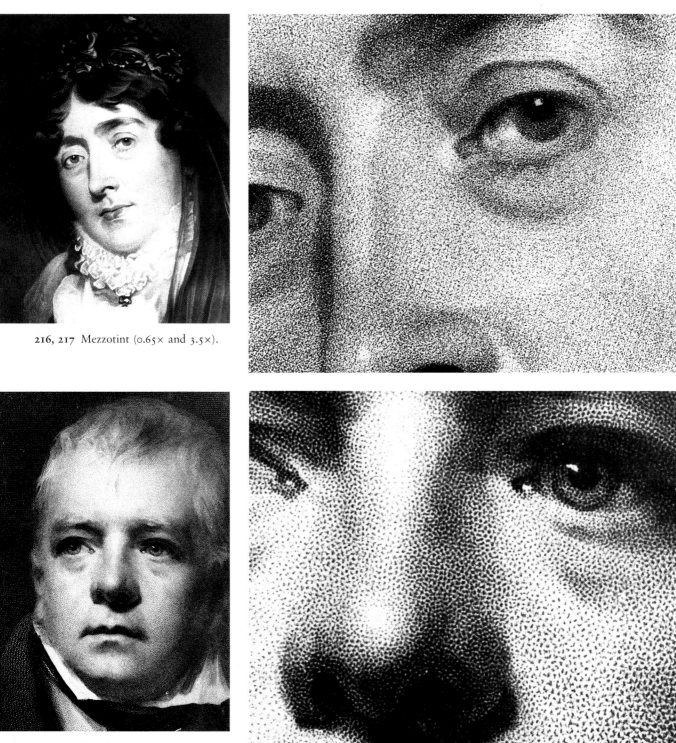

216, 217 Mezzotint (0.65× and 3.5×).

218, 219 Stipple engraving (0.85× and
4×).

220, 221 Lithograph (actual size and
4.5×).

222, 223 Wood engraving (0.85× and
4.5×).

55 DIFFERENCES

a Relief, intaglio or planographic?

This is the basic and most important single question in identifying any printed image, but the quickest clue may lie in the paper rather than in the ink. Is there a plate mark (50)? – a likely sign of intaglio. Is there embossing (59a) on the back of the paper, caused by shapes within the image? – an almost certain sign of relief.

How the ink lies is the next question. Choose a small detail of the image, either near the edge or isolated in a large area of white. Through a strong glass, does the ink appear to be squashed to the edge of the printed area, leaving a darker rim (51a)? This is an almost sure sign of relief printing. Choose a strong dark line. Does the ink seem to rise up from the paper, somewhat like rust (51b)? This is one of the main characteristics of intaglio printing. Find a line which looks to the eye much paler than others. Through a glass is its paleness an illusion, caused by white spaces among specks of ink? Or is the ink itself genuinely paler, a shade of grey rather than black? If so, this will be a sure sign of intaglio, the only method intrinsically capable of depositing differing depths of ink. (A similar but different effect can derive from the lowering of a wood block, 51d.)

The darkest parts of a monochrome image can be very revealing. Choose the area which seems nearest to a solid black. If it is indeed solid, is it hard to imagine anyone drawing such a shape? Is it easier to imagine the white areas around being cut away? And are there perhaps white specks or fine white lines within such a black area which could have been removed with knife or engraving tool? All these are signs of relief printing. Or is the solid black, on closer inspection, made up of single lines or patterns of ink marks drawn very close together, or of lines drawn across each other as crosshatching, in a probably unsuccessful attempt to prevent any small spaces of white from surviving between them? If so, this will suggest intaglio. The only true solid black in intaglio printing is that of the mezzotint (53a), but here the black will merge imperceptibly into paler tones in a manner very different from the sharp black edges of relief printing.

There is one final test in a solid black area. Does it have clear white lines within it which are not hard-edged, like those in a relief print, but are crumbled-looking, as if caused by the scratch of a sharp point on a soot-blackened white stone? This is one of the few unmistakable signs of lithography, the main planographic method.

This has been the first mention in this section of the planographic techniques (which at this stage can include screenprinting), and the reason is that the very absence of relief or intaglio characteristics will often provide the first indication that a print may be planographic. The essential quality of a planographic print is flatness, both of paper and of ink, whereas it is the non-flatness of paper and ink in relief and intaglio printing which give them, in different ways, their most immediately recognizable characteristics. Even so, a flat appearance will not in itself prove conclusive, for relief and intaglio

75

prints can seem flat – from a plate mark being trimmed away, or a weak impression, or bad paper.

Unintended ink marks can sometimes provide clues. Intaglio plates often acquire small accidental scratches in the surface of the metal; these will pick up the ink and will print as extremely fine and often very faint lines, quite unlike anything in either of the other methods of printing. A similar accident in lithography is when a piece of grit damages the surface of the stone while it is being ground level before use. The grinding is done with a circular action, so the resulting scratch may appear as a curving white line through an area intended to print black. Another lithographic hazard is the gradual weakening of the ink-resisting quality in the non-printing areas of the stone, with the result that blotches of ink, clearly not intended, appear on the print – a common misfortune known to lithographers as scumming up.

Straight white lines through parts of an image may suggest one particular kind of relief print, a wood engraving. The reason is that end-grain boxwood was available only in fairly small pieces. For large wood engravings in the nineteenth century the procedure was to bolt several small squares of box together, and any gap between adjacent surfaces will result in an uninked line.

If no positive indication of any one method has yet been found, it becomes necessary to analyse the type of line (52) or tone (53) composing the image. If a print is finally established as planographic, the next possible area of confusion will be between a lithograph and a screenprint (55q).

b Woodcut or wood engraving?

The difference is basically between a block cut on the plank edge (woodcut) and one cut on the end grain (wood engraving), but the easiest clue may be the date. Before the second half of the eighteenth century it will be a woodcut (5); from then to the late nineteenth century it is likely to be a wood engraving (6); in the twentieth century each medium has been used by artists, the woodcut for broad effects, often making much of the natural grain, and the wood engraving with precisely cut white lines and very clear-edged shapes. A finely engraved line in white will always indicate a wood engraving rather than a woodcut, for the graver cannot be successfully used for such delicate effects on the plank edge. Many of the smaller white areas in a wood engraving will have been made with a single scoop of the graver, whereas in a woodcut they are more often the result of at least two cuts (one each side) with a blade, and the resulting difference in the image may well be noticeable.

c Wood engraving or line block?

Wood engraving is the likely answer before 1880; it could be either of the two from 1880 to 1900; and a commercial print will normally be a line block after 1900, while an artist's print will be a wood engraving. The distinction is that the white spaces in a wood engraving have been engraved away, whereas the black lines or areas in a line block have been drawn. The basic difference of origin is likely to show up in at least some part of the image and may provide the only basis for a decision. Crosshatching may also give a clue. If it is as

224 The white spaces in a wood engraving (12×).

225, 226 White spaces which are either too vaguely shaped or too perfectly regular to have been achieved with the graver, implying that the black lines were drawn and the print is a line block (12× and 10×).

227 Signs of a graver in a line block, reducing the drawn lines on the right to a succession of dots (5×).

perfect as in Figure 226, the black lines must have been drawn and therefore the answer must be a line block.

Line blocks were often finished by hand, and the clear white lines of the graver slicing through black lines of very different character may well provide an indication, for if the image had been wholly created with the graver, as in a wood engraving, the engraved lines would not be so out of character. Even so, there will be many occasions when the two are indistinguishable. To give an extreme example, if a wood engraving has been well photographed and reproduced actual size in a twentieth-century book as a line block, there will be no visible difference beween the original and the process reproduction.

d Line or halftone?

The basic question is whether the image appears to the eye to be composed entirely of black and white (line) or to contain shades of grey (halftone). The distinction can therefore be applied to the manual prints – aquatint and mezzotint, for example, constituting halftone methods – but in practice the terms line and halftone are used almost exclusively of process prints,

228, 229 A suitable subject for line treatment – a woodcut – printed also as a halftone (3×).

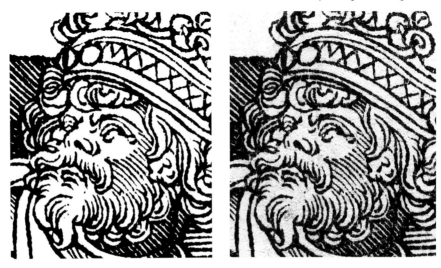

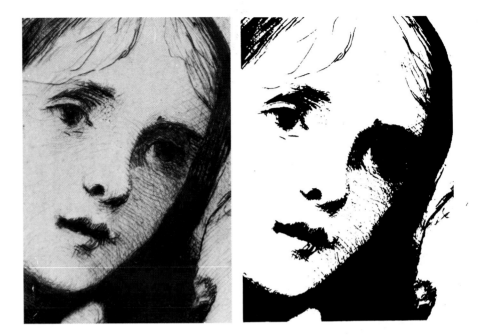

230, 231 A suitable subject for halftone treatment – a drypoint – printed also in line (2.5×).

distinguishing between those images which use a screen (halftones) and line subjects which do not require one. It is only necessary, therefore, to look at the image through a glass and to see whether it is composed of the dots or other repeated artificial shapes which result from the use of a screen (74). A woodcut, with hard edges, is a natural subject for printing in line; a screen would cause a blurred effect. Different treatment is required for a drypoint, of which all the delicate tonal details would be lost if treated as a subject in line but which can be quite realistically printed with the help of a screen. Among the three common methods of printing modern illustrations, the difference between line and halftone applies only to process printing in relief and offset lithography, for gravure is an exclusively halftone process, the screen extending over the entire plate and making the clear edge of line work an impossibility (49d). 228, 229 230, 231

e Engraving or etching? The difference between the typical engraved and etched line can be demonstrated (52b–c), but with practice the overall look of an engraving or etching will suggest the method to the eye more immediately and perhaps more reliably. An engraving and an etching on a similar subject after drawings by the same artist were published, in 1658, in the same book. The details have been chosen to provide closely related subjects as interpreted by the engraver and by the etcher. The characteristics which emerge are the much more formal and artificial lines of the engraving as opposed to the freedom, genuinely akin to drawing, of the etching. A useful analogy is to imagine the surface of the paper as a thin layer of snow on a frozen pond. The engraver is limited to making lines with the edge of a skate; the etcher can draw with a pointed stick. 172, 173 234- 243

f Etching or drypoint?

The drypoint engraver has a freedom close to that of the etcher except that he must force his point through the surface of the copper. His characteristic line will therefore be more nervous, scratched or scored into the metal with differing degrees of violence, compared to the relaxed line of the etcher. It is, in origin, the difference beween slash and corrosion. The heavier drypoint lines will reveal the characteristic furry edge, which is different from the thin 233 film of ink beside the line sometimes achieved in etching by *retroussage*. The 232 palest lines in a drypoint are likely to be fainter than anything in an etching (assuming each is a good impression), and a drypoint may occasionally show a very faint tonal effect where the surface of the plate has perhaps been scratched with a bunch of needles or with an emery pencil. Such details may also, of course, be added in drypoint to an etching.

232 *below* The ink teased by *retroussage* out of etched lines (7×).

233 *below right* The ink held in the burr of drypoint lines (7×).

g Copper engraving or steel engraving?

Here, almost more than in any other point of identification, there will be cases where it is impossible to decide, even though typical examples of each are easy to recognize. The period of confusion is only from 1820 onwards, for any intaglio print before that will be on copper (except for a few etchings on iron in the early sixteenth century). Between 1820 and 1860 it became increasingly common for small line engravings to be on steel, while larger prints still tended to be engraved in the more congenial copper. After about 1860, with the introduction of steel-facing (13*b*), the engravers could revert to copper and add the harder surface before printing, such prints being also commonly classified as steel engravings.

It is sometimes said that the easiest way to identify a steel engraving is in the closeness of the ruled lines, as in the sky, a rating of about 5 lines to the millimetre suggesting steel. This is true in general but is not entirely reliable since in the early years of the nineteenth century, before the use of steel, it 246, was becoming increasingly fashionable to produce small prints with very 247 finely engraved detail. Steel plates merely met this demand more effectively.

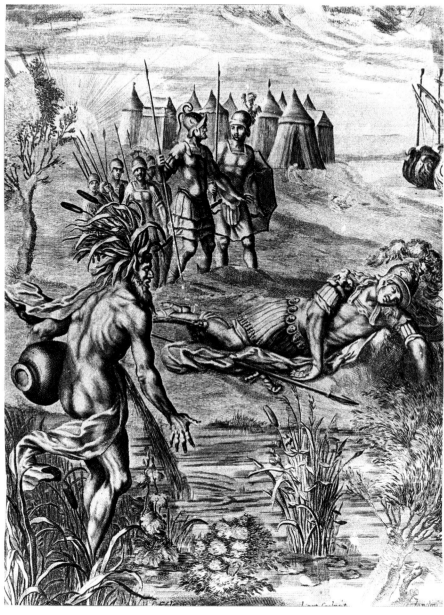

234–238 Part of an engraving after Frans Cleyn (0.65×), 1658, with four details (3×).

239–243 Part of an etching after Frans Cleyn (0.65×), 1658, with four similar details (3×).

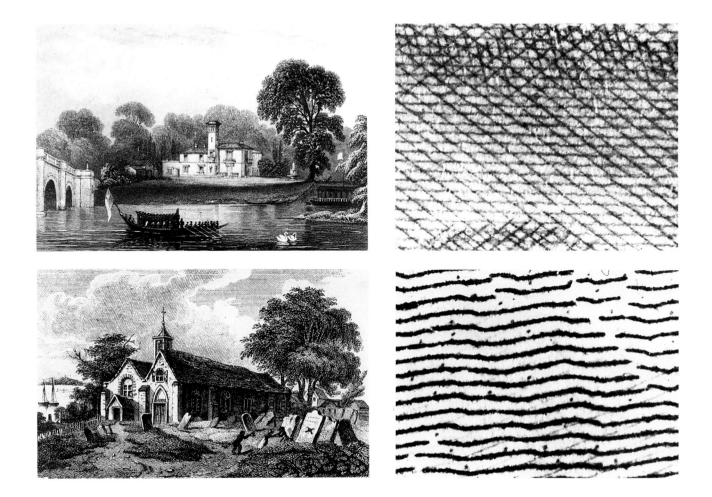

244, 245 *top* A steel engraving of
*c.*1840 (actual size), with a detail of the
sky (15×).

246, 247 *above* A copper engraving of
*c.*1820 (actual size), with a detail of the
sky (15×).

The more reliable sign of steel is in the lightness and delicacy of the pale
lines. The hardness of the metal meant that it was possible to use a much
finer and shallower line without it wearing away in the printing. Steel-
engraved lines therefore retain clarity and firmness while being thinner and
fainter than their counterparts in copper. A shimmering pale grey became
for the first time a possibility in line engraving, and it is this that provides the
most recognizable characteristic of steel beside the heavier and warmer
mood of copper. In a party of traditional wedding guests, the gentleman in
grey tail coat and top hat stands out from those in conventional black much
as a good steel engraving does among copper engravings, providing less
intensity of tone but a greater subtlety and elegance.

244,
245

h Soft ground etching or crayon manner engraving?

These will only be confused because each imitates a chalk or crayon
drawing. Through the glass they can be immediately distinguished. The soft
ground etching has a genuinely random broken line, exactly like a crayon
line on rough paper. The crayon manner engraving, by contrast, imitates
such a line by deliberate runs of separate dots achieved with the roulette.

248

249

248 Soft ground line (4×). 249 Crayon manner line (3×).

i Soft ground etching or chalk lithograph?

This is one of the most difficult of all detective problems. The confusion arises with only one type of lithograph, the chalk lithograph, and the reason is easy to understand. Each of these two prints derives its texture from the pressure of a broad and soft drawing instrument. In a soft ground etching the pressure of the pencil on the paper causes only some of the soft ground to be lifted from the plate. In a lithograph the pressure of the chalk on the roughened stone causes the grease to adhere to the peaks in the stone's surface. In both cases the weight of the artist's hand will control the size of the patches of ink, and thus the density of the line. With more pressure, more of the soft ground will be lifted: with more pressure, more of the areas between the peaks in the stone will receive grease. The result is so similar that only the basic differences between surface and intaglio printing will settle the matter. A plate mark will argue for a soft ground etching, and a good impression should show the encrusted intaglio look in the ink of the darker lines (51*b*). The lettering may provide a clue, for the soft ground etching will have either engraved or etched letters in contrast to lithographic equivalents (49*b,c*). The intensity of the ink will be another reliable guide, soft ground being capable of lighter and darker tones of the same ink, impossible in lithography. And a date will help, for soft ground etchings were much more in use up to about 1820 than after that time, the reason being their very similarity to a lithograph. With the arrival of lithography (common for pictorial work only after 1820), artists had at their disposal an easier method of achieving the same effect.

If there seems to be no way of deciding, look through a glass at any blank areas either within the image or just outside it. It is possible that there may be scratch-like ink marks, thin and clear but probably extremely faint. These could only have been made by scratches on the surface of an intaglio plate and they will prove that it is a soft ground etching.

146–
149
150–
152

j Mezzotint or aquatint?

250 The border of a mezzotint (5×).

251 The border of an aquatint (4×).

These are sometimes confused, largely because they are the two most common forms of tonal intaglio prints. They could not in fact be more different. Mezzotint is capable of areas of solid, even black, impossible in aquatint. It will usually have a steady gradation between darker and lighter tones, whereas aquatint will often show sudden transitions, reflecting the edges of areas which have been stopped out. In the pale grey tones a mezzotint will reveal its characteristic threadbare quality, where the criss-cross structure of linear dots left by the rocker begins to show through. By contrast an aquatint will reveal, in these pale areas, the fine network which constitutes its grain. At the most basic level mezzotint consists of dots of black (each one an ink-bearing pit left by a tooth of the rocker) while aquatint consists of islands of white surrounded by rings of ink (each being where a blob of resin protected the copper from the acid, the ink lying in the groove formed by the action of the acid around that blob). The lines made by the teeth of the mezzotint rocker will often be seen projecting round the edge of the image where they have been imperfectly burnished away, whereas the aquatint tone is likely to come to a firm edge, often emphasized by an etched border.

k Original intaglio or photogravure?

From the 1850s it was possible to reproduce earlier etchings and engravings in line photogravure, and from the 1880s stipple and tonal intaglio prints could be reproduced in tone photogravure. It will often be almost impossible to tell an original etching from a photogravure except by such indications as the paper, because in each case the line is indeed etched. An engraving is less likely to cause confusion, for the lines of the photogravure reproduction will lack the clear edges of the engraved original, having the slightly more broken quality of etching. The intaglio prints most often reproduced in the late nineteenth century were stipple engravings, and the method was aquatint photogravure. The clue here will be a very fine aquatint grain appearing within each stippled dot.

l Screened photogravure or gravure?

Nearly all photo-intaglio plates with a cross-line screen are rotary-printed gravure, often with a false plate mark added to suggest a manual origin. But occasionally craftsmen and artists have used the cross-line screen instead of an aquatint ground to create a tonal photogravure plate for printing on the hand press. Only a genuine plate mark (50a–b) will identify such a print as being screened photogravure.

m Steel engraving or stone engraving?

Steel engravings (13) were extremely common in the mid-nineteenth century whereas stone engravings (19f), in use at the same period, were comparatively rare. The fineness of the lines in a stone engraving, combined with the somewhat mechanical appearance caused by drawing with a sharp point, will often make it resemble a steel engraving. But it will lack the two intaglio characteristics which give a good steel engraving its special quality – the shimmering delicacy of the pale greys, where the faint lines merge to the eye in one continuous tone, and the corresponding richness of the darkest areas.

Judged by these specifically intaglio standards the stone engraving, for all its own delicacy, will retain the essential flatness of a lithograph. The lines may have visibly broken edges, where the needle has scratched into and crumbled the stone.

n Steel engraving or transfer lithograph from steel engraving?

In each case the original image has been created on an intaglio plate. In the former it has been printed in the normal way on the rolling press. In the latter an impression has been taken on transfer paper on the rolling press and that impression has been transferred to stone for printing as a lithograph. The nature of the lines will therefore be the same, but a very recognizable difference will be in the way the ink lies. The lithograph will lack both the raised-ink effect of the intaglio print and the difference in intensity between dark and light areas. The lines in the lithograph will also tend to blur or break up because of the transfer, in many cases acquiring blotchy edges and sudden gaps.

o Stone engraving or transfer lithograph from steel engraving?

Since the image in each case has been drawn with a sharp point, there will be the same immediate similarity as between the original steel engraving and a stone engraving (55m). However, the transferred image will be more easily distinguished, for the lines will tend to have a blotchy or even positively untidy look through a glass, compared to the firmness of the lines in a stone engraving.

p Collotype, lithograph or screenless offset lithograph?

Collotype is such a delicate medium that it can easily be confused with the more subtle among the other types of print. (Its differences from the intaglio methods, aquatint and photogravure, are described in 53h.) A very fine chalk lithograph and the modern screenless offset lithograph will present similarities to collotype because all are planographic and because each depends on a random ink pattern to achieve the gradations of tone in the image. It is in the nature of this texture that the clue will be found. The lithograph and the screenless offset lithograph use the peaks of a roughened surface to hold the ink, whereas collotype relies on the network of crinkles in dried gelatin. The former will therefore show a pattern of tiny dot-like irregular shapes of differing sizes, while collotype will reveal a more regular structure of wormy little lines. Any lettering below a collotype image will often be relief, because collotype is ill suited to text material, but words below a lithographic image will almost certainly have been printed at the same time by lithography.

134, 135 132

 In three-colour work the collotype grain will be most easily identified in the blue (cyan) ink.

q Lithograph or screenprint?

There is little danger of confusion between screenprints and lithographs in the chalk style, for screenprinting is not well adapted to imitate the tiny irregular specks of ink which are held on the peaks of a roughened stone. The difficulty comes with lithographs in the smooth-stone tradition, excellent for line work, stipple and solid tints. Even here there may be little problem

with the majority of screenprints, for the ink used has often been so thick that it seems more like paint, coating the paper as if it were a skin or an emulsion, with a visible rim where one colour ends or overlaps another.

However, thinner screenprinting inks in recent years have meant that some screenprints do now look astonishingly like lithographs. There may be a few specific hints which will help. It is possible in a screenprint to print white ink over another colour – a certain indication that it is not a lithograph, where pure white will invariably be the paper showing through. Similarly, it is only in a screenprint that fluorescent ink can be used. A screenprint is far more likely to make use of the rainbow effect (66c), known to screenprinters as blending. Finally, in some screenprints a hint of the mesh fabric can occasionally be seen at the edge of patches of ink, or even on the ink surface.

r Gravure, relief halftone or offset lithograph?

The three processes which between them account for nearly all twentieth-century books and magazines are easy to tell apart through a glass of about 10 × or through the 30 × microscope. A first indication will be the letters of any accompanying text (49d). However, it is not always the case that the illustrations have been printed by the same method, so the next step is to choose a halftone image and to look at the dots of the screen. 268 270

Choose an area where two different shades of grey merge. Are the dots all of much the same size but of differing intensity, usually appearing square in shape and separated by a grid of straight white lines? Or are the dots of greatly differing sizes? The former is characteristic of gravure, and the ink in the dark areas will submerge the white-line grid entirely, becoming solid grey or black. The latter may be relief or offset lithography. In either case the black dots will begin to merge at their circumferences when approaching the dark areas, thereby forming a reverse effect of round white dots surviving in areas of black. (There are exceptions to this rule about dots in gravure being all of the same size, for they will vary in either invert halftone or in the recent development of engraved gravure – see 39f. However these processes, limited to magazines and packaging, are most unlikely to be found without printed text of some sort, where the edges of the letters will already have signified gravure.) 252

252 The square ink pits and white-line grid of the gravure screen (15×).

The distinction between relief halftone and offset lithography depends on how the individual dots look. In the former each will have a clean edge with the characteristic ink rim of relief printing, often most noticeable at the point where the dots just begin to merge into each other. In offset lithography each dot will have a blurred edge, but the ink will lie evenly within the dot. 253 157 254 158

253, 254 The cross-line screen in letterpress (*top*) and in offset lithography (15×).

All three methods have been used in colour printing, though gravure less than the others. In pale areas, where the dots of colour remain separate, relief halftone and offset lithography can be distinguished by the same characteristics as in monochrome. (The squashed ink rim of relief printing will usually be easier to see in the cyan dots than in the magenta or yellow.) Gravure has one characteristic which is very noticeable in the paler areas of images in colour, and it is caused by the doctor blade scooping most of the

ink out of the shallower cells in the surface of the cylinder. The result is a hollow square or circle (easily mistaken at first for the squashed rim of relief printing), or even an open U or V or C left by just three or two sides of the recessed cell. While highly confusing at first, these shapes – impossible in the other two methods – soon become a useful indication of gravure in colour printing.

The possibilities in modern colour magazines are virtually limited to offset lithography or gravure, and the effect will be very different through the 30 × microscope. In a very pale grey area the dots of offset lithography will show up much like soft-edged snowflakes coloured red and blue; in modern gravure the equivalent dots will seem more like coloured bubbles, or distant balloons, each with its own white highlight.

s Colour printed relief or planographic?

Confusion will mainly arise among nineteenth-century colour prints, since there was a continuing rivalry between the relief methods of chromoxylography and chromotypography, and the planographic method of chromolithography.

The easiest short cut is to look at the back of the paper in the image area. Is there any sign of embossing? This will be a sure sign of a relief print, but should not be confused with the darker inks of a chromolithograph showing through to the back of the paper and so appearing sometimes to be embossed. The outlines of any strong detail in the image and the outer edges of the entire printed area are the two most likely places to reveal embossing on the reverse of a chromoxylograph. Absence of embossing should not be taken as conclusive, since the paper may be too thick.

If there are any words below the print, they are likely to provide another quick indication. It should not be difficult to tell whether they are printed relief or planographic (49, 51), and in the vast majority of cases the image will have been printed by the same method.

The next reliable clue will be the shape or nature of the ink marks in any one colour. Are they in any way sharp-edged or even linear? This will suggest the outline left by the graver and so will imply a chromoxylograph. The most frequent sign will be thin parallel lines of a lighter colour within an area of tone, where the graver has cut grooves in the darker block so that the lighter colour printed beneath shows through in the gaps. Sometimes an impossibly perfect and delicate area of crosshatching will suggest at first that the graver could not possibly have scooped out such small and regular interstices, but on closer inspection the lines in the two directions will be found to be of slightly different colours. Immediately it becomes clear that this is a characteristic sign of a chromoxylograph, for each of the two blocks has been very easily engraved with straight parallel lines which when overprinted form the crosshatching. By contrast the marks in a chromolithograph will tend to be soft-edged and even rounded, consisting literally of a gentle spotted effect in one very common form (28d), for each mark must have been individually drawn or painted or else transferred to the stone in the dotted pattern of a Ben Day tint (63b).

85, 87

98 95

Late in the nineteenth century colour printing by either relief or planographic methods will often include the most delicately random textures (63*a*), so the linear or rounded shapes of the ink marks will no longer necessarily provide a reliable clue. However one small detail will often identify the chromolithograph. Are there tiny printed dots of any of the colours just outside the area of the image itself? This can easily happen in a chromolithograph, for any unwanted speck of grease on the flat stone will print. It is unlikely to happen in a relief print, where the block outside the image will have been engraved or etched deeply away. Specks of dirt can just as easily reach the printed sheet in either method, but these will most often be black. Unwanted dots in any of the other colours are more likely to have been printed and therefore will be a more reliable indication of a chromolithograph. 106

I have left to the end the most basic test of a relief print, that of ink squash (51*a*). The reason is that the darker inks in a chromolithograph can often exhibit something very similar to ink squash when printed above other inks or on heavily coated paper. On such occasions the ink may form a rim at the edge of a printed area, collecting there much as pigment does at the edge of a patch of hand-colouring (64*b*). Once warned it is fairly easy not to be misled, for the effect when viewed through a strong glass is not precisely that of squash, with its hint of great pressure. Small isolated patches of colour in a relief print will often reveal conclusively the relief characteristic of being actually punched into the paper, looking as though heavy pressure has squashed the ink to the edges – as indeed is the case. In a chromolithograph the ink will appear more to have drifted to the sides, as if a sticky coloured liquid has been spilt and has dried on a white non-absorbent surface.

t Colour woodcut or colour wood engraving?

The basic difference is between images cut on the plank edge or engraved on the end grain, as described for monochrome prints (55*b*), but the two will often be easier to tell apart in colour. The colour woodcut will tend to go for broader effects, similar to washes of colour, sometimes showing the grain of the wood. The colour wood engraving is more likely to mix the colours in intricately overlapping details. Except in the limited and early form of the chiaroscuro print (21), colour woodcuts are virtually limited to Eastern prints, particularly Japanese, and to artists' prints of the twentieth century. By contrast, colour wood engravings were one of the two main reproductive processes in nineteenth-century colour printing (in the form of the chromoxylograph, 23*b*–*d*) but have been little used since. 80
82
84-
87

u Colour relief etching, chromoxylograph, chromotypograph or colour line block?

From the 1840s through to the twentieth century, colour relief printing progressed through these four stages. The earliest method, that of manual relief etching, was experimented with from the time of Blake in the 1780s (mainly for monochrome work in his case) to Charles Knight in the 1840s. It was the forerunner of the chromotypograph and eventually of the colour line block, since all three methods used acids to etch down the non-printing areas of a metal block. Chromoxylography intervened, from the 1840s to the 88

1890s, because the skills developed by the engravers in producing monochrome wood engravings were more reliable than the relatively untried metal technology in the delicate matter of preparing the separate blocks for colour printing. Metal blocks made a comeback from the 1860s through their ability to provide more delicate tints, the resulting prints being referred to here as chromotypographs (regardless of whether the metal blocks were used in combination with wood-engraved blocks or on their own). By the early twentieth century the relief halftone could provide more simply the tonal colour effects of which the chromoxylograph and the chromotypograph had been capable. Their natural successor for less elaborate purposes was the colour line block.

The distinction between the various forms depends on how the separate colours within the image were originated. The hard edges and white lines of wood engraving (see 23c for their appearance in colour printing) will be a relatively easy indication that some at least of the colours were achieved in that form. Even these blocks were likely to have been metal by the time of printing, because of the practice of stereotyping (71), but this change of material will not alter the appearance of the ink on the paper. Origination in metal will usually account for those characteristics of the image which could not have been produced by the graver. In the first half of the century the signs will be the softly curved edges to the printing areas, achieved by stopping out in the manual process of relief etching (24a). From the 1860s the clue will be any delicate random texture (42a) which could only be the result of acid on a metal block; such textures, either on their own or combined with any indication of wood-engraved blocks, will identify the print as a chromotypograph.

The term chromotypograph could be extended to include all colour prints from metal blocks where no halftone screen has been used. However, there is a clear distinction to the eye between the nineteenth-century version where the blocks were prepared by hand with a wide range of delicate textures and its twentieth-century successor, familiar mainly from comic strips and advertisements, where the colours are in mechanical tints. In this book the former are referred to as chromotypographs and the latter are called colour line blocks. Inevitably there will be borderline cases.

v *A la poupée* or multiple-plate intaglio?

The distinction here is between colour intaglio prints from a single plate at a single impression and those using two or more plates for the different colours. In a print inked *à la poupée* the colours will be seen to merge and to make a third colour wherever two different inks are adjacent, for the inks were sharing the same intaglio grooves in the copper plate. In a multiple-plate print, patterns of two or more inks can overlap and intertwine without any colour change, except where there is overprinting at the exact intersections. A multiple-plate print will also have more than one plate mark (50a), but printers are sometimes so accurate with their register that this may not show up as a clue.

56 THE PLEASURE OF ODDITIES

Even after the basic identification has been established, there will often be intriguing questions as to what has gone into the making of a particular print. Here are three prints which reveal the pleasure of oddities.

Figure 255 looks at first glance very much like a page of photographs stuck into an album, in spite of the brutal trimming of one into an L-shape, and the letters at the bottom mention only 'Photos by J. Sawyers, Kendal'. The print comes from a volume called *The Camera Series: Album of Views of the English Lakes*. It dates from around 1890, a period when the public wanted photographs but only the more sophisticated printers were as yet using the new process methods which made possible the reproduction of a tonal image (as a collotype, a tone photogravure or a relief halftone). Ordinary printers were relying still on the traditional methods, and closer inspection reveals that this album page is in fact a hand-drawn lithograph. The detail shows what has happened. The printer's craftsmen have set about reducing a monochrome photograph into separate patches of black, three different greys and the white of the paper, giving five tones from four stones. Their method was exactly that of the chromolithographers, interpreting a painting in four or five colours, and the print is therefore a chromolithograph in greys. To add to the false impression that these are actual photographs pasted in, the printer has left a white strip (the paper) round each image, like the border of a photograph, and has printed a pink tint outside these borders to suggest the paper of the album.

Figure 257 is an illustration from a book of 1847 about Glasgow. The image appears to be a steel engraving but the ink lies very flat on the paper, so a lithograph by transfer from steel (20c) is the obvious diagnosis. The letters below the print confirm that it comes from a stable where such a device was probably commonplace: 'Allan & Ferguson, Lithographers, Engravers & Draughtsmen, Glasgow'. The rectangular tint is also quite normal, making it a tinted lithograph by transfer from steel. The ornamental framework is achieved by medal engraving or anaglyptography (62), slightly less mainstream than the other methods. But the image sits so precisely at all points within this frame, and other views in the book fit equally well within quite different frames, that this cannot be a case of old steel engravings being pressed into service. Messrs Allan & Ferguson must have procured or commissioned a series of ornamental scroll frames done as low reliefs in plaster which could be turned, by means of the medal-engraving machine, into *trompe-l'oeil* lines on the steel plate. The plate was then passed to the engraver, and in the space left clear within the frame he engraved the view. Very pretty steel engravings could have been printed from the plate as it now stood, but for this particular edition Allan & Ferguson pulled a proof on transfer paper, transferred that to stone for printing on the lithographic press, and added the buff tint in the normal way from another stone.

Although the central part of Figure 258 looks like a traditional stipple

255

256

257

258

255, 256 *above* The lithographer's attempt to suggest a page of photographs (0.25×), and a detail showing the hand-drawn shapes and dots which make up the image (5×).

257 *opposite, above* A tinted transfer lithograph in a medal-engraved border (1.1×).

258 *opposite, below* A collotype invitation card based on an engraving with calligraphy (0.3×).

VIEW OF GLASGOW FROM THE GREEN.

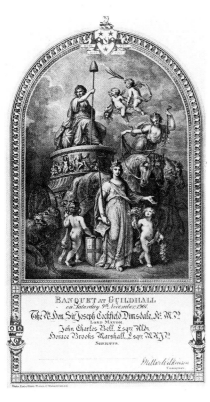

engraving, the date (9 November 1901) and the calligraphy raise an early and an easy warning. The thin band of printed tone which extends outside the border of the image will suggest collotype (40), and a glance through the glass does indeed reveal the characteristic collotype grain. But what, then, has actually happened? The answer must be that when the Rt. Hon. Sir Joseph Cockfield Dimsdale planned his banquet at the Guildhall in London, he told his art director to provide an invitation card which would be both spectacular and yet apparently traditional. The art director did him proud, though almost certainly at the cost of cutting up a genuine eighteenth-century stipple engraving. Even if this engraving of Britannia already had its present arched shape (relatively unlikely), it was still necessary to cut out a section at the top to make way for Sir Joseph's coat of arms. The mutilated print was pasted down, the arms and the decorative border were painted in, and then the artwork was sent to a calligrapher to add the lettering. Finally the finished object had to be sent to Millar Wilkinson to add his signature, by which time the entire splendid creation was ready to go before the printer's camera to be turned into an image in reticulated gelatin for printing as a collotype. To make the result seem more like a traditional intaglio print, an entirely fictitious plate mark was then added by blind embossing (50b). It only remained for the calligrapher to fill in each guest's name by hand on the line provided, and the invitations could go out. I have little doubt that the guests, while unaware of just how much had gone into Sir Joseph's invitation card, felt that the lavishness augured well for the banquet.

57 IS THE IMAGE PRINTED?

This may seem an unnecessary question, for in the majority of cases a print is quite obviously a print. But there are various borderline cases which can cause confusion, particularly when the paper has been trimmed to the edge of the image.

a Photographs A photographic print is one made by the action of light on silver salts or similar ingredients. In our own century this light-sensitive material has usually been held in an emulsion on the surface of the paper, and it is this emulsion – particularly in its glossy form – which gives most monochrome photographs their characteristic look, very different from an image printed in ink. However, various nineteenth-century photographic papers held the light-sensitive substances by absorption within the paper itself. It could therefore be uncoated, of the type used for conventional prints, and this is where confusion begins. The danger becomes greater when the photograph is itself reproducing a conventional print.

Once suspicion is aroused, there are two certain ways of recognizing a photographic print. In a photograph the image is never on the surface, but is always either within the emulsion or within the paper itself; with a print the image, being formed of ink, is always on the surface of the paper (even though the paper may on occasion absorb some of the ink, to the extent in some colour prints of its showing through at the back). Following on from this, every image made from printer's ink must at some magnification reveal a clear-edged pattern or structure in which the ink is deposited, for that has also been the structure by which the ink was retained on the plate before transfer to the paper. In some part of the print an identifiable hard edge between ink and paper will sooner or later appear. In a photograph there is never such an edge. The pigmentation of the photographic medium is capable of imperceptible changes from pure white all the way to pure black, and every change of tone – however abrupt to the eye – will therefore seem gradual through a strong glass. Even apparently quite sharp details will obstinately refuse to come into focus when seen through the $30 \times$ microscope.

Black-and-white postcards (76) provide a useful context in which to test the difference between photographs and prints.

b Chalk or crayon drawings These are unlikely to be confused with the print which specifically imitates them, the engraving in the chalk or crayon manner (52e), which will show the very mechanical dotting of the roulette. There may be more danger with a soft ground etching (52f), though here the encrusted intaglio look should distinguish the print. The most difficult choice will be between a drawing in rather greasy crayon on a rough paper and a lithograph drawn in lithographic crayon on a roughly grained stone (52g), for the crayon will only stick to the raised points of the paper just as the lithographic crayon does to the raised points of the stone. The main clue is in the nature of printer's ink. Through a glass it does have a look different from crayon (more stark, more like something that has been deposited on the paper rather than rubbed into it), and with experience this becomes easier to identify. Another indication is whether the tiny patches and dots of the image coincide with the surface texture of the paper: if they pick up the grain of the paper the image must be hand-drawn, because the ink dots in a print derive from the surface of the stone and bear no relation to the paper.

c Line drawings Certain drawings in pen and ink may at a glance be mistaken for etchings (52c), and can more easily be confused with a lithograph done in the pen-and-ink method (52g). Most inks from a pen nib dry unevenly on the paper, some parts of the line showing darker pigment and others lighter in the manner of a watercolour wash, and this is visibly different through a glass from the way printer's ink lies. A very heavy ink, such as India ink, will sometimes lie on the paper as evenly as printed ink. In such a case another clue may help. Drawn ink covers the paper completely within the inked line: printer's ink almost invariably has many tiny breaks within a line in which, when viewed through a $30 \times$ glass, the white paper shows through. If the drawn ink is thick enough to lie really flat, its complete coverage of the paper may provide the only clue that it is not printed.

d Charcoal drawings It can sometimes be easy to mistake a tonal charcoal drawing for a mezzotint (53a), since each method involves solid black areas merging imperceptibly into lighter tones. The pale greys will give the answer. In a mezzotint the threadbare criss-cross pattern left by the rocker will be visible in those areas through a glass, whereas charcoal can provide a genuine pale grey which seems no more than a faint darkening of the paper.

259, 260 Detail of a woodcut, *c.*1550 (*left*) and the same detail from a xerox of the woodcut (30×).

e Wash drawings in ink These can be mistaken for aquatints (17), the type of print developed specifically to imitate them, but again each will be easily distinguished in the pale grey areas. Wash laid on with a brush covers every bit of paper within the washed area; by contrast the aquatint tone is made of the reticulated aquatint ground (53*b*) and so through a glass shows up as meandering lines of ink on the otherwise untouched white paper.

Another possible area of confusion is with a lithograph where the image is formed largely by lithotint (19*d*). Each patch of lithotint will have a rim similar to a hand-painted wash, but it will usually be more stark in appearance and the reticulation or spotting within a lithotint area will also differ from the more bland tone of a painted wash.

f Drawings confused with collotypes Being the most subtle of modern photochemical processes, collotype will reproduce all drawings or light monochrome washes in a very convincing manner. The clue is, as nearly always, in the pale grey areas, where the reticulated pattern of collotype (53*h*) will most easily be seen. Also it is impossible for any part of the printed area to remain totally white in the collotype process. As a result the image will always extend to a clear rectangle or other similarly precise shape, however pale it may seem at the edges, this being the line at which the film has been masked out. (Oddly enough, this subtle tone will usually vanish and seem pure white when viewed through a glass.) It is inconceivable that a wash drawing should come to such

precise edges, and there will also often be patches of white within the image which have not been passed over by the painter's brush.

One potentially confusing situation, giving a drawing what seems like a rectangular tint, is when it has at an earlier stage been within a mount, exposing all but the outer margin to the yellowing effect of light.

g Xerography (laser) and inkjet Xerography (electrostatic printing) is the process used in photocopy machines and in laser printers (2*c*). It is by now the likeliest pitfall in identifying traditional prints in monochrome. Images printed originally in a single black ink (woodcuts, 259 engravings, line or chalk lithographs, wood engravings) can be convincingly reproduced in xerography, since it is 260 the contrast between the extremes of dark and light that creates the xerographic image. But this is true only to the eye. Through a glass (for safety's sake the 30× microscope) the signs are unmistakable.

The black lines of a xerox image are made up of thousands of tiny dust-like grains of pigment which have rushed into the charged areas of an electrostatic field before being fixed by heat to the paper. An exact analogy, at a rather larger scale, is those photographs of letters formed on the ground by pigeons which have flocked into the areas charged by the advertisers with corn. As with the pigeons, there will always be a few specks of pigment which are not quite in line and it is these deviants which give the method away.

Inkjet is more suited to reproducing coloured images (dealt with in 79*e*), but it too will provide a monochrome reproduction that is convincing to the eye. However, the way the black ink is sprayed on to the paper means that lines and letters will have a much softer edge than in an original print, or indeed than in a laser print. This softness, becoming jagged under high magnification, will be the identifying characteristic.

h Rubbings There is an Eastern tradition of pictures made by rubbings from surfaces carved in relief, and there is in the West the more limited custom of brass rubbing from church monuments. The results of either can look in one sense like printed material, because there will be, as in relief printing, an embossing or a difference of level between black and white areas in the paper (59*a*). However, the black areas in a rubbing will be raised (the white spaces having been pressed down into the recesses

of the carving and not taking the greasy crayon because of lack of resistance), whereas in relief printing the black areas are pressed into the paper. Moreover, the rubbed black crayon will tend to reflect the patterned texture of the paper surface in a way that does not occur in printing.

i Airbrush and stencil During the twentieth century images were created by applying ink or paint in a fine spray to areas defined by means of stencils, the airbrush being the most common spraying device. The evenness of the texture may suggest printing, but the spray will result in a lack of hard edges; and there will often be a very gradual fading away of a solid colour into tiny specks of pigment which is uncharacteristic of printing. Monochrome printed images were also sometimes coloured in this way.

58 ORIGINAL OR REPRODUCTION?

A great deal is written in books on print collecting about what can be considered an 'original' print. This question is a strange hybrid – a philosophical problem stimulated by commercial considerations – for its urgency derives from the financial value of some prints rather than others. The easy solution has been to say that the artist must have worked on the plate or stone himself for the print to be classed as original, but the use by modern artists of transfer and photographic methods has blurred this dividing line. Fortunately this book is concerned only with how each print was created. In that area hard and fast distinctions are possible, and they do help to throw a little light on the broader question. The consideration of how a particular image was achieved in ink on a specific sheet of paper suggests three clear categories.

a 'Originals' If a print is on paper of roughly the period when the block, plate or stone was created, then the print itself is a straightforward and 'original' object of its time. The image may not be original – it may be a craftsmanlike reproduction of an oil painting, or even a copy by another hand of a Rembrandt etching done perhaps with intent to deceive – but the print itself is by any standards a true printed object of its period.

b Restrikes A potentially more confusing area is an engraved or etched image of the eighteenth century which seems to be on paper of the nineteenth or even twentieth century, but this too will be a genuine version of the original print if it has been printed from the same plate. As such it is merely a very late impression, known technically as a restrike. It is often considered that there is something immoral about printing new impressions from old surviving copper plates, but this has always been a basic part of the print business. It was a nineteenth-century innovation to limit artificially the size of editions by specifying in advance the maximum number of impressions. Old plates made up every intaglio printer's stock in trade, like a publisher's backlist. Before the introduction of steel-facing (13b) such plates were likely to show wear quite quickly if too many impressions were taken, but there should be no further deterioration in restrikes printed since the mid-nineteenth century. There are three national printing establishments (in Italy, France and Spain) which produce new impressions of a large range of old prints as required.

The same principle holds good for woodcuts or wood engravings printed from old blocks. It is much less common in lithography, where the chemical image on the stone will deteriorate with time and the stone itself is awkward to store.

c Reproductions The third category is process prints, where photography or electronic scanning has been used to recreate in a printed version an image already existing in another medium. The original image in such a case may be a photograph, a painting, a drawing, or even – the cause for confusion and potential indignation – a print. The resulting process print may seem to be an etching but be in fact a line photogravure of an etching. It may look like a woodcut but be a line-block reproduction of a woodcut. Those two cases will be among the hardest to identify because each uses a printing method identical to that of the original, with the result that the modern quality of paper may well provide the first or only indication that the print is not what it seems. Other examples will be easier to spot because of some disparity between the original and the reproduction. Thus a wood engraving reproduced without a screen by offset lithography will show the line characteristics of its relief original but the flat ink quality of a planographic print. The easiest type of reproductive print to recognize will be one using any of the various process screens (74) or showing the characteristic grain of collotype (53b). The hardest will be a modern screenprint reproduction of a painting (see 45f).

59 EMBOSSING

Embossing is the raising of parts of the surface of a piece of paper. It may be done for different reasons and in different ways.

a **Relief** Reverse embossing is an automatic element in relief printing, because the printing areas press down onto the paper and therefore appear embossed on the back of the paper. The most familiar example is the text which shows through as raised letters on the back of the pages of most books printed in the traditional letterpress method.

This natural result of the pressure involved in relief printing can be used for decorative purposes without ink, when it is known as blind embossing (59d). Or it can be combined with ink on the embossed side, as in the grander forms of invitation card or visiting card in the old days. In the method known as die stamping these were printed between two plates, one showing the letters in relief and the other having them intaglio, or recessed. The ink was in the intaglio lines, and during printing the relief letters forced the paper up into the corresponding recessed areas, causing it to be at the same time embossed and inked. (The old desk-top machines for blind-stamping a sheet of writing paper with one's address, by depressing a lever, work on precisely the same principle but without the ink.) Cheaper modern versions of invitation cards or letter headings with raised ink letters are achieved by thermography (see 107), which gives the effect of embossing by depositing a thick layer of pigment. If genuinely embossed, the card or paper will show the corresponding indentation on the reverse side.

b **Intaglio** Embossing is also a natural part of the intaglio processes in the sense that a plate mark is itself a form of embossment, and the greater pressure of the intaglio press means that it is particularly suitable for deep embossing. Modern intaglio printmakers have made considerable use of deep-etch methods to give an extra sculptural quality to the print, sometimes even to the exclusion of ink in the form of blind intaglio (18d).

c **Planographic** A lithograph will sometimes show an embossed effect where highlights have been scraped or etched away, particularly in the tint stone (27a). White patches will often seem to rise up in such prints, on occasion almost like a blister in the paper, and if properly controlled this can give an extremely convincing imitation of highlights added in chalk or gouache.

d **Blind embossing** Embossing without the use of ink has often been popular as a decorative effect on mounts or paper covers, and it has also played a part within images. The Japanese colour printers' use of *gauffrage* (22a) was particularly effective in adding embossed patterns to areas of the print representing fabric. In the West embossing within the image has mainly been used to add an overall texture, as for example when attempting to make the surface of a colour print seem more like an oil painting through an embossed pattern suggesting the canvas or even, more ambitiously, the texture of the paint itself. This device was first used on those nineteenth-century chromolithographs, reproducing oil paintings, which had varnish added to the final surface of the print and which were known as oleographs.

e **Blocking** Whereas the term embossing is used for parts of the paper or other material forced up in relief, blocking is the usual name for areas similarly forced downwards or recessed. The principle is identical; and if approximately half the surface has been either embossed or blocked, the appearance will be very much the same in either case. Blocking is standard practice on book spines; in the nineteenth century elaborate blocking was popular on the covers of cloth-bound books; in recent years it has been sometimes used to dramatic effect on dust jackets; and from time to time printmakers have borrowed the technique to embellish their images. In most of these cases the blocking has been with gold leaf or foil, though it can be done today in foils of many different colours. The method is to place the foil between the block and the surface to be blocked. When the heated block meets the surface, the pressure between the two not only causes reverse embossing but also sticks down the foil. The foil remains unattached in all those areas where the block did not exert pressure, and so can be dusted away leaving the design in gold.

60 LIFT GROUND

Sometimes in an intaglio print there will be flowing pen-like lines, or extremely finely drawn areas of aquatint, which it seems impossible to believe were achieved with the ordinary etching needle or with conventional stop-

ping-out processes. The answer is likely to be that a lift ground was used.

a Method The lift ground technique, also known as sugar lift, enables the artist to draw on a copper plate with the freedom of ordinary pen or brush strokes. The medium used is any solution containing sugar; half Indian ink and half saturated sugar has been a standard recipe. When the artist's drawing is dry the entire surface of the plate is covered with stopping-out varnish, and as soon as this also is dry the plate is washed in warm water. The water gradually reaches and dissolves the sugar, causing it to separate from the plate and to lift with it the layer of varnish. The artist now has a plate in which his freely drawn design exists in exposed copper, with the whole of the rest of the metal surface stopped out. If the lines are sufficiently fine, the plate can be etched as it is. The result will be an etching showing the characteristic lines of the pen rather than the needle. If there are broader areas, an aquatint grain will have to be added to retain the ink. The aquatint can be applied in either of the normal ways (17*a*), but will only reach the plate in the exposed areas of the design.

This combination with aquatint has been the most common use of lift ground. It is particularly valuable when only a small area of the design needs a further spell in the acid bath, since it avoids the lengthy and inevitably fiddly process of stopping out. The lift ground can be painted directly onto the plate before the laying of the aquatint ground, the likely procedure in a modern plate where the lift ground is part of the artist's conception; or it can be painted above an already existing aquatint ground, more common in the greatest period of aquatint, around 1800, when the lift ground was merely a convenient part of the craftsman's repertoire and when stopping out and lift ground would be employed on different areas of the same plate.

b In lithography The same technique has been used by artists for lithographs where the intention is to achieve an image in white. The image is drawn in the lift ground and the stone or the zinc plate is then covered with lithographic ink. When soaked in water, the ground lifts the greasy ink from the lines of the design, which will therefore remain white while the rest of the stone prints black. A version of lift ground is also normal practice in screenprinting (45*b*).

61 STATES

a Definition A print is described as existing in a different state every time the block, plate or stone is in any way altered and is then used for further impressions. At the simplest level this may happen while the image is still being created, for the artist or craftsman will sometimes pull impressions to check on how the work is progressing. He will then add further details, and the next impression will be a new state. States of this kind, before the completed print is published, are normally called proofs or trial proofs. It may also happen at any time after publication, and for a wide variety of reasons. The letters below the print may be altered to accommodate a change of title or publisher. Worn areas of a successful plate often had to be reworked to give the print a continuing though false air of pristine condition. Inclusion in a newly published volume might make necessary a reduction in the size of the image. And there are many famous examples of faces being re-engraved to adapt an old scene to a new central character.

b Methods Such alterations of the printing surface, leading to a new state of a print, are possible in all three printing methods but have been most common in intaglio. The procedure can be laborious. If a detail has to be removed and replaced with something new, the first stage is to scrape away the copper around all the offending lines – a lengthy process if any of them are deeply engraved. Next, that area of the surface of the plate has to be flattened, by beating from the back. Then all unevenness has to be smoothed away with the burnisher, leaving a blank but level area of copper. In this space the engraver or etcher can create the new details, carefully joining them up with the surviving lines all round. In a wood block it is necessary to cut out the appropriate part and replace it with a new piece of wood, a drilled hole and a circular plug being the easiest method if the area is small. On a lithographic stone or zinc plate the task consists in removing all grease in the relevant area and returning the surface to its original neutral state. In the early days of lithography this involved picking out each morsel of grease with a needle, but chemical methods soon made the job less time-consuming.

c What to look for If the change has been very slight, the problem of identification may well be limited to noticing that there are indeed differences between two impressions

261–263 Two states of the same engraving, *c.*1640 (0.6×). The paleness of the impression on the right would suggest that it is the later state, a conclusion confirmed by the detail (2×), with its traces of obliterated curls and awkward linear work in the new shoulder line.

from the same plate. If large changes have been made, the difficulty is often the precise opposite – that of believing that such different images can be two states of the same print rather than two different prints. The question boils down to whether the two pieces of paper were printed from the same (but altered) piece of wood, copper or stone. With line engravings of the eighteenth century the matter is complicated by the fact that printers often plagiarized each other's images, deliberately trying to engrave a new copper plate as an exact replica of an existing print. The only way of deciding is to choose a small area of the two prints which appear to the eye to be identical and then to look at them very closely through a glass. Pick some lines of an unusual shape or interaction. Are they exactly the same in the other print, allowing only for any slight variation caused by wear and tear or by different inking of the plate? If so it is the same plate, and the visible differences elsewhere in the images mean that they are two states of the same print. But if these tiny details are differently drawn, then one image is a copy of the other and you are dealing with different prints.

d Variations in size Any variation in the size of the image will strongly suggest a different print if dealing with relief methods (unless the change is due to the printing surface being cut down on one or more sides), but this guideline is less reliable with intaglio prints. The reason is that for intaglio the paper is heavily dampened before passing through the press. Each sheet will shrink as it dries out, and this shrinkage may in some cases alter the size of the image from one impression to another by as much as 2%. The same is true to a lesser extent for lithographs. They were often printed slightly damp, and the scraper (1c) could also have the effect of stretching the paper in one direction.

e Earlier or later? In deciding which of two intaglio states is earlier, the easiest indication is likely to be more signs of wear in the later state, resulting in a paler impression or even the vanishing of the faint lines in unaltered parts of the image.

261
262

If this test provides no indication, or if the prints in question are relief or planographic, the place to look will be around the edge of an altered area. In the earlier state the lines will be genuinely continuous. In the altered state they will either make an attempt at continuity, not likely to be successful in every case, or they will break and start again where the new work begins. And there will often be ghostly traces of imperfectly removed lines.

263

62 RULING MACHINES, MULTIPLE TINT TOOLS, MEDAL ENGRAVING

Mechanization was introduced into the making of prints from the late eighteenth century, when the first ruling machines were developed. The term is used here to cover any machine designed to create evenly controlled lines, whether straight or curving, on any printing surface. (The same term was used in the past for a machine which ruled lines in ink for account books.) These devices were valuable to printmakers in improving the regularity of the parallel lines which were widely used as background tone or for the sky in line engravings, with the added advantage 264 that they also speeded up the work.

For intaglio printing the machine passed a needle across the hard wax ground of the copper plate, exposing a line which could then be etched. Screw controls made it possible to rule the next line an exact distance from the first, a smaller gap leading to a darker tone. Soon the machines were improved to provide parallel curved lines. With the arrival of lithography it was easy to adapt the same idea for the ruling of lines on the stone, and similar effects were achieved manually in wood engravings with multiple tint tools – gravers which had from two to five cutting points, to cut parallel grooves at one stroke. Linear shading effects in the nineteenth century will always have been achieved by devices of this sort if they seem noticeably regular, as will the type of elaborate linear patterning seen on banknotes. In Figure 264 the lower lines have been laid by a ruling machine and the upper ones added by hand.

265, 266 Reproduction of a medal by anaglyptography, 1844 (actual size), and a detail showing how the ruling machine interprets contour (6×).

264 Typical cloud effect in a line engraving, combining the ruling machine – at the bottom – with etched lines put in by hand (10×).

The most fanciful extension of the ruling machine was an invention of the 1820s which became known as medal engraving or anaglyptography. By linking the needle on the plate to a needle passing over an uneven surface, a machine was able to convert any object in low relief, such 265 as a medal, into a pattern of printed lines which uncannily 266 suggested the contours of the original object. Plaster reliefs could easily be moulded as templates for the machine, and decorative borders of this type became popular for a 257 while.

63 PREPARED, MANUFACTURED AND MECHANICAL TINTS

Any design student in the past knew how much time may be saved by prepared textures, intended for transfer to selected areas of a piece of artwork and consisting of lines or dots or a wide range of almost random patterns (an example is reproduced as Figure 3). Such devices are about a century old and have been much used by printers, though they are now being made obsolete by computer graphics.

a Prepared tints In the early days of process printing, it became possible for the individual printer to prepare his own tones for use as line blocks. For example he could put rough sandpaper on a block and then duplicate it in metal by means of stereotyping (71), thus achieving a relief printing block with a surface of tiny raised dots which would print as a sandpaper grain. This could be turned into a background tint for selected areas of a colour print merely by gouging away the surface of the block in those parts where the particular colour was not required. Alternatively, areas of solid tone in a block could be textured by direct aquatinting of the metal surface, reducing the printing area to a pattern of ever smaller dots according to the length of the bite. Some parts of the block could be made to print the same grain more faintly by bringing those areas a fraction below the surface of the rest, so that they would print with less pressure in a version of the ancient device of lowering (51d). Or, by the Gillot method (33c), any printable tone from another medium – that of reticulated gelatin, for example (73e) – could be transferred to the block as an acid resist, thus achieving the same texture in relief printing; in the same way tonal areas could be hand-drawn on textured paper for transfer to the block; or ink could be spattered onto the block before etching, to achieve a totally random pattern of varying sized dots in a version of the method long used in lithography (19e). Finally, once photography was involved, tonal patterns from any source could be borrowed for use in any of the three basic printing techniques, and could even be reversed photographically between negative and positive, meaning also between relief and intaglio. From the second half of the nineteenth century, for this reason, tone as such ceases to be a reliable indicator of the printing method and one has to fall back on the basic question of how the ink lies (51).

b Manufactured tints In 1879 a New Jersey printer by the name of Benjamin Day patented and began to market 'shading mediums' for chromolithographers. Of these Ben Day mediums the most commonly used was a simple stipple, but an advertisement of 1887 reveals that there were then more than a hundred varieties available, in line, stipple, grain and other textures. The company provided transparent flexible sheets, one side of which had been embossed with the required pattern. The lithographer inked the embossed side with transfer ink, and then held it face down in a frame just above the lithographic stone. The key outline of the image had already been transferred to the stone (in a red chalk which contained no grease and so would not print) and this outline was visible through the transparent shading medium. The craftsman merely had to rub with a blunt point above those areas to be tinted. In doing so he pressed the embossed pattern down onto the stone and the ink was transferred. Light pressure would transfer just the tips of the embossed areas, making small dots if the pattern was stipple. Heavier pressure would force more of the flexible pattern onto the stone, providing a denser tone. It was argued that such textures would look natural since the originals, on which the embossing was based, had all been hand-drawn. In fact they have a very mechanical look. The ordinary late nineteenth-century commercial chromolithograph, sometimes to the eye but certainly through a glass, will seem to have an advanced case of measles. Exactly the same method of transferring patterns from a Ben Day medium would later be used in the making of line blocks, the dots of ink in this case functioning as areas of acid resist (33c).

c Mechanical tints With photographic methods of block- and plate-making it became possible to add entirely regular and mechanical areas of tone in any of the printing methods. The term 'Ben Day' stuck as a general name for such a tone, particularly as used up to the mid-twentieth century in the making of line blocks. It became normal for the commercial artist or cartoonist to draw his linear illustration in ink and then to shade it roughly with blue crayon in those areas where he wanted the printer to add a tone, specifying in the margin its relative density. The printer would have sheets of transparent film on which the tone ranged from tiny dots (very pale grey) through heavy dots to solid black. He would cut out patches of these and stick them on the areas specified by the artist before exposing his photographic negative. Pale blue does not register in normal black and white photography, so no

107

trace of the artist's shading would survive in the printed version.

Mechanical tints did not invariably consist of dots. They could be made up of lines or squiggles or any other repeated pattern, though dots have been the most common. A dotted Ben Day will look similar to a genuine halftone, but the distinction will be clear on closer inspection. In a mechanical tint the dots will all be of the same size, as well as being in a regular pattern. In a true halftone the grid will be regular but the dots will vary in size.

210, 211 207, 208

In colour prints the artist can specify the intensity of any of the four colours in a particular area of his image (the intensity depending on the size of the dots and being expressed in percentage terms), so that by judicious mixing almost any colour is available even on this mechanical basis.

64 COLOUR PRINT OR COLOURED PRINT?

a **Intaglio** Intaglio prints are the only class in which it is immediately easy to distinguish printed colour from hand-colouring. The reason is that in every intaglio print, with the single exception of the dark areas of a mezzotint, the ink is held in visible lines or dots or patterns. If the colour is printed it will only appear in the appropriate pattern, leaving patches of white paper between the dots or other shapes of coloured ink. On the other hand, if the colour has been washed on, it will cover the paper fully, leaving no white.

90–93

112

b **Relief and planographic** It is with these prints, capable of printing areas of solid tone, that separating printed colour from hand-colouring becomes harder. Colours put in by hand tend to have a more recognizable quality than those which are printed, so the first step in analysing such a print is to look for signs of hand-colouring. This will usually have been done in watercolour, of which the most visible clues are as follows (most can be clearly seen in a detail from a hand-coloured etching by Rowlandson): an uneven quality, tending to dry in some part of the wash in a blob of thicker pigment and therefore of darker colour; a similar darkening in a thin rim along the edges of a patch of colour; and the likelihood that a wash of colour will either fail quite to reach the exact edge of an area being filled in or else will overlap it, such an overlapping area of

114

112

wash often having the curve of a brush stroke and being most noticeable at the straight edges of a rectangular image area. Dark pigments will usually show the various signs more clearly than pale ones. (For those cases where paint other than watercolour has been used, see 64e.)

c **Stencils** One type of colouring which will obscure the brush-stroke edges is the use of a stencil. This method was employed for colouring some of the earliest woodcuts in books of the fifteenth century, and had a minor revival for book illustration in the first half of our own century. The colour will approximate more to the solid blocks of printed ink, but will still show the signs of watercolour paint in places. For example, if a broad brush has been used to wash paint in one stroke over the spaces cut in the stencil, straight lines of pigment will often be visible where some of the bristles have released more paint than others. The use of a stencil will also be suggested if any colour is consistently out of register in one direction, the stencil having been placed slightly off the mark.

113

Another use of stencil is with an airbrush or similar device in the method sometimes called spray printing, which gives a more even tone to the colour than is likely to be achieved with conventional hand-colouring and provides a slightly furry edge to each area of colour (different in appearance from printed edges), where the spray has crept beneath the stencil.

d **Printed colours** If traces of hand-colouring are found, the next step is to check whether any of the colours are printed. This is a matter of looking for characteristics precisely opposite to those of watercolour: a noticeably level tone in large areas of plain colour, which is extremely hard to achieve with a wash; also perhaps occasional tiny flecks or blobs of unprinted white paper showing in such areas of plain colour, unlike the flooding wet wash of watercolour; precise but often non-linear or randomly shaped edges to patches of colour, it being hard to imagine such an edge being achieved by a brush stroke, which will give either an even sweep or a positively jagged effect where the hairs of the brush have lifted separately; an unnaturally straight edge to a single colour at the border of a rectangular image; and patches of colour either fitting into their allotted space with uncanny accuracy, or being visibly shifted a fraction to one side or the other while retaining the correct shape.

Some of these signs can be seen in Figure 114, where the red is hand-painted and the other colours are printed. The

114

even tone of the printed yellow is very different from the painted red, and the green overlaps the line of the girl's back and head in a regular manner which proves that it is printed slightly out of register. Both the green and the brown inks help by showing in many places the squashed ink rims of relief printing, and the colour follows a firm line at the bottom of the image in a manner almost impossible to achieve by hand.

It is important to remember that more than one printed colour needs to be found (counting black as a colour) for a print to class as a colour print. If the image has letters printed below it, they will usually have been printed at the same time and the ink of the letters can be sought out as the first printed colour in the image. If there turns out to be only that one printed ink, all the rest being colour added by hand, then it is a monochrome print and will need to be identified on the evidence of that one ink alone.

A quick indication that more than one colour is printed will be pin holes at two or more corners of the paper outside the image area, or sometimes in a straight line parallel to one edge of the image. These are made by the pins which printers have commonly used as a means of achieving register (68), and register is necessary only when more than one impression is made on the same sheet of paper.

e **Opaque paint; varnish** At certain periods prints have been coloured with an opaque paint, very different in appearance from pure watercolour. One of the most common examples is the light blue gouache which was often used for the sky in eighteenth-century topographical prints. Such colours will usually be easier than watercolour to recognize as hand-painted, for they will coat or even cake the paper, obscuring the lines of the image, in a way that was not true of any printing technique until the arrival of screenprinting in the twentieth century.

A shiny appearance, often limited to particular parts of the image, is likely to be varnish, which was sometimes painted on by hand to add richness to the darker tones in a colour print.

f **Metallic colours and flock printing** It is hard to achieve a convincing gold or silver in printer's ink, so the normal solution was to print a sticky varnish in the required pattern and then to blow or dab metallic dust over the print while the varnish was still wet. This is not uncommon in expensive books of the nineteenth century,

attempting to suggest the splendour of illuminated manuscripts. The technique can always be recognized by small specks of the metallic dust clinging to nearby patches of ink or even to the paper round the borders; such specks shine out very clearly through the 30 × microscope with its built-in light. In our own century screenprinting has for the first time made it possible to print a really thick and rich metallic ink, which will leave no dust specks to either side.

Another application of the dust technique was in flock printing, which involved blowing wool or other similar powdered fibre onto the wet varnish. Printing of this kind is found, astonishingly, in a very few examples from as early as the fifteenth century; it became widely known from the eighteenth century as a technique in the manufacture of wallpaper and has been used by some artists as an ingredient in modern printmaking.

65 TINT OR COLOUR?

Any print using more than one ink constitutes an example of colour printing, but within this category there has conventionally been a separate class of print described as tinted (in particular the tinted lithograph, 27). The distinction is a useful one, for such prints have a characteristic appearance due to the colour being applied in flat tints rather than in small intermingled patches. However, as with many useful distinctions, it is hard to draw the line. A print consisting of an image in black ink against an even background of fawn is clearly tinted. But prints of certain subjects – flags, for example, or Egyptian friezes or stained glass – may use several different flat colours, none overlapping and each in effect a tint, to build up an image which will from its appearance demand to be called a colour print rather than a tinted one.

The problem is merely one of establishing a definition and sticking to it. In this book a tinted print is defined as one using flat colours to enliven an image up to a maximum number of three inks (nearly always black with two tints). Thereafter, even if the colours are used as tints, a print is described here as a full colour print. By contrast a print using only two inks, but merging them to create a broken colour effect, will be classed as a colour print.

94

66 COLOUR FROM ONE OR MORE IMPRESSIONS?

a Multiple impression The vast majority of relief and planographic colour prints have been printed from several different blocks or stones, the chromoxylographs and chromolithographs of the nineteenth century sometimes employing twenty or more for a single print. The chief sign of this will be lack of register round the margins, with patches of one colour sticking out beyond the borders of another. Pin holes at the corners, the printer's aid to register, will often have been trimmed off but if visible will prove that more than a single impression was involved. An almost certain indication of more than one impression will be colours crossing each other or overlapping without mixing. The only exception to this rule is a complex modern method combining intaglio and relief from a single plate with inks of differing viscosities (31c). With multiple-plate intaglio, very much less common than relief or planographic, there will be plate marks for each separate plate, though a careful printer may succeed in making them fall almost precisely above each other.

b Single impression Various methods have been used to achieve different colours on the same plate, block or stone and thereby to avoid more than a single impression. The most common has been the *à la poupée* inking of an intaglio plate, with different colours of ink dabbed by hand onto specific areas of the plate (26a), but there have also been equivalent devices in relief and planographic printing. If a patch of colour is sufficiently isolated on a block or stone, it can be separately inked in an exact equivalent of the intaglio *à la poupée* method. As an extension of this, certain artists in the twentieth century have made colour woodcuts from a single block with grooves cut between areas of differing colours to keep them separate in the inking (31a). A more complex version of the same idea is the compound print, whether relief (24b) or intaglio (26d), where the printing surface is dismantled for the inking of the separate pieces. The identifying characteristic in either of these cases will be a white line separating the colours. One most unusual modern way of colour printing from a single block is that of the reduce-method linocut (31b).

c Rainbow An effect of graduated colour from a single impression is possible in those methods where the ink is applied to the printing surface with a roller (relief or planographic) or is spread with a squeegee (screen-printing), and it is known appropriately as rainbow printing. Ink of two or more colours is mixed on the ink slab in an even gradation, or rainbow effect, and the roller or squeegee is charged from this. The ink will be printed on the paper in the same graded colours. Any such gradual change of colour would be impossible from separate impressions, so this characteristic will prove that at least the colours in the rainbow were from the same block, stone or screen (there may well be other colours in the same print which are not part of the rainbow, and which therefore required a separate impression). The technique is more commonly called blending or melding by screenprinters. A similar effect is possible in all modern forms of machine printing, where the ink flows from a long duct of many separate compartments onto a cylinder, and in this context it is known as split-duct printing.

A rainbow effect can often be seen in Japanese colour woodcuts. In these cases the printers applied ink of graduated colour to the block with a brush rather than a roller, but the method was intrinsically the same.

67 COLOUR SEPARATION

In multiple-plate colour printing the problem is that of breaking the image down into a limited number of colours and then of creating a separate printing surface for each colour, including on it every detail which is to be printed in that colour. A painter has a similar problem, for he too must arbitrarily interpret his subject in terms of areas or lines or dots of colour. But he can fine-tune in different parts of the picture, and a painter in oils can even adjust every tiny patch of colour as much as he wishes. The printer must go for a much more rigid analysis of the basic colours required to produce the finished effect, and apart from minor adjustments at the proofing stage the important work will all have been done before he sees any results. Before the involvement of the camera this taxing procedure depended solely upon the hand and eye of a skilled craftsman. Sections 23c and 28c give examples of how the colour separater set about his task for a chromoxylograph and a chromolithograph. This section concentrates on photographic colour separation.

Since Newton's experiments with light in the seventeenth century it had been known that any colour could be created by the appropriate combination of three primary colours. In the mixing of light these three primaries are

green, red and blue (which together will make white). In the mixing of pigments, where the colour is formed by reflected light, the scientific principles are different and much confusion has resulted. The primaries for a modern printer are magenta, cyan and yellow (which together make black). To the eye of the layman these approximate closely enough to red, blue and yellow. And so for most of us, accustomed to dealing more often with pigment than with coloured light, red, blue and yellow have become the well-established three primaries.

For reasons both of scientific elegance and of economy it became the colour printer's ideal to create a realistic image in these three primaries, perhaps with the addition of black for emphasis. In the eighteenth century there were brave attempts to separate the colours of a picture by eye into red, blue and yellow, and in the 1860s a few printers began to achieve successful results with three colours plus flesh tint for the faces. But the camera was at that time about to achieve the task with scientific accuracy.

The camera can measure the exact amount of each of the primaries in an image through a system of colour filters. The scientific law making this possible (somewhat simplified) is that a filter composed of any two primaries will absorb the light of those two colours but will let through the light of the third. Thus an orange filter (red and yellow) will cause only blue light to reach the photographic plate; a violet filter (red and blue) will allow through only yellow light; and a green filter (blue and yellow) will let through only red. It therefore becomes possible to make three negatives of the original subject, giving the exact distribution of blue, yellow and red over its surface. With this the colour separation is complete, and the problem becomes that of conveying the three inks – cyan, yellow and magenta – to the paper in such a way that they will maintain the correct balance. In modern printing this is achieved by the cross-line screen (74c).

Nowadays it is normal to add a fourth printing in black, to give more depth in the darkest areas, from an extra plate deliberately exposed to give maximum contrast between the highlights and the shadows. For special effects, or for a more perfect facsimile of certain originals, extra colours are sometimes added from further impressions – perhaps for a light overall background tint, as when imitating old yellowed paper, or to hold fine detail in a single specific colour without the overlapping dot structure of the two, three or four inks which would normally constitute it.

In recent years the electronic scan (by now familiar even in domestic use) has taken over from the camera the task of colour separation. But the principle, and the printed result, remain the same.

68 REGISTER

One of the most important technical problems for the colour printer is to achieve correct register, which means ensuring that on each successive passage through the press the piece of paper is aligned with the plate carrying the new colour. Only if the register is correct will the image appear with the colours fitting together as intended. Some degree of error in register is inevitable, which the eye accepts without noticing, and it can be useful as an indication that a colour is printed. The most immediate place where it may be seen is at the edge of a print. If one particular colour sticks out consistently beyond the others in one direction, the print is out of register. (If it sticks out at only one or two points, the originator of that plate has merely strayed over the margins.) Another indication will be a block of colour which is visibly intended to fit within a specific area, but has shifted over the border on one side and left a narrow white line on the other. In modern colour printing a rim of one of the three primaries will often be seen skirting the edge of an object.

Printers have devised a great many techniques for keeping register, but most are not relevant here in that they leave no identifying trace on the finished print. There are two exceptions. A very common method has been to make two or more holes at the corners or down one side of each plate or stone, ensuring that the holes are placed with perfect consistency in relation to the printing area of each separate colour. When the first colour is to be printed, a pin is pushed through the paper into the holes. If the sheet of paper is then successively aligned by means of pins with the corresponding holes in the other plates or blocks, the register should be correct. Another method, still in use in offset lithography, has been to have small right-angle crosses at the same point on each plate. These crosses will appear on the paper when it receives the first colour, and the task then – whether achieved by manual or mechanical means – is to ensure that the printed cross on the paper always falls exactly above the cross on each successive plate. Such crosses are intended to be trimmed off and so will rarely survive as an indication of colour printing, but the telltale pin holes of the more common method of register will often be found on nineteenth-century prints – particularly on tinted lithographs of the mid-century.

69 HOW MANY PRINTED COLOURS?

It is rarely of importance to discover how many separate inks there are in a colour print, but the matter is occasionally intriguing and certain clues are useful in what can prove a very difficult task. The 30× microscope with the built-in light will prove much more revealing than a normal glass.

a Manual prints The first place to look is round the edges of the image, where pure colours are likely to stray into the margin and can be individually spotted. Thereafter the best chance is with pure colours inside the image. In the majority of colour prints the title will have been printed at the same time as the image, and it is most unlikely that the ink of the printed letters is not also used within the image – thus providing quick identification of at least one of the inks. For an accurate count in a complex print, the colours will have to be noted down as they are identified.

The places where any two pure colours overlap also become important, for it is essential to avoid accepting their joint effect as an extra colour. Following the outlines of colour patches into an area where several are superimposed will often reveal whether any extra colour needs to be accounted for in the combination. Finally, parts of the print which seem to contain two shades of the same colour are significant, because the darker parts can only be accounted for by a second ink. Nineteenth-century printers were very fond of using two shades of the same colour, which gave them three separate tones (each on its own and the two superimposed). A fairly basic palette was two blues, two reds, two yellows, two greys and a dark brown (28c). It will often be hard to believe that a green has not been used, because an overprinting of yellow and blue produces it so easily, but it was a colour which printers for that very reason usually did without. It should be assumed to be absent unless a patch of it can be found with no blue or yellow anywhere in the vicinity.

Where some colours merge gradually into each other (in contrast to others within the image which overlap), it is likely that one of the blocks or stones has been inked in the rainbow method (66c). This is one of the occasions where the number of inks used will be greater than the number of blocks or stones. The other is when small isolated patches of colour have been separately inked on a block or stone mainly devoted to another colour. It will never be possible to prove from the print alone that this was done, but the economics of printing do mean that with very small patches of colour it was often the case.

b Process prints In relief-printed colour halftones of the first thirty years of the twentieth century it is often hard to believe that no black has been used, but many printers at the time did prefer the three-colour to the four-colour process and they achieved some very convincing blacks by mixing the three primaries. Again the natural place to look is round the edge of the image. Do any pure black dots protrude? The next place is at the edge of any area where there is a rapid change from a dark tone to a light one. In such a border region blue and black dots will be seen coexisting if it is four-colour, while in three-colour work the grid of apparently black dots in the dark tone will merge imperceptibly (while remaining part of the same grid pattern) into blue dots in the pale tone. If a title is printed under the image in blue letters, this will suggest strongly that there is no black.

70 PAPER

a Watermarks Paper provides no indication towards identifying a print except in so far as it may help in dating it, and the most obvious way in which it can do that is through a watermark. If there is one, it will be seen as a pale pattern when the paper is held up to the light. Many watermarks give the year of the paper's manufacture, which can be useful in indicating whether a particular impression has been taken some time after the date given on the print itself, though even a large difference in date will not invalidate it as an authentic example of that print (58b).

b Laid and wove paper An even longer time gap may be revealed by the type of paper used. Until the 1750s all paper was made on a mesh consisting of strong wires about an inch apart, with finer wires laid close together across them, and this pattern can be seen when paper of before that date is held up to the light. In about 1755 there was invented a method of paper manufacture using a more finely woven mesh which left no rigid pattern of lines. The two types of paper are known as laid and wove; writing paper can still be bought in either form, though the lines in modern 'laid' paper are now merely a decorative texturing of the surface. The value of the distinction in identifying a

print is that any claiming to be earlier than 1750 should arouse suspicion if not on laid paper. It may prove to be a perfectly innocent restrike (58b), but it could also be a modern process reproduction (58c) of the original print.

c **India paper** This is a very smooth paper, capable of holding the finest possible detail, but so flimsy that it is difficult to print on its own. It was used during the nineteenth century in all three methods of printing, though most commonly seen in intaglio work. A dry adhesive was spread on the back of the India paper which was placed, face down as usual, on the inked copper or steel plate. A much larger sheet of heavy paper was then laid on top and the entire sandwich (India paper in the middle) was passed through the press. The pressure transferred the ink to the India paper and at the same time fixed the paper to its backing sheet. A print of this type therefore has a plate mark in the heavier paper, with the much thinner printed sheet sitting within that plate mark. It thus appears to have a mount carrying the plate mark, something which in any other context will imply a false plate mark (50b) and a print which is only pretending to be intaglio.

d **Coated paper** This is the only other easily recognizable type of paper which can help in the very broad dating of a print. Such paper, known also in its shiniest form as art paper, has been made smooth to a greater or lesser extent by a coating of china clay. It is the paper used in the standard illustrated books of our own time and it became gradually more common during the second half of the nineteenth century, particularly for colour printing. It was first introduced in the 1830s, so a print on such paper must be after that date.

71 PROCESS, MECHANICAL: STEREOTYPING

The most important mechanical process for producing printing surfaces has been the stereotype. The system had been developed before the eighteenth century as a method by which an exact replica could be made of a page of type. Its uses included speeding up the printing of newspapers, by duplication for use on several presses, and keeping in facsimile the type for a book, in case another edition should be required, while freeing the movable pieces of type for the setting of new material. Various methods were used, but the general principle was that a mould was

taken of the page of type, into which hot metal was poured to form the replica.

In the nineteenth century this process acquired greater significance as a way of reproducing wood blocks for illustrations. The immediate benefit of the stereotype lay in ensuring that there would be no wear and tear on the irreplaceable wood block. Another advantage is made clear by a report of 1837, stating that blocks from cheap English periodicals were then being exported in the form of stereotypes to no less than seventeen countries for reproduction in foreign magazines. As the century progressed the majority of wood engravings were printed from these metal facsimiles and it was generally agreed that a well cast stereotype would print with as fine detail as the original block.

Stereotyping represented no new direction in the nature of the printed image itself. A wood engraving printed by this method remains essentially a wood engraving, and the metal of the stereotype could be worked and improved with the graver in exactly the same way as the original wood.

72 PROCESS, CHEMICAL: ELECTROTYPING

A process of very great use to the printing industry was discovered in 1839, the same year as photography. It was electrotyping, or the creation of a metal facsimile through the deposition of copper by electrolysis. Those who remember this basic experiment in school chemistry will know that copper collects gradually on any electrically conductive surface suspended in a solution of copper through which electricity passes. If left long enough (a matter of weeks), the copper will become sufficiently thick to have a rigidity of its own and it can then be separated from its matrix. Its surface will now present a reversed or negative version of the matrix. If an exact facsimile is required, a second process of electrolysis will do the trick (or, cheaper and probably more common, the making of a reverse mould of the original for use as the matrix in a single spell in the electrolytic bath). The newly created copper surface was known to the printer as an electrotype, and could be used for either intaglio or relief printing.

Electrotypes were introduced, as early as 1840, for the duplication of existing intaglio plates, avoiding wear and enabling a long edition to be printed to a consistent standard and very much more quickly (on several presses).

But the electrotype offered more exciting opportunities in terms of the creation of new images for printing. A design could now be drawn in some easily worked material, itself too soft to print from, and could be recreated down to the finest detail in copper. If the material itself was not suitable for the electrolytic bath, a mould was made in gutta percha or wax and was dusted with graphite to become electrically conductive. The electrotype became an essential part of many printing processes – providing plates from widely differing originals, whether hand-drawn in wax (33*b*) or developed photochemically on sheets of gelatin (33*d–e*).

73 PROCESS, PHOTOCHEMICAL

a Properties of gelatin All the printing processes involving photography derived from the discovery that certain chemical substances are sensitive to light, hardening where light falls on them but remaining soft and soluble elsewhere. This had first been noticed early in the nineteenth century as a characteristic of bitumen, of which the soft unexposed areas could be dissolved by benzine. Later it was discovered that more convenient water-soluble substances, such as gelatin or the white of egg, could be made sensitive to light by the addition of chemicals. The most commonly used material in the nineteenth century was gelatin sensitized by the addition of potassium dichromate, or bichromate as the manuals of the time call it. I will therefore limit myself to gelatin in giving the outline of the different processes.

An author writing in 1887 reminded his readers in homely terms of the special properties of the extract of animal bones and hides known as gelatin. 'Plain gelatin is, as every cook knows, soluble in hot water but not in cold. When soaked in cold water, gelatin softens and swells; but to dissolve it requires the application of heat.' All that needs to be added to this account is one fact less familiar to every cook, that a thin layer of gelatin cracks into a network of fine lines as it hardens and dries. These three useful properties of gelatin, together with the chemical additive which made it harden after exposure to light, were to provide all that was needed for the different processes described below.

b Gelatin exposed to full depth, with warm rinse If a layer of light-sensitized gelatin is exposed through a transparency consisting entirely of whites and blacks, with no middle tones, parts of the gelatin will become fully hardened and the rest will remain fully soluble. A warm rinse will remove the soluble parts. So if a negative is used (the white lines of the image exposing the gelatin below), it will be the image itself which remains as hardened gelatin. If a positive is used (the black lines of the image protecting the gelatin below), it will be the white spaces which become hard and insoluble. The choice of negative or positive will depend on the printing process to be used: invariably negative for relief printing, because the hardened lines of the image will serve as a resist on the zinc block, while the blank spaces between are etched down (33*f*); positive for intaglio, since the soft lines of the image will expose the copper plate and will allow the acid to bite in those areas alone (37); and either for lithography (the white areas will be washed clear in the negative process and can be made receptive to water, the black areas will be washed clear in the positive process and can be made receptive to grease). In all cases it is only a subject composed of pure blacks and whites which can be printed in this way, for the metal or other printing surface is either wholly exposed or wholly protected.

c Gelatin exposed to varying depths, with warm rinse It is possible to expose a layer of light-sensitized gelatin through a transparency containing any of the greys between white and black, and to do so for a period which allows the gelatin to be hardened almost throughout its thickness where most light falls, to remain fully soluble where no light falls, and to harden to varying depths in all the intervening tones. After the layers of soft gelatin have been washed away in warm water, the remaining film of hardened gelatin will resemble a relief map of the image, with the contours reflecting every gradation of tone. If a positive transparency has been used, the darkest areas of the image (minimum light, maximum solubility) will be washed away to a thin film of gelatin, while the lightest areas will show up as the thickest layer. Gelatin retards but does not entirely impede the action of acid, so an intaglio printer was in this way provided with a perfect variable resist for the etching of his copper plate – the acid biting fast and deep through the thin areas of gelatin (those which must print dark) and correspondingly less strongly through others. This was the method behind the two most effective of all monochrome printing processes, aquatint photogravure (38*a*) and machine-printed gravure (39).

One practical requirement of this process was that the gelatin film be transferred to another surface before the

warm rinse. The reason is that the top layer of the gelatin would be hardened all over, though to varying depths, and therefore the rinse would not be effective without the transfer. (An exact parallel to the action of light on the layer of gelatin is that of frost on a pond; the surface of the ice is flat, but the ice will be thinner where the frost has acted less, as under a tree or a bridge.) After the layer of gelatin has been transferred, and its original support peeled or washed off, the unexposed portion is on the surface – enabling it to be rinsed away in warm water to reveal the necessary contour map.

d Gelatin exposed to varying depths, with cold rinse The process starts in exactly the same way as that in 73c, with exposure through a positive transparency, up to the point where a cold rinse is used instead of a warm one. The unexposed gelatin therefore swells, instead of being washed away, and it swells in proportion to the depth of gelatin which remains unexposed in each area. The result is again a relief map of the image, but this time the dark areas are high and relatively moist while the light areas are low and relatively dry. This was to be the basis for sand-grain photogravure (38b), using the raised areas as recesses in an electrotype copper plate. For the so-called swelled gelatin line block (33e), a negative of a line subject was used. The lines of the original image therefore hardened in the gelatin, and cold water caused the white spaces to swell around them. From this matrix an electrotype line block could be formed.

e Gelatin reticulation If light-sensitized gelatin is allowed to dry in a certain way, a fine network of cracks develops in its surface. These become more pronounced where the gelatin hardens most (i.e. where most light falls), and there are several ways in which this variation in the amount of reticulation can be used as a method of tonal printing. The most direct is to use the surface of the gelatin itself as the printing surface, in the process known as collotype (40), the principle being that of lithography; the unexposed gelatin remains water-absorbent while the hardened areas of reticulation reject water but accept ink.

Once a printable image is established in this way, composed of a clear grain structure, it can also be used in other printing methods – most notably by transfer to stone for conventional lithographic printing as an ink-photo (41b). Or a large area of regular reticulation could be transferred to a metal surface as an acid resist, capable of providing a line block with tonal qualities of a kind much

used in relief colour work (63a). The reticulation of gelatin, recognizably different from aquatint grain, became a familiar feature of the printer's repertoire in the late nineteenth century.

These mainstream methods used only the patterning of the gelatin. Earlier and more complex processes had relied on the contour element of the reticulation when the gelatin was soaked in cold water. The reticulated areas, being hardened, would swell less than the exposed gelatin around them. The recessed reticulation could then be turned by single electrotyping into a relief printing surface (rarely used and not very successful), or by double electrotyping into a conventional intaglio copper plate – a method which was also quite rare but was triumphantly successful under the name of photogalvanography (36).

f Process experiments The behaviour of light-sensitized gelatin underlay not only the successful printing processes of the late nineteenth century but also a host of other ingenious but less practical ideas in that most inventive of periods. Prints by the many forgotten methods of the time will probably be impossible to analyse with any certainty, though they are likely to be based on one or other of the properties of gelatin as described in the preceding sections. A certain Mr Winstanley's technique, written about with approval in the 1880s, can stand as an example. Winstanley apparently started with a hardened gelatin relief map of his image (73c), onto which he pressed a brush-like forest of tiny needles – a sort of three-dimensional profile gauge. The needles protruded furthest into the deep areas of the gelatin map (the darkest areas of the image). Each needle tapered rapidly from a broad shank to a sharp point, giving a marked variation in the circular cross section at different levels. Having achieved a reverse relief map in these needles, Winstanley ground all of them down to the level of those which had rested on the high points of the gelatin. He was left with a flat surface, consisting of thousands of dots of varying sizes (largest in the dark areas), which he could use as a relief printing block. He had anticipated by a few years, and by a very laborious process, the system of the halftone block and the cross-line screen (34). If anyone finds a Winstanley print it will be impossible to recognize, unless he signed it, and it may well be taken for an early version of the normal halftone block. The moral is that analysing early and uncredited process prints will always be a hazardous business, even though the basic methods are common to nearly all.

g Diazo compounds In recent years new chemical processes have made possible a reversal of the long-standing technique with light-sensitized plates. Traditionally the light has always hardened the emulsion, and it has been the unexposed parts which are washed away (73c). Now, with the use of diazo compounds as sensitizers, an appropriate solvent can wash away those parts of the emulsion which have been exposed to light. This adds a considerable flexibility in processes where the emulsion is exposed to varying depths. Previously any such process involved the transferring of the emulsion to another base so that the unexposed parts beneath the hardened surface could be reached and washed away. The recent development makes possible many new techniques, as for example the partial exposure of the roughened metal plate in screenless offset lithography (41e).

74 HALFTONE SCREENS

a The principle From the start it was relatively simple to apply the photochemical processes to subjects in line. The difficulty lay in reducing any natural image, with its range of greys, to a pattern of various-sized areas of pure black – which is all that the printer's block or stone can cope with.

The problem was solved by means of thousands of tiny openings in a screen, placed during exposure between the photographic transparency and the light-sensitized printing surface. Bright areas of the transparency would transmit intense rays of light through the holes of the screen, strong enough to spread out sideways behind each hole and to expose a relatively large area of the plate. Dark areas of the transparency would transmit rays so faint that they would expose a much smaller area on the surface of the block or plate, even though passing through holes of the same size in the screen. In the final printed result these larger and smaller areas would print as larger and smaller ink marks. Being too small to appear as separate dots when seen at normal reading distance, they would successfully reproduce the darker and paler tones of the original.

b Varieties of screen This principle holds good regardless of the shape of the translucent holes in the screen. In the 1860s screens composed entirely of lines began to be used, some straight and some wavy, and linear screens of this type are still in occasional use today for special effects. The desire for a more random looking screen led to

267 The metzograph screen, based on the patterns of reticulated gelatin (8×). It is similar to collotype grain, but larger in scale and far less delicate (compare Figure 203).

adaptations of the aquatint tone (in one version even creating the screen in the traditional aquatint method, melting opaque specks of bitumen onto a glass plate so that the light could only pass around the grains). Other similar screens were based on the pattern of reticulated gelatin; a very successful version of this was known as the metzograph screen, and process prints with a screen of this type can quite often be seen today. But from the 1880s it was the cross-line screen, yielding a rectangular pattern of dots, which gradually became the standard halftone method for process printers.

c Cross-line screen This consists of a grid of black lines on a glass screen, similar to a fine metal mesh. The light passing through the mesh results in the pattern of larger or smaller dots which can be seen in nearly all modern halftone images printed in monochrome. The fineness of the screen varies according to the purpose and is defined in terms of the number of grid lines to an inch. About 70 lines is normal for rough paper, as in newspapers, while most books and glossy magazines will be found to use screens of between 120 and 150 lines. (The type of glass known as a linen-prover is marked off in eighths of an inch; it is not difficult to align the glass along one of the white lines of the grid in a modern halftone print, to count the dots in a single calibration, and to multiply by eight to get the size of screen). For very fine detail on good paper a 300 screen is used, giving an astonishing 90,000 dots per square inch. The dot structure resulting from a cross-line screen will be the same in both relief printing and offset lithography.

270

268–270 A mouth, interpreted in relief halftone, halftone offset lithography, and gravure (12×).

d Gravure screen Gravure differs from relief printing and offset lithography in that it is capable, like any intaglio process, of depositing varying depths of ink. For this reason the cross-line screen fulfils a different function in gravure. The ink has to be held in separate cells in the gravure plate, much like the cells of a honeycomb, and the screen provides the firm walls which keep these cells apart. It does this by protecting a cross-line grid on the surface of the plate from light and therefore from the action of the acid. This grid remains flat and unetched while the square openings in between can be etched down to differing depths according to the variable resist, which itself has been formed by exposure to the tones of the original subject (73c). The resulting printed pattern – a grid of white lines with inked squares in between – is best seen in the pale grey areas. In the darker areas, where the square recesses in the plate have been bitten deeper, the amount of ink will be sufficient to flood the surface of the paper and to obscure entirely the white lines of the grid.

Much gravure in recent years has lost the traditional honeycomb appearance. New methods of engraving the cylinder, rather than etching it, have made it possible for the ink dots of gravure to be round rather than square and to vary in both depth and size. The very characteristic appearance, as seen in cheap magazines and in packaging, is described in 39f.

e Invert halftone There is an intermediate type of screen process where dots of differing sizes but of the same depth are etched in gravure plates. This therefore has the dot structure of relief or lithographic screens but some of the printed characteristics of gravure. It is used only for cheap and long runs, such as packaging or magazines, where the paper will often be so rough that little of the ink structure remains. The most likely indication that it is gravure will be any accompanying text, which will show the unmistakable broken-edged characteristic of gravure lettering (49d).

f Colour Process colour printers expose a plate for each colour through a cross-line screen combined with the appropriate filter (67). One problem has been to prevent the dots of separate colours from falling in such a way as to set up an unpleasantly wavelike or *moiré* effect. Early solutions included using lined screens instead of the dotted cross-line variety. In process colour prints of around 1900 one colour can sometimes be found in lines going diagonally left, another in lines diagonally right, while the third forms a grid of colour running vertically and horizontally. The best solution was found to lie in separating the dots in a controlled pattern (by shifting the screen through a precise number of degrees between exposure for each colour), so that they fall in tiny circular groups. This effect of circular patterning is very

visible through the glass in the pale areas of almost any colour illustration in a modern book or expensive magazine, and can be seen in its simplest form, with only two colours, in Figure 108.

75 ILLUSTRATED BOOKS

A brief survey of the methods most commonly used for book illustration at different periods may help to identify the prints. See also 47.

a 1460 to 1550 In this first period virtually every book with printed illustrations used woodcuts, and for the most part they were 'integrated', in the sense of appearing on the same pages as the text.

b 1550 to 1650 Engravings now competed with woodcuts, at first often appearing in the manner of woodcuts on text pages even though this required a separate passage through the intaglio press, but later becoming used more and more as plates to be bound into the book.

c 1650 to 1790 The intaglio plate now held a dominant position in book illustration. At any part of this period the plates could be mezzotints, in addition to pure engravings or etchings, but the vast majority were line engravings (12).

d 1790 to 1820 Line engravings continued to provide the plates for most purposes, but in the more expensive works of topography or natural history the aquatint took over, frequently hand-coloured before publication. Relief blocks, bringing illustration back to the text pages increasingly in the form of wood engravings rather than woodcuts, staged a revival.

e 1820 to 1850 Line engravings were still the standard form of plate, but increasingly as steel engravings rather than copper engravings. Both they and the more expensive aquatints were threatened during this period by lithography, which began to be widely used by publishers from the 1820s for books with separate plates. Lithography also provided the first relatively common colour printing in books, in the limited form of the tinted lithograph which from the 1830s effectively supplanted its natural predecessor, the hand-coloured aquatint. Books with wood engravings on the text pages became increasingly common

in the cheaper part of the market, providing by far the majority of the smaller illustrated volumes as distinct from the quarto and folio publications with expensive plates.

f 1850 to 1900 Among books with separate monochrome plates, steel engravings and lithographs predominated until, from the 1870s, photolithography, collotype and photogravure gradually began to take over. There were also many books with photographs pasted in as illustrations. In colour plates the period saw a mass of tinted lithography, chromolithography and chromoxylography, with a smaller supporting cast of Baxter prints (from the Baxter licensees and their imitators) and a few Nelson prints. Monochrome integrated books and magazines (those with illustrations on the text pages) continued to be published in ever greater numbers, with wood engravings providing all the blocks until the commercial arrival of the line block in the last two decades, followed by the halftone block in the final years of the century.

g 1900 to 1950 In the early years collotype and photogravure remained common among art books, but the majority of books had illustrations printed relief. Because halftone blocks require very shiny paper to achieve the best results, it became normal to have the text and any line blocks together on uncoated paper (more pleasant to read) and the halftone illustrations in a section of their own on coated paper. For this same reason colour plates were often trimmed to the edge of the image and tipped in (glued, usually along just one edge) on spaces left clear in the text pages. Some magazines continued to have halftone blocks and text together on coated paper, but many were now printed gravure.

h 1950 to 1970 This was the period when gravure was used with the greatest success for monochrome illustrations in many art books, before becoming too expensive during the 1970s. There was, however, the problem that gravure will not print text satisfactorily, so the illustrations were again often kept in separate sections, interspersed with sections of letterpress text. In the most expensive productions a full integration of illustrations and text was achieved by printing the images gravure and then running the same sheets through the relief press to add the text. But integrated books can also be found where both images and text are gravure, accepting the inevitable fuzziness of the letters as a price to pay for the richness of the images.

In the early part of the period the pictures in ordinary illustrated books continued to be printed relief, as line blocks and halftones. But during the 1960s offset lithography began to make massive strides, and by the 1970s it had become the norm.

i 1970 onwards It is by now rare to find an illustrated book that is not printed by offset lithography. The introduction of photographic methods of typesetting, in place of the time-honoured metal type of the letterpress printer, has meant that there are advantages both of economy and convenience in printing the text by offset lithography. For the first time in the history of printing a process has been available which can print both text and halftone illustrations, by a single impression and to a reasonably high quality, on paper which is not too shiny for comfortable reading. In many such books the old letterpress technique has been followed of printing the colour separately on more shiny paper, though the colour plates have usually then been interspersed through the book in groups of two or four leaves, wrapped round or inserted between the monochrome sections. Recently the ultimate luxury has been becoming more common, that of having good colour integrated with monochrome illustrations on the text pages. Monochrome illustrations retain their place in most cases for reasons of economics (colour photographs are more expensive to procure and to print), but public demand calls for an increasing proportion of colour. Once it has become standard practice for a well-illustrated book to have colour images on the text pages, perfection in the technique of the illustrated book will have been achieved – just in time, perhaps, for it to be rendered obsolete by the visual display unit.

76 POSTCARDS

Most of the modern printing processes have been used in the manufacture of postcards, which can therefore provide a cheap and challenging test for the detective. They will fall into two broad categories.

Colour postcards printed since the middle of the twentieth century will almost invariably be four-colour halftones printed either relief (42f) or by offset lithography (44e). The nature of the individual dots will distinguish between them (53k). In a very few cases the colour may be gravure (43c).

Among black-and-white postcards the large majority, surprisingly, will turn out to be actual photographs (57a), the other candidates being collotype (40), relief halftone (34) or offset lithograph (41c).

While these more recent postcards provide examples of the mainstream printing methods, the printers of the first half of the twentieth century were more adventurous and their products can present some very challenging puzzles. The majority, looking very garishly coloured, will turn out to be relief halftones in black with yellow, red and blue added from either relief blocks or lithographic plates which are far from subtle in the way they distribute their colour. Sometimes they will be genuine but primitive four-colour work, filter-separated (67), but often they will have used the same monochrome negative for each block, with the blockmaker stopping out those parts not required to print in yellow, red or blue. There was also a considerable amount of crude hand-colouring.

Out of twelve colour postcards from the early years of the century, bought almost at random in a single shop and mostly for ten or twenty-five pence each, seven were four-colour relief halftones of the types described above. One was a hand-coloured collotype (40); one was a duotone collotype (44b) with a gold-dust border (64f); and one was a filter-separated three-colour collotype (44b). There was a greeting card folded in two, which had gold-dust lettering on the front with blind embossing (59d), while inside it had a line block of hand-written lettering on the left (33f) and a sepia collotype of a seductive lady on the right. (This splendid object, justifiably, cost fifty pence.) And finally there was a traditional chromolithograph in at least six colours from manufactured tints (28d), decorated with gold blocking (59e).

77 BANKNOTES AND STAMPS

a Banknotes Fine printing has long been associated with the production of paper money, largely for the practical purpose of keeping ahead of the forgers, and the modern notes of almost any country will still provide striking examples of the engraved line and of intaglio printing. Many also have elements added by other printing methods. The banknotes of the United States, for example, are entirely intaglio on the reverse side, and they give a clear example of the two intaglio characteristics – the ink in the dark lines rising up visibly from the

paper, and some lines printing much more faintly than others (1*b*). On the front side of the notes the black ink is intaglio, but the bright green of the number and of the official seal is printed relief, showing unmistakably the characteristics of ink squash (51*a*).

British banknotes are even more revealing in the wide range of techniques used. On the front of each denomination the Queen's head is printed intaglio, revealing very clearly in her hair the swelling line of the engraver's burin and the way the ink from the intaglio grooves stands up from the surface of the paper. Nearly all the larger text is also intaglio (the sections mentioning the Bank of England, and the value of the note both in figures and words).

There is a clear example of the ink squash of relief printing in the number of each individual note, seen to the right and top left below the value of the note. And the number to the top left is a useful example of rainbow printing (66*c*) in its gradual change from one colour to another.

By comparison with both the intaglio and relief on the front of the British note, the background patterns and the small text have a decidedly flat appearance through a glass, showing the relative effect of planographic printing (51*c*). That said, there may be occasional lines which do seem to display a hint of ink squash. The reason is that this is not straightforward offset lithography (41*c*) but is offset letterpress or letterset (33*j*) where the image derives from a relief cylinder but reaches the paper via a flat offset cylinder.

The back of the British notes provides one further useful example. The image of each British worthy on the right shows every sign of having been created as a relief block in the manner of wood engravings (with white lines scooped out of the black, 6*a*–*c*) but the absence of ink squash reveals that they are here printed planographically along with the rest of the reverse side.

Euros are printed with a combination of processes similar to British notes. On the front side the architectural details and the monetary values are printed in splendidly crisp intaglio, showing very forcefully the raised ink which is the main characteristic of the process. By contrast in the background patterns the ink lies visibly flat, indicating that it has been printed lithographically. Lithography also provides everything on the back of the E.U. notes, except for the individual number of each note which is printed relief.

b Stamps The world's first postage stamp, the British 'Penny Black' of 1840, was printed intaglio from steel, but since then stamps have been produced by all the main printing methods. Numerous examples can be found in any stamp collection which will reveal the characteristics of each method.

The most likely printing method of any modern stamp is stylus-engraved gravure (39*f*), the technique that best combines quality with economy when dealing with very long print runs. Unlike the rectangular grid of traditional gravure (39*b*), by which British stamps were printed until recently, the stylus-engraved version will reveal through the glass a pattern of variable-sized round dots of ink, with the middle of each scooped out to white in the mid-tone areas.

78 NEWSPAPERS AND MAGAZINES

a Newspapers Newspapers have traditionally been in the forefront of relief printing technology, making early use of stereotypes (71), and *The Times* pioneering the steam press in 1814. But in the latter part of the twentieth century British national newspapers were in the rearguard, still clinging to the old relief systems while others were changing to offset lithography (41*c*).

By the early twenty-first century nearly all newspapers in the developed world had gone over to offset lithography. For economy one side of each sheet will often be printed in black and white, reserving colour for the other side, but the trend is inevitably towards four-colour printing throughout.

b Magazines Those magazines with a glossy look and an eye on the upper reaches of the market are nowadays all printed by offset lithography (41*c*). Large circulation magazines with a cheaper cover price will often combine gravure (cheaper for long runs, 39*c*) with offset lithography (cheaper for short runs). The latter will tend to be used for sections of local interest which can be inserted in the appropriate regional edition of the magazine. The scene is too changeable for any precise examples to be of use, but magazines do make interesting testing grounds for identifying the different signs (55*r*) of gravure and offset lithography. The rough edges to the letters in gravure will always provide the easiest first clue.

79 AROUND THE HOUSE

a **Wallpaper** Many of us live with prints not only hanging on the wall but glued to it as well, for wallpaper has been one of the earliest and most important fields of colour printing. The traditional method was by hand from large wooden blocks, differing technically from Japanese colour woodcuts (22a) only in that the scale was far larger, making exact register less crucial, and the block was pressed down onto the paper from above. This process, now more than two centuries old, has been joined over the years by relief printing from cylinders, by gravure and by screenprinting. The characteristic appearance of these wallpapers is briefly described below.

Relief The traditional method of printing by hand from flat wood blocks uses thick water-based colour, in effect an emulsion paint, and each colour is allowed by dry before the next is applied. The result is an immensely thick and caked appearance, unlike anything in other forms of colour printing. The nearest equivalent to the way the colour coats the paper is screen printing (45), but there the colour, however thick, lies flat. On block-printed wallpaper it dries more like a layer of fine mud, cracking in places and with the surface pock-marked by little cavities. In some parts, where the pressure of the block has been greatest, this thick colour will sometimes show the ink squash of relief printing (51a).

Ink squash becomes a more reliable indication in the other two methods of relief printing. One, dating from the mid-nineteenth century, uses water-based colours printed from relief cylinders – originally of wood, more recently of various other substances. Since the colour is of the same distemper-like nature as in printing by hand from wood blocks, there will be an appearance of thickly caked emulsion paint much as in the older method. However, the greater pressure in the machine process will mean that ink squash more often provides an indication of relief printing.

The final relief process, flexography (33k), differs from the earlier mechanical method chiefly in the nature of the cylinder and the way the image is originated. The colour may be either oil- or water-based, but it is likely to be thinner than the colour used in the other relief methods, giving therefore a more even tone and unmistakable ink squash.

Gravure Here the effect through a glass will be identical to traditional gravure in books (39), the ink forming a honeycomb or waffle-like grid of small squares in the paler tones and then flooding the paper in the darker areas.

Screenprint Again the result is exactly as with screen-printing elsewhere (45). The colour will lie flat, like a skin on the paper, and the edges will often show a noticeable serration, resulting from the fairly coarse mesh of the screen.

Flock Flock coverings are often added to wallpapers (usually those with a design printed relief or gravure) by dusting the flock on wet varnish, as described in 64f.

b **Packaging** The packaging industry tends to be in the forefront of new printing techniques. There is a constant impulse to provide brighter and more lavish wrappings in a wide variety of materials, and the massive print runs on any item mean that even the most sophisticated techniques become economically feasible. As a result packages offer a bewildering variety of processes, many of them much harder to distinguish than the more traditional methods used on paper.

Cans Printing on tin was the original reason for the development of offset lithography in the 1870s, and it remains the method by which the majority of cans are printed today. Early printed tins reveal all the skills and stylistic devices of the traditional chromolithographers in the creation of the image. Nowadays the can is often coated first with a shiny white paint, in a process known as roller-coating, and this often causes two characterics which can also be found in chromolithographs on coated paper. One is a tendency for the ink to gather at the edges of printed areas in a manner misleadingly suggestive of the ink squash of relief printing, and the other is a puckering of the ink in certain colours, as it dries on the slippery surface, to form a pattern which again is misleading in its hint of a printed grain such as aquatint.

When cans have wrap-around paper labels with pictorial images, the labels will usually be printed by four-colour offset lithography and will be similar to any other such image on paper.

Cartons Cardboard cartons (cereal packets, for example) are mostly printed by offset lithography and will show the usual characteristics (55r), though frequently being far more elaborate than such printing elsewhere. Extra colours are added for increased effect with a lavishness reminiscent of the old chromolithographers.

Plastics carrying halftone images On plastic wrappings where an attractive four-colour photographic image is required the usual process seems to be gravure – most often today of the stylus-engraved variety, with circular cells of different sizes and depths (39f). In many ways plastic surfaces provide clearer examples of this technique than equivalent printing on the coarse paper of long-run magazines (78b). The open centres to the cells in light areas will show up very well through the 30× microscope, and the engraved dots will also reveal in these lighter areas the circular patterning (74f) which was previously characteristic only of relief or planographic four-colour work.

Plastics carrying line images Relatively simple printing on plastic is usually relief in origin – variously letterpress (33f), letterset (33i) and flexography (33k) – and so will show, often in extreme form, the ink squash of relief printing.

Alcohol Labels on bottles of wine and spirits are now nearly all printed by offset lithography, but very often extra words will be found to have been added in a separate printing, usually relief – being such details as volume, percentage proof, or when and where the liquid was 'mis en bouteille'.

c Ceramics The ceramics industry was a pioneer in the use of transfer printing. From the mid-eighteenth century designs were engraved on copper plates, were printed intaglio on paper with special metallic oxide inks, and then were pressed while still wet against the unfired piece of china. The design was fixed when the item was fired. During the nineteenth century lithography became the chief medium for transfer-printing (20), and it remains today the most common method in the decoration of ceramics.

While an occasional plate may therefore show the characteristics of line engraving (12), by far the majority of items in kitchens or dining rooms will be found to have the ink patterns of a chromolithograph (28c–d). The excep-

tions are likely to be a plate or bowl which has been hand-painted, the oldest of all ceramic traditions and still in use today. Any such hand-painted item will reveal, perhaps even more clearly than the equivalent on paper, the build-up of pigment at the edges which is an identifying sign of hand-colouring (64b).

d Textiles The printing of textiles from wood blocks predates the earliest prints on paper, and hand-printing from blocks is still an important part of the textile industry, particularly in the East. The more modern methods include relief printing from rollers, gravure and screenprinting.

Everyone's wardrobe (or the soft furnishings in the sitting room) will provide some examples of fabrics where the pattern is printed and others where it is woven. The distinction is not always clear to the eye but is immediately obvious through a glass. In a woven fabric the coloured pattern is achieved by the mixing of the colours of the individual threads, and it will therefore appear much the same on the reverse side. With a printed fabric the colour is imposed and bears no relation to the warp and weft of the threads. It is printed on one side only. On a thin material such as silk, it may appear much the same on the other side, but on a thicker fabric it will be faint on the reverse where only a fraction of the colour has seeped through.

Although fabrics are printed by all the main printing methods except lithography, they will provide no useful clues to the appearance of these methods on paper because the ability of the fabric to absorb the colour, instead of holding it on the surface as paper does, means that any distinguishing characteristics are dissipated.

e Laser and inkjet prints in colour One domestic change from the 1980s is that there are now likely to be found, around the house, colour images printed by one or other of the new electronic methods. A colour print resulting from a trip to the local photocopying shop will be a xerox or laser print (for usage see 80h). One generated at home from a desktop printer is more likely to be inkjet, since colour laser printers are still expensive.

The only important task of identification with prints of this kind will be distinguishing them from original coloured prints or paintings which, unlike the laser or inkjet reproductions, may have some value. To the naked eye this will often seem difficult (the much more recognizable signs in monochrome prints are described in 57g), and this will be particularly true if the print has

been framed and is behind glass. But under magnification the linear screen of a laser print will become evident in the darker areas (showing something of the effect of corduroy). The tiny dots of ink sprayed on the paper by an inkjet printer are more subtle, but at a similar magnification they too should begin to become evident as separate dots of red, blue, yellow or black (or sometimes up to seven inks) in the paler parts of the image.

Figures 109 and 110 show the same small detail from a watercolour, scanned into a computer and then printed by inkjet and laser. The inkjet will be seen to have much gentler gradations between the areas of colour – almost approaching the vagueness under magnification of a photograph (57a). In the laser print, by contrast, the patches of colour are created by tiny specks of dust-like pigment (the toner) fused together by heat, providing under magnification a harder and more jewel-like effect.

109, 110

80 A PRINT VOCABULARY: A Guide To Consistent Usage

It is convenient to standardize one's own terms for particular types of print, and it will be even more convenient if a consistent vocabulary becomes more widely accepted. It is much needed. In the catalogue of a major exhibition organized by the printing trade in 1980 (*British Coloured Books*, IPEX 80) three successive exhibits were described as 'colour wood engraved block', 'coloured wood engraving' and 'colour wood engraving'. Each of these entries referred to an identical type of print, that described in this book by its old name of chromoxylograph.

One solution is that of the better sale catalogues, where the nature of each print is exhaustively given in such phrases as 'etching with drypoint, roulette work and traces of burin'. But not every print can be looked at by the cataloguer with equal care, so even this method results in inconsistencies – with several traces of burin inevitably going unrecorded.

For everyday purposes it is easier to fix on a less demanding vocabulary and to stick to it. Here, therefore, is a list of the terms used in this book with a suggestion of how much variation each of them can legitimately accommodate.

a Manual: relief

woodcut (5) cut on the plank edge of the wood

wood engraving (6) cut on the end grain of the wood

metalcut, metal engraving (7*b*) cut by hand on metal blocks, the choice of name depending on whether the result is more like a woodcut or a wood engraving

metalcut in the dotted manner (7*a*) metalcut with tonal decoration from dots and stars punched into the metal

relief etching (7*c*) from a metal block on which the printing areas have been achieved by etching down the white spaces

linocut (8) from a design cut in linoleum (and so with **vinylcut** etc.)

collagraph (8) from a block formed by glueing various flat objects or substances to a base (also called **collograph**)

chiaroscuro woodcut (21) colour woodcut from two or more plank-edge wood blocks, in a muted range of tones imitating a wash drawing; see also CHIAROSCURO WOODCUT WITH INTAGLIO, in 80*d*

colour woodcut (22) colours printed from plank-edge wood blocks

tinted wood engraving (23*a*) wood engraving with one or two tints from wood blocks

colour wood engraving (23) colours printed from end-grain wood blocks; chiefly used for reproductive purposes in the period 1850–1900, and as such referred to in this book as CHROMOXYLOGRAPH

chromoxylograph (23*b–d*) reproductive print from end-grain wood blocks, constituting the vast majority of prints classifiable as COLOUR WOOD ENGRAVINGS

chromotypograph (42*a*) colours printed from variously textured metal blocks, with or without other colours from wood-engraved blocks; an intermediate stage between a manual and a process print (see 80*e*)

colour relief etching, colour linocut, etc. as monochrome versions, but from more than one block

relief compound print (24*b*) any colour relief print where the printing surface has been taken apart for separate inking and then reassembled for printing

b Manual: intaglio

engraving (9) all the lines incised with the burin

etching (10) all the lines bitten by acid through a hard

ground; the term can also include any work done with acid directly on the plate, such as open bite, brush bite, spit bite, marbling or deep etch (18*d*); in practice it can also be used for any print mainly etched, and having the informal character of an artist's etching, even if a burin or a drypoint needle (the burr being removed) has been employed in a few places for added emphasis or minor correction

etching with drypoint (10, 11) an etching, as above, but with drypoint lines included from which the burr has not been removed, giving the characteristic rich furry look to parts of the image

etching with aquatint (10, 17) an etching, as above, with aquatint tone added to only a small part of the image

drypoint (11) all the lines scored with the drypoint needle and the burr left on the plate

line engraving (12) a reproductive print combining engraving and etching in whatever proportion best suits the subject, lacking therefore the spontaneity of an artist's etching

copper engraving (12*c*) a line engraving on copper, in practice all line engravings before 1820 and a minority thereafter

steel engraving (13) a line engraving on steel or, after about 1860, on a copper plate steel-faced for printing

crayon manner engraving (14*a*) one imitating a chalk drawing by means of the roulette

stipple engraving (14*b*) the important parts achieved by means of stipple, whether etched or engraved, regardless of whether etched or engraved lines are also used to reinforce the image

soft ground etching (15) the greater part of the image achieved by pressure on a soft ground, whether the result be linear (original use) or textural (more common today)

mezzotint (16) surface of the plate textured with the mezzotint rocker to print a solid black, and the image achieved by burnishing towards white, regardless of whether etched or engraved lines are also added

carborundum mezzotint (16*c*) modern print in which mezzotint-like tone is achieved by roughening the surface of the plate with abrasives

sand-grain mezzotint (16*c*) modern print in which mezzotint-like tone is achieved from sandpaper grain

aquatint (17) aquatint tone on a major part of the image, regardless of whether etched or soft ground lines are added

sulphur print, sand-grain etching, sugar- or salt-ground etching (18*a*–*c*) tone added to a major part of the print by any of these methods, regardless of whether etched or other lines are also included

intaglio compound print (26*d*) any intaglio print from a plate which has been cut up for separate inking and then reassembled, or from two or more separate plates placed together on the bed of the press

blind intaglio (18*d*) uninked embossed print from deep-etched plate

viscosity print (31*c*) single-plate relief-with-intaglio on the intaglio press, using inks which do not mix because of differing viscosity

mixed method intaglio monochrome print from a single plate achieved by any mixture of methods not covered in the standard categories above

colour mezzotint, aquatint, stipple engraving, etc. (26) colour-printed version of each print; further classification will be *à la poupée* for a single plate, **multiple-plate** if from several

mixed method colour intaglio mixed method intaglio using more than one ink, regardless of whether from one or more plates

c Manual: planographic

lithograph (19) printed from a stone or metal surface on the principle of antipathy between grease and water, therefore including ZINCOGRAPH; if wishing to distinguish more precisely between different types of lithograph (the difference relating in each case to how the image was achieved on the stone), the likely categories are **pen-and-ink** (19*a*), **chalk** (19*b*), **mezzotint style** (19*c*), **lithotint** (19*d*), **spatter** (19*e*) and **stone engraving** (19*f*)

zincograph (19*g*) subdivision of LITHOGRAPH, emphasizing that the printing surface was zinc rather than stone

transfer lithograph (20) lithograph in which the image was created elsewhere than on the final printing surface and then transferred

tinted lithograph (27) lithograph coloured with one or two tints but not more; when describing an example

with two tints it may be worth specifying **double-tinted lithograph**

colour lithograph (28) lithograph in two or more inks if the colours are split up and merged, or in three or more colours used as tints; conventionally used for an artist's lithograph as opposed to a CHROMOLITHOGRAPH

chromolithograph (28*b–d*) the term commonly used for any of the vast number of COLOUR LITHOGRAPHS produced commercially in the second half of the nineteenth century and later

screenprint (45) any print made exclusively by the screenprinting method, whether originated by hand or photographically

d Manual: mixed method

chiaroscuro woodcut with intaglio (21*c*) intaglio key plate coloured from one or more wood blocks

Baxter print (29) intaglio key plate (or occasionally lithographic), coloured from relief blocks; collectors of prints by George Baxter may prefer to reserve this term for the work of the master himself, in which case **Baxter-process print** is the conventional name for prints of the same kind by other printers

Nelson print (30) lithograph coloured from two relief blocks

e Process: relief

line block (33) a subject in line from any relief block on which the image has not been achieved manually on the block's surface by artist or craftsman but has been created mechanically or chemically; the term includes line subjects where areas of tone have been added to the block by means of prepared, manufactured or mechanical tints (63); in recent decades the term has usually been reserved for the type of line block which became the standard twentieth-century version, with the image transferred photographically to the block and then etched (33*f*); if wishing to specify more precisely the predecessors of this standard line block, the possible variations are the stereotyped line block (33*a*), the electrotyped line block (33*b,d,e*) and the transfer line block (33*c*)

colour line block (42*b*) colours printed from two or more line blocks, of which some are likely to be

textured with prepared, manufactured or mechanical tints (63)

chromotypograph (42*a*) colours printed from metal blocks using various hand-originated textures; when combined with other colours from wood-engraved blocks it represents a transition stage between manual and process prints (see 80*a*)

relief halftone (34) from a block on which a tonal image has been achieved by means of a screen

doubletone (42*e*) halftone using doubletone ink, which spreads to create a halo of a different shade round each dot of the printed screen

tinted relief halftone (42*c*) halftone coloured from drawn or manufactured tints on line blocks

relief duotone (42*d*) two halftone blocks from the same monochrome original, given different exposures and printed in different inks

three- or **four-colour relief halftone** (42*f*) filter-separated halftone blocks printed in yellow, red and blue or yellow, red, blue and black; **two-colour halftones** have also been produced, differing from DUOTONES in that the blocks are filter-separated from an image in colour

colour relief halftone a term which will adequately describe any colour print from halftone blocks not fitting exactly any of the categories given above

letterset (33*j*) printed by offset from a relief cylinder

flexograph (33*k*) printed direct from a relief cylinder of rubber or similar composition

f Process: intaglio

nature print (35) from copper plate formed as a mould of the actual object being printed

photogalvanograph (36) from copper plate formed by electrolysis from light-sensitized gelatin surface

photogravure (37, 38) from copper plate formed using a light-sensitized coating, printed in the traditional manner on the rolling press; the term can cover all examples, but if more precise distinctions are required they will be **line photogravure** (37) for any print not involving tone, or **aquatint photogravure** (38*a*), **sand-grain photogravure** (38*b*) and the much less common **screened photogravure** (39*a*)

gravure (39) from plate formed by a cross-line screen and a variable acid resist, printed on a rotary intaglio press

invert halftone (39*f*) a form of GRAVURE, with round dots variable in size but not in depth

stylus-engraved gravure (39*f*) a modern form of GRAVURE, with round dots variable both in size and in depth

three- or four-colour gravure, etc. as for similar varieties in 80*e*

g Process: planographic

collotype (40) from a surface of light-sensitized gelatin used as a lithographic plate

ink-photo (41*b*) an image from a surface of light-sensitized gelatin, transferred to stone and printed lithographically

photolithograph (41) from a stone or plate on which an image has been achieved photochemically – in practice for most of the twentieth century nearly always printed offset, so **offset lithograph** or **offset litho** are now more common terms; **line photolithograph** (41*a*) and **halftone photolithograph** (41*c*–*e*) will make the same distinction as between line block and relief halftone (80*e*)

tinted line, tinted halftone, duotone, three- or four-colour all can be used before PHOTOLITHOGRAPH or offset lithograph with the same meaning as in 80*e*; similarly duotone and three- or four-colour can be used before COLLOTYPE

screenless offset lithograph (41*e*) halftone achieved by graining of the lithographic plate rather than by a cross-line screen

h Electronic

inkjet (2*d*) an image transferred from a computer file and printed by the spraying of tiny specks of ink on the surface of paper or other material

laser and **xerox** (or **photocopy**) (2*c*) an image composed of grains of pigment fused together and stuck to the paper by heat; prints of this kind can be produced by a laser printer (from a computer file) or by a photocopier (directly from a scanned image); both varieties will show the same characteristics, but it is a useful convention to reserve laser for an image printed from a computer and xerox or photocopy for the instant replication of a scanned image

81 SELECT BIBLIOGRAPHY

Books on prints and printing history are legion. I include here merely a recommendation of one excellent title for each of the main directions in which the material in the present book will need amplifying. Each of these titles either contains or is itself a bibliography, and so will lead the reader further into each aspect of the subject.

Griffiths, Antony *Prints and Printmaking; an introduction to the history and techniques*, 1980. An extremely useful brief account, balancing very well the rival claims of aesthetics and technicalities, by an Assistant Keeper (subsequently Keeper) of the Department of Prints and Drawings at the British Museum.

Eichenberg, Fritz *The Art of the Print*, 1976. A joyful visual indulgence in a profusion of prints of all kinds and periods, by a practising printmaker who was also Director Emeritus of the Pratt Graphics Center in New York. Outstanding also because of the superb gravure printing of the monochrome illustrations.

Coe, Brian and Haworth-Booth, Mark *A Guide to early Photographic Processes*, 1983. A useful tool for identifying the various kinds of Victorian photograph, thereby making it easier to distinguish them from prints as well as from each other.

Bridson, Gavin and Wakeman, Geoffrey *Printmaking & Picture Printing; a bibliographical guide to artistic and industrial techniques in Britain, 1750–1900*, 1984. An invaluable round-up of all the technical literature, enabling one to find further information about even the most esoteric types of print. The authors also identify which publications include specimens of each type of print.

Levis, Howard C. *A Descriptive Bibliography of the most important Books in the English Language relating to the Art and History of Engraving and the Collecting of Prints*, 1912–13, reprinted 1974. Although it ends in 1913, this massive compilation provides most seductive browsing for anyone interested in any aspect of prints.

82–106 THE SHERLOCK HOLMES APPROACH

This sequence of questions is intended to lead as quickly as possible to those clues within the book which may help in identifying a particular print. Once a likely solution has been reached, look up that type of print in the Glossary-Index (107). This will provide references to sections where the apparent answer may be pursued further or tested against other possibilities. For the sake of simplicity only the more common forms of print are included here, but the text references will lead towards their more exotic cousins. If a hunch is proved wrong, return to this series of questions.

A number in brackets gives the main entry for each type of print. A number with 'see' means that the section referred to is specifically concerned with the relevant process of detection. 'Go to' merely indicates the next stage in the quest.

It is not worth beginning the detective process without a glass of at least 4× magnification (see Introduction).

Begin at 82, and whenever the answer is 'no', or the question does not apply, move on to the next question.

82 Is the image formed by means of a regular pattern of dots or squares? This will indicate that it is a modern process print. If it is monochrome, the only choice will be whether it is relief halftone, gravure or offset lithography; see 55*r* for the differences. If it is a colour print, go to 106.

83 Does the image consist of more than one colour? If so, go to 96.

84 Is any embossing (59*a*) visible on the back of the paper within the area of the image? If so, this is usually a sign of relief printing. Go to 93.

85 Does the image have areas of tone as opposed to line? If so, does the tone tally with any of the examples in 53? This should easily catch an aquatint (17) and a collotype (40) and is likely to be sufficient for the identification of a mezzotint (16) and a stipple engraving (14*b*). If the tone cannot be identified go to 87.

86 If the image is composed of lines, do they tally with any of the examples in 52? This will catch most pure engravings (9) together with etchings (10) and drypoints (11). If the

print seems to have characteristics of both engraving and etching, it will be a line engraving and the choice will be between a copper engraving (12*c*) and a steel engraving (13); for the difference between them see 55*g*.

87 If the print is a portrait, does the face tally with any of the examples in 54?

88 Does the image appear within a rectangular depression of the paper? If so, this is probably an intaglio plate mark (50). Go to 94.

89 Are there words immediately below or within the image, giving details such as title and artists? If so, see 48 and 49.

90 Is there text printed with the image, or on the back of the sheet of paper? If so, see 47.

91 If none of these short cuts has provided any useful clue, it is time to ask a fundamental question. Is the image in fact printed? For the main areas of likely confusion, see 57.

92 If the image is indeed printed, the next step must be the basic one of analysing whether the method of printing has been relief, intaglio or planographic. For the characteristic differences see 55*a*. If the answer is relief, go to 93. If intaglio, go to 94. If planographic, which at this stage will include screenprinting, go to 95.

93 Relief The most likely answer up to the eighteenth century is a woodcut (5*a–b*). From the late eighteenth to the late nineteenth century a relief print will most probably be a wood engraving (6*a–d*), while from the late nineteenth century to the present time a line block (33*g–i*) will be the probable answer if it is a commercial print. For the differences between a woodcut, a wood engraving and a line block see 55*b–c*. Artists' relief prints during the twentieth century will most often prove to be woodcuts (5*d*), wood engravings (6*e*) or linocuts (8).

94 Intaglio An engraving and an etching are likely to have been identified already by their line; a mezzotint, an aquatint and a stipple engraving by their tone; and a drypoint by its combination of line and tone. An etching

can very often be confused with a line photogravure (37), and indeed they may often be impossible to tell apart; see 55*k*. One quite common form of intaglio print which may not easily have yielded up its identity through the nature of its line or tone is a soft ground etching (15). It is sometimes confused with a crayon manner engraving (see 55*h*), but the greater difficulty is with a chalk lithograph (see 55*i*). One form of tonal intaglio print, common from about 1880 to 1930, is at first hard to identify because the ink pattern is often too fine to be made out even through a glass; this is the tone photogravure (38), the likely solution with any intaglio print which has almost the appearance of a photograph. An intaglio print which seems to reproduce perfectly a natural object, such as a leaf, will be a nature print (35).

95 Planographic Among those prints where both paper and ink are characteristically flat, the first task is to distinguish between a lithograph and a screenprint; see 55*q* for the difference. Often the date will give the easiest clue, for lithography has been one of the common forms of printing since the early nineteenth century whereas screenprinting is limited to the twentieth century and has only been common since the 1960s. There is little need to distinguish between the various types of manual lithographs (19*a*–*e*), though stone engraving (19*f*) is perhaps the exception; a delicate stone engraving may be hard to tell from a steel engraving (see 55*m* for the difference). It may also be worth specifying a transfer lithograph (20) since such a print will often look like its original in a different medium, again perhaps resembling a steel engraving in its linear structure though not in the quality of the individual lines (see 55*n* for the difference). A pen-and-ink lithograph or a transfer lithograph may be impossible to distinguish from a line photolithograph (41*a*) or, in the more modern version, a line offset lithograph (41*c*). A chalk lithograph is easily confused with a soft ground etching (see 55*i* for the difference).

96 Is any of the colour added by hand? See 64*a*–*c* for ways of deciding. If traces of hand colouring are found, check whether any of the colour is printed (64*d*) apart from the basic image itself – which will usually be black but may be in any other colour of ink. If only the single colour of the image is printed go back to 84, for this is a monochrome print with the addition of hand colouring. If more than one printed colour is found, continue with 97.

97 Are there just one or two flat colours in addition to the ink of the main image? If so, this is a tinted print (65). The nature of the image should be analysed as for a monochrome print (if necessary go back to 84), but by far the most likely result is a tinted lithograph (27). The other main possibility is a tinted wood engraving (23*a*). Normally the tint will be printed in the same manner as the image, planographic or relief, but an exception is the Nelson print (30). A much earlier form of print which may also have large areas of flat tone in a limited range of colours is the chiaroscuro woodcut (21). Sometimes a monochrome print may incorrectly appear to have a yellow or brown tint if it has been framed, the reason being that the rectangle of paper exposed by the mount has been altered in colour by the action of light.

98 Is there embossing (59*a*) on the back of the print? If so, it is almost certainly some form of relief colour print. Go to 102.

99 Is there a plate mark (50)? Can fainter and darker lines or areas be found which seem to be different shades of the same colour (26*c*)? If either is the case, it is likely to be an intaglio print. Go to 103.

100 Do the ink marks of each colour look as though they could have been separately drawn or otherwise applied by hand? Do the spaces between the ink marks of each colour look as though they could have been carved or engraved away by hand? In either case go to 101. Or are there patterns of ink which look too regular or too fiddly for each mark to have been created by hand? If so, go to 105.

101 Choose an area where any one colour is easily visible but is in separate patches rather than a solid tone. (The spaces between the patches may be white or the colour of another ink printed beneath.) Do such spaces look as though they have been cut or engraved away? If so, it is probably relief; go to 102. Or do the ink marks themselves seem to have been individually drawn or dotted? If so, it may be planographic; go to 104. The choice between relief and planographic in nineteenth-century colour prints is almost invariably that between chromoxylographs (or later, chromotypographs) and chromolithographs; for ways of distinguishing between them see 55*s*.

102 Relief colour The most likely relief colour prints are: chiaroscuro woodcut (21) for any period up to the mid-

eighteenth century; colour woodcut (22) for Japanese prints from the eighteenth century and for artists' prints from the late nineteenth century to the present day; chromoxylograph (23b–d) and chromotypograph (42a) during the second half of the nineteenth century. Artists' prints in the twentieth century may also be colour linocuts (25 and 31b).

103 **Intaglio colour** Before our own century by far the most probable candidate is stipple engraving (26a), followed by mezzotint and aquatint (26a–b), but among modern prints aquatint may be the most common. The characteristic ink patterns will usually be distinct in patches of a single colour; test one such patch against the tonal examples in 53a–c. Intaglio prints since the 1880s may turn out to be tone photogravure (43a–b); for the differences between original intaglio and photogravure see 55k. An intaglio colour print will most often be printed from a single plate at one impression, in which case it is described as *à la poupée* (26a). The alternative is multiple-plate printing (26b). For the differences between them see 55v. If the key image and perhaps the letters below seem to be intaglio, but the other colours are printed relief, the answer will usually be a Baxter print (29).

104 **Planographic colour** The only candidates are a colour lithograph (28) and a colour screenprint (45). It is impossible that it should be a screenprint before this century, and relatively unlikely before the 1960s. Since that time the decision can sometimes be difficult; for the differences see 55q. Most nineteenth-century colour lithographs are of the very recognizable type known as chromolithographs (28b–d) which differ from artists' colour lithographs (28e) only in their lack of artistic pretension, involving therefore a very subjective line of demarcation.

105 **Colour using prepared or manufactured tints** The creation of random tones (63a–b) in colour printing was common mainly in the period from about 1870 to 1900. The two likely answers at that time are chromotypograph (42a) and chromolithograph (28d). For the differences between them see 55s. An extremely fine grain in a planographic print may indicate a colour collotype (44a–b), possible from the 1870s to the present time; choose an area where the grain of a single ink is easily visible and check it against the example given in 53h. In case an intaglio print has slipped through the net, it is worth checking a single patch of colour tone against the examples in 53a–c. One type of modern process print which should have been caught in 82 but may have survived this far is colour gravure, where the doctor blade often obscures the regular cell pattern by scooping out most of the ink in the lighter tones and leaving the ink in thin hollow circles or semicircles (55r).

106 **Process colour** To work out whether a process colour print is printed by gravure, relief halftone or offset lithography, choose an area where a single ink is easily visible and analyse which method has been used for that ink; for the differences see 55r. With gravure the only variation will be in the number of colours used. In either relief or offset lithography there is a wide range of possibilities, with some colours in line and others in halftone. The choices will be a colour line block (42b), a tinted halftone (42c), a duotone (42d), a doubletone (42e), and three- or four-colour halftones (42f) or the equivalents in offset lithography (44c–e). For special effects some process prints will use extra colours above the normal complement of the three primaries and black. Among artists' prints of recent years photographically originated halftone images will quite often be combined with hand-originated material in both lithography and screenprinting; for the differences between them see 55q. Manually applied Ben Day tints occasionally give such a regular pattern of dots that a chromolithograph (28d) may accidentally have been diverted into this section with the process prints.

107 GLOSSARY-INDEX

Any glossary of a subject as complex as prints is inevitably selective. This one is limited to those terms which are likely to be encountered when trying to identify a print, occasionally by being found on the print itself but more often in other people's description of the print, as for example in sale catalogues. A few terms have been included which have nothing to do with prints in the traditional sense but which often crop up and which may be useful to have defined. Examples are the more important types of nineteenth-century photographs, or terms which are part of current jargon such as *inkjet*. Methods and terms dealt with in the text are merely indexed, while others are defined. Foreign terms are included only if they are also current in English. If a word is in CAPITALS within an entry, it means it has an entry of its own where index details or further information will be found.

acrograph a form of GYPSOGRAPH
à la poupée intaglio, 26a, 66b; relief, 31a, 66b; photogravure, 43a; planographic, 66b; difference from multiple-plate intaglio, 55v; banknotes 77
Albertype early name for COLLOTYPE
airbrush confusion with printed colour, 57i; use of stencil, 64c
albumen print form of PHOTOGRAPH
algraph term for LITHOGRAPH from aluminium plate
anaglyptograph another name for MEDAL ENGRAVING
anastatic printing 20b
aniline printing an early photographic method of document copying, similar in concept to the BLUEPRINT; aniline printing is also an alternative name for FLEXOGRAPHY
aq., aquaf., aquaforti, aquaforti fecit (on print) 48
aq:tinta, aquatinta (on print) 48
aquatint 17; colour, 26; aquatint photogravure, 38a; varieties of tone, 53b; difference from collotype, 53b; mezzotint or aquatint, 55j; original intaglio or photogravure, 55k; mistaken for wash drawing, 57e;

aquatint tone online blocks, 63a; halftone screens, 74b; usage, 80h
aquatint photogravure 38a; difference from collotype, 53b; original intaglio or photogravure, 55k; usage, 80f
artists' prints and reproductions, 45f
artotype another name for COLLOTYPE
assemblegraph a form of COMPOUND PRINT in which the separate pieces to be assembled for printing are not cut from a single plate or block
auto- a prefix sometimes used in the nineteenth century to imply that the print in question was entirely created by the artist, without a craftsman as intermediary, as in 'autolithograph' etc.
autochrome occasionally used around the turn of the century for four-colour relief halftone, but also the name for the first successful commercial version of a colour photograph
autogravure an early name for SAND-GRAIN PHOTOGRAVURE
autotype another name for CARBON PRINT; the term was also sometimes used for COLLOTYPE, the reason being that many early collotypes were printed by the Autotype Company, who called it their 'Autotype mechanical process'

banknotes 77; use of ruling machines 62
Baxter print 29; illustrated books, 75f; usage, 80d
Baxterotype a term used by George Baxter for chiaroscuro prints published by himself in the 1850s with an intaglio key plate and sepia tone from a single wood block, the style and the choice of name reflecting the popularity at the time of DAGUERREOTYPES
before letters used of a PROOF taken before the plate was sent for the title and other letters to be engraved
Ben Day mediums 63b–c
blending screenprinters' term for RAINBOW PRINTING
blind intaglio 18d; usage, 80b
block the printing surface in relief printing, whether of wood or metal
blocking 59e
blueprint a form of photograph, used chiefly in the copying of plans etc.

brass etching early term for RELIEF HALFTONE
bromide print nowadays the most common form of monochrome photograph
bromoil print a form of photograph, achieved by turning a BROMIDE PRINT into an image in which the tones depend on the amount of ink accepted by the moistened GELATIN of the emulsion; the term was also occasionally used for a transfer method in lithography
bromoil transfer an image transferred to paper from the inked surface of a BROMOIL PRINT, in a process akin to COLLOTYPE in its use of the reaction between damp GELATIN and ink
brush bite 18d; usage, 80b (etching)
burin 9a
burnisher in mezzotint, 16a; in aquatint, 17c; for alterations, 61b
burr drypoint, 11; mezzotint, 16a

cael., caelavit (on print) 48
calotype the earliest form of photograph on paper from a negative
cancelled plate a print with a printed line or lines slashed across the image, issued to prove that the plate or stone has been defaced and that no further unspoilt impressions can be taken now that the edition is complete
carbon print a form of photograph achieving tone through differing thicknesses of darked gelatin, on the same principle as that used for a variable gelatin resist (73c)
carborundum mezzotint 16c; usage, 80b
Carbro (trade name) a form of photograph based on the nineteenth-century principle of the CARBON PRINT
cardboard cut modern form of relief print, for which printing areas are cut from cardboard and glued to a base
cast paper print another name for BLIND INTAGLIO
celluloid print modern version of DRYPOINT, using a sheet of celluloid instead of a copper plate